The Spirit of the Brush

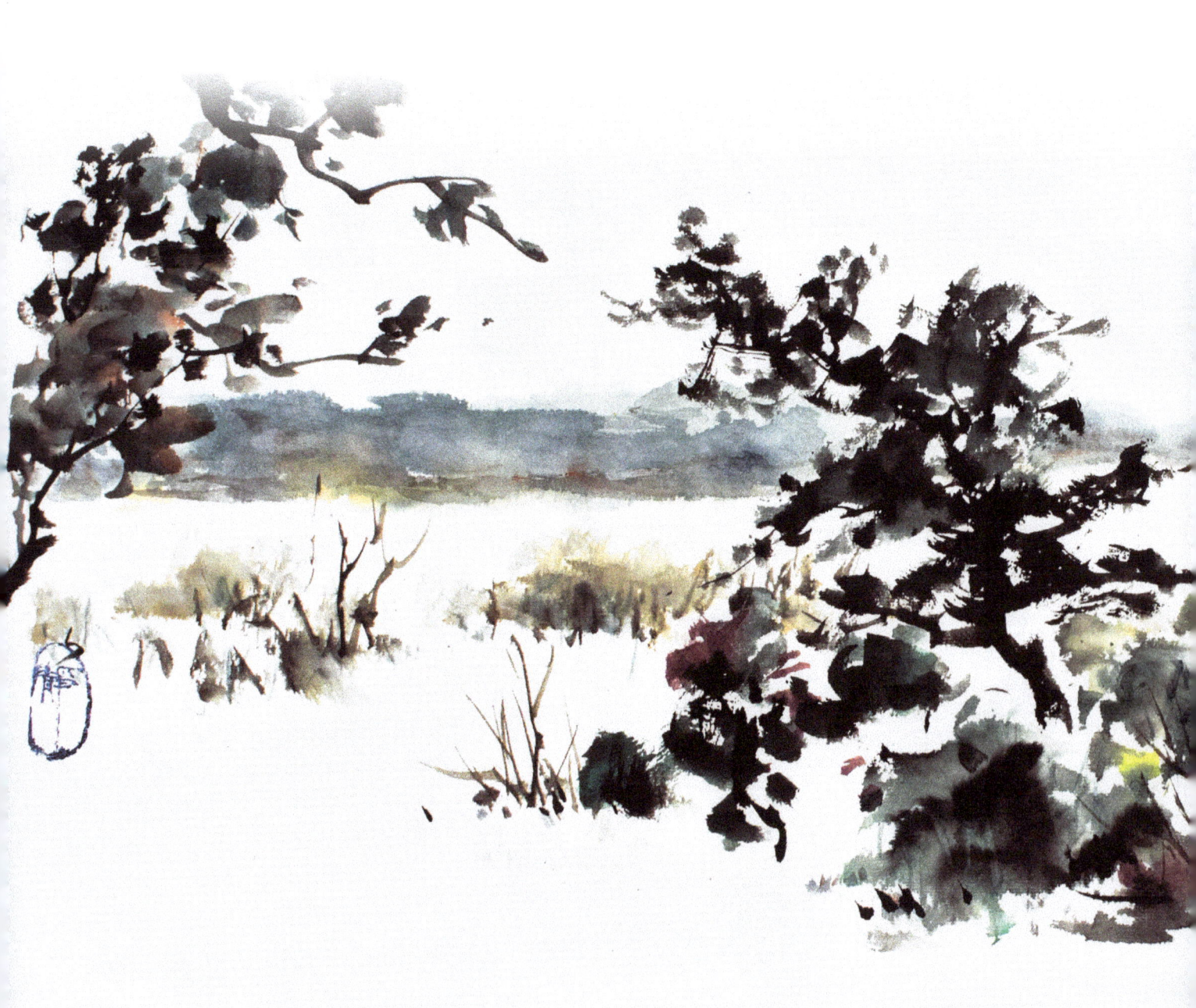

The Spirit of the Brush

CHINESE BRUSH PAINTING TECHNIQUES:
SIMPLICITY, SPIRIT, AND PERSONAL JOURNEY

SUNGSOOK HONG SETTON

Brimming with creative inspiration, how-to projects, and useful information to enrich your everyday life, quarto.com is a favorite destination for those pursuing their interests and passions.

Inspiring | Educating | Creating | Entertaining

© 2017 Quarto Publishing Group USA Inc.
Text and Illustrations © 2017 Sungsook Hong Setton

First Published in 2017 by Rockport Publishers, an imprint of The Quarto Group, 100 Cummings Center, Suite 265-D, Beverly, MA 01915, USA.
T (978) 282-9590 F (978) 283-2742 Quarto.com

All rights reserved. No part of this book may be reproduced in any form without written permission of the copyright owners. All images in this book have been reproduced with the knowledge and prior consent of the artists concerned, and no responsibility is accepted by producer, publisher, or printer for any infringement of copyright or otherwise, arising from the contents of this publication. Every effort has been made to ensure that credits accurately comply with information supplied. We apologize for any inaccuracies that may have occurred and will resolve inaccurate or missing information in a subsequent reprinting of the book.

Rockport Publishers titles are also available at discount for retail, wholesale, promotional, and bulk purchase. For details, contact the Special Sales Manager by email at specialsales@quarto.com or by mail at The Quarto Group, Attn: Special Sales Manager, 100 Cummings Center, Suite 265-D, Beverly, MA 01915, USA.

ISBN: 978-1-63159-290-4

Digital edition published in 2017

Library of Congress Cataloging-in-Publication Data available

Design and Page Layout: Rita Sowins / Sowins Design
Cover Image: Sungsook Hong Setton
Photography: Christina Bohn Photography

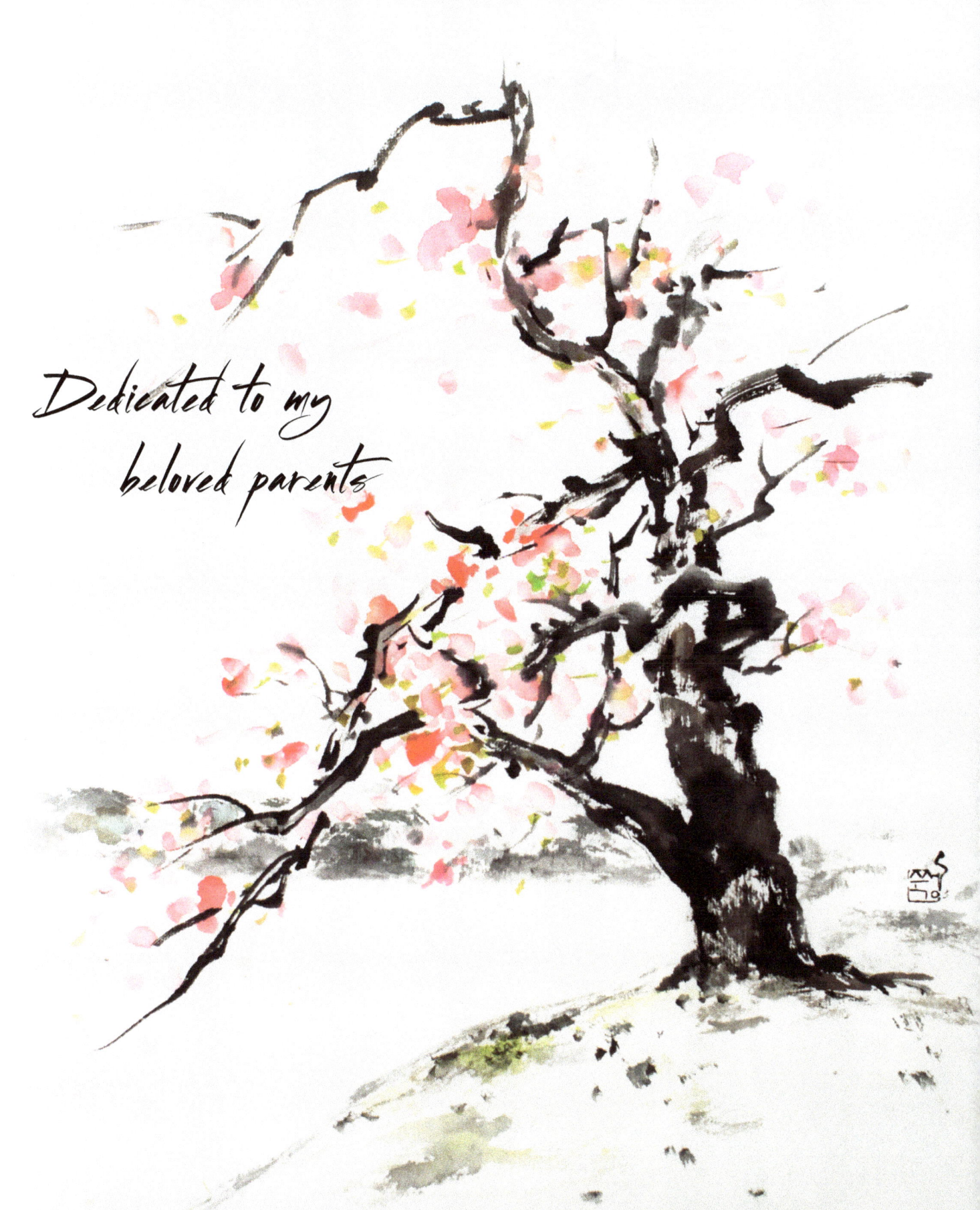

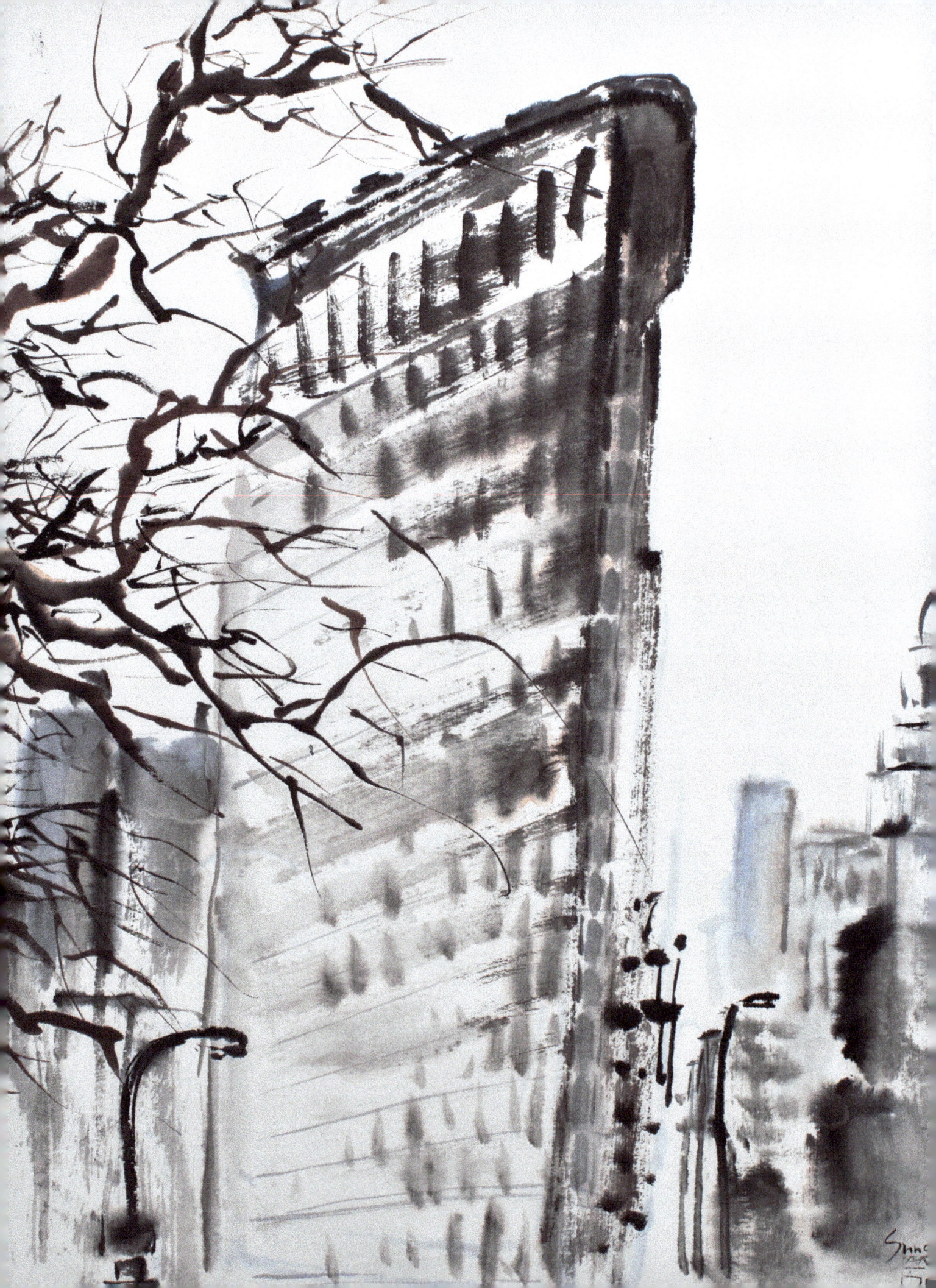

Contents

- 9 INTRODUCTION:
 Letting the Brush Lead

- 12 SPIRIT: IN SEARCH OF *Qi*

- 16 TOOLS AND MATERIALS
 - 16 Brushes
 - 17 Preparing a New Brush & Brush Maintenance
 - 18 Ink Sticks and Ink Stones
 - 18 Grinding Ink
 - 19 Paper
 - 19 Other Accessories
 - 20 Paint
 - 20 How to Set Up a Table

- 21 BASICS TECHNIQUES
 - 21 Holding & Loading a Brush
 - 24 Ink Tones
 - 25 Basic Use of the Brush
 - 26 Center Brush Stroke
 - 27 Reverse Stroke
 - 28 Side Brush Stroke
 - 29 Orchid Flower or Bamboo Leaf Brush Stroke
 - 30 Flying White Stroke
 - 30 Split Brush Stroke
 - 31 *Hake* Brush Stroke
 - 31 Dancing Brush Stroke
 - 32 The Four Noble Plants
 - 52 Landscape Painting
 - 68 Composition, Perspective, and Space

- 72 SPRING
 - 73 Willow Tree
 - 74 Spring Branches with Birds
 - 76 Pond with Ducks

- 79 SUMMER
 - 80 Avalon Garden: Echinacea and Dragonflies
 - 82 Dunes
 - 84 Banana Palms

- 86 FALL
 - 87 Fall at the Beach
 - 88 Silver Birch Tree
 - 90 Maple Tree

- 92 WINTER
 - 93 Snow-Covered Pine Needles
 - 96 Central Park
 - 100 Misty, Windy, Stormy Day

- 102 PAINTING MUSIC
- 108 MOUNTING PAPER
- 112 NAME AND MOOD SEALS
- 114 GALLERY
- 122 CONCLUSION
- 124 RESOURCES
- 125 ACKNOWLEDGMENTS
- 126 ABOUT THE AUTHOR
- 127 INDEX

OPPOSITE: THE FLATIRON BUILDING, NEW YORK

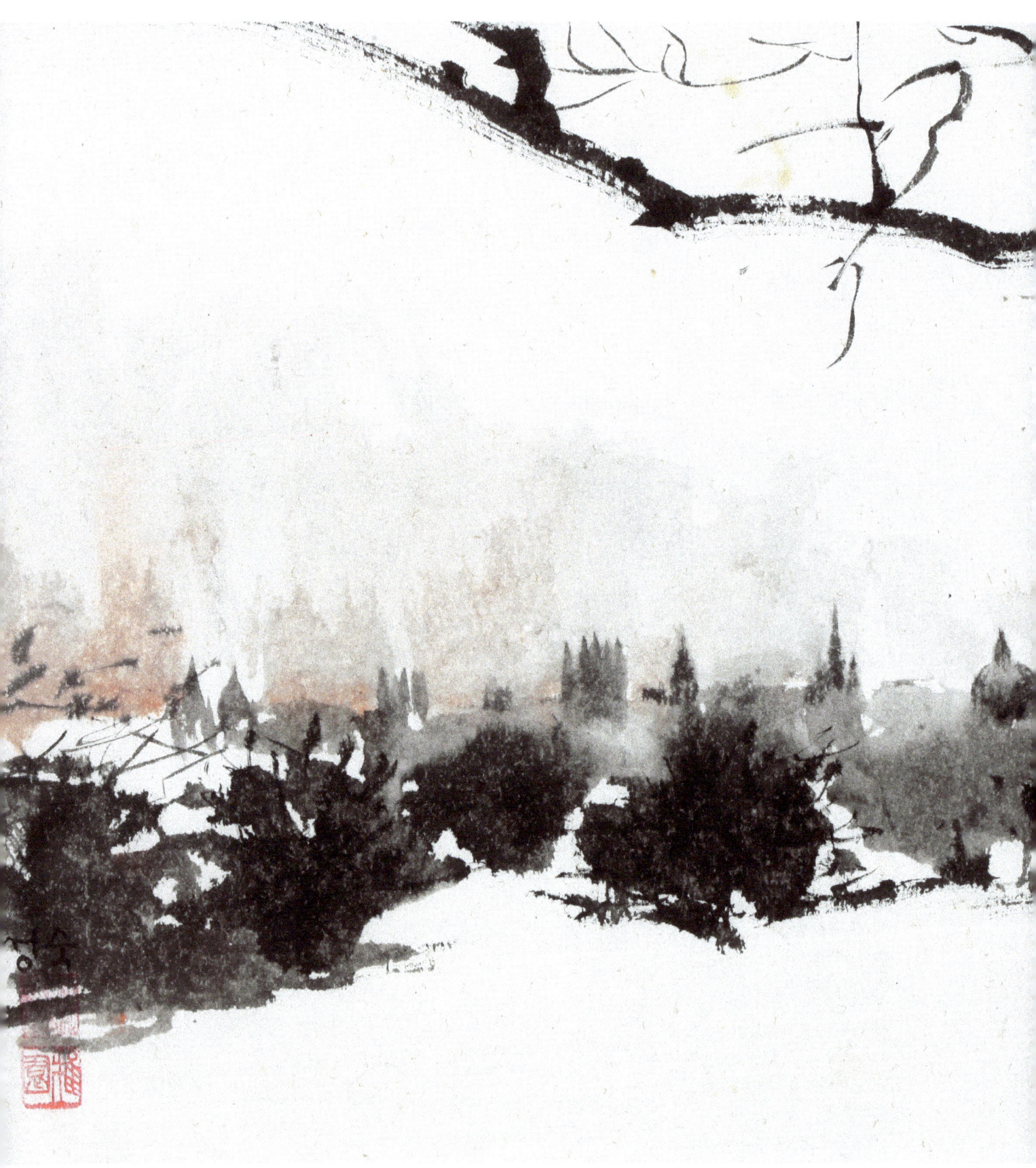

OXFORD IN WINTER

Introduction

LETTING THE BRUSH LEAD

MY BRUSH HAS TAKEN ME ON A SPIRITUAL JOURNEY AROUND the globe that I couldn't have imagined as a girl growing up in South Korea. It has led me from East Asia to the West, from following the masters to discovering my own inner nature, from traditional painting to abstraction. With my brush, I feel that I am not only a painter, but also a dancer and a musician. I sing songs with my brush and dance with it.

The techniques of water-ink (ink-wash) painting began in China and then flowered in Korea and Japan. It is the goal of every water-ink painter to become one with the brush, which can be done only through practice. For me that began in Korea in the 1980s, when I learned to paint an orchid leaf with a single brush stroke. My master, Chang, had me practice *only* that one stroke for a month, until I was able to paint it almost perfectly. Then he taught me how to paint the orchid flower. Just as musicians play scales and dancers practice their steps, water-ink painters practice the basic strokes to prepare for more intricate work.

The brush strokes and the brush itself have their own lessons to teach. One of the most important lessons for me is tranquility—while I paint and afterward. Becoming one with the brush is a meditative experience that requires the preparation of materials and the cultivation of a calm mental focus. It took me a long time to gauge just the right amount of water,

ink, and paint on the brush, and to move with the necessary pressure and speed. It's not an easy balance to master, but when you do, it frees you to just paint. The brush becomes an extension of your thoughts and feelings, and, in the language of Daoist philosophy, allows you to express your inner spirit—*qi*, or vital energy.

I discovered this when I moved from Korea to Oxford, England, with my husband Mark and our young family, and fell in love with the English landscape. Led by my brush, I began to experiment, using my East Asian method to depict local scenes. I was surprised at how well the interpretation of Western landscape through East Asian eyes worked on the page. The *qi* was there, even though the location was different. The brush didn't fail me; it seemed to know what to include—and what to leave out.

We later moved back to Korea, and then to the United States, where I began teaching, and where my landscape painting has continued. In the United States, I set off on a new journey toward minimalism. I am drawn to the idea of capturing the essence of things. I was inspired to do this by two artists: the Chinese water-ink master Bada Shanren (Zhu Da) and Korean master Wol-jeon (Woo-sung Chang). I love discovering what happens when I paint an American city scene, a meadow, or ocean dunes. In this book, I have chosen to focus mainly on landscape painting, because I enjoy it so much. While my brush is an extension of my thoughts, which have diverged from tradition, it also keeps me linked to the past. In China, "landscape" is *shan sui*, which means "mountains and water." The Chinese have been painting landscapes since the fourth century, and from the eleventh century onward, it has been the most important genre of Chinese painting.

Of course, landscape is also a good place to talk about a journey—*my* journey. In my painting and through my teaching, I seek to provide a meditative space for people to breathe and grow. In this book, I am happy to share what I've learned about the spirit of my brush, so that you can follow yours on the journey waiting for you, wherever it may lead.

SUNGSOOK HONG SETTON

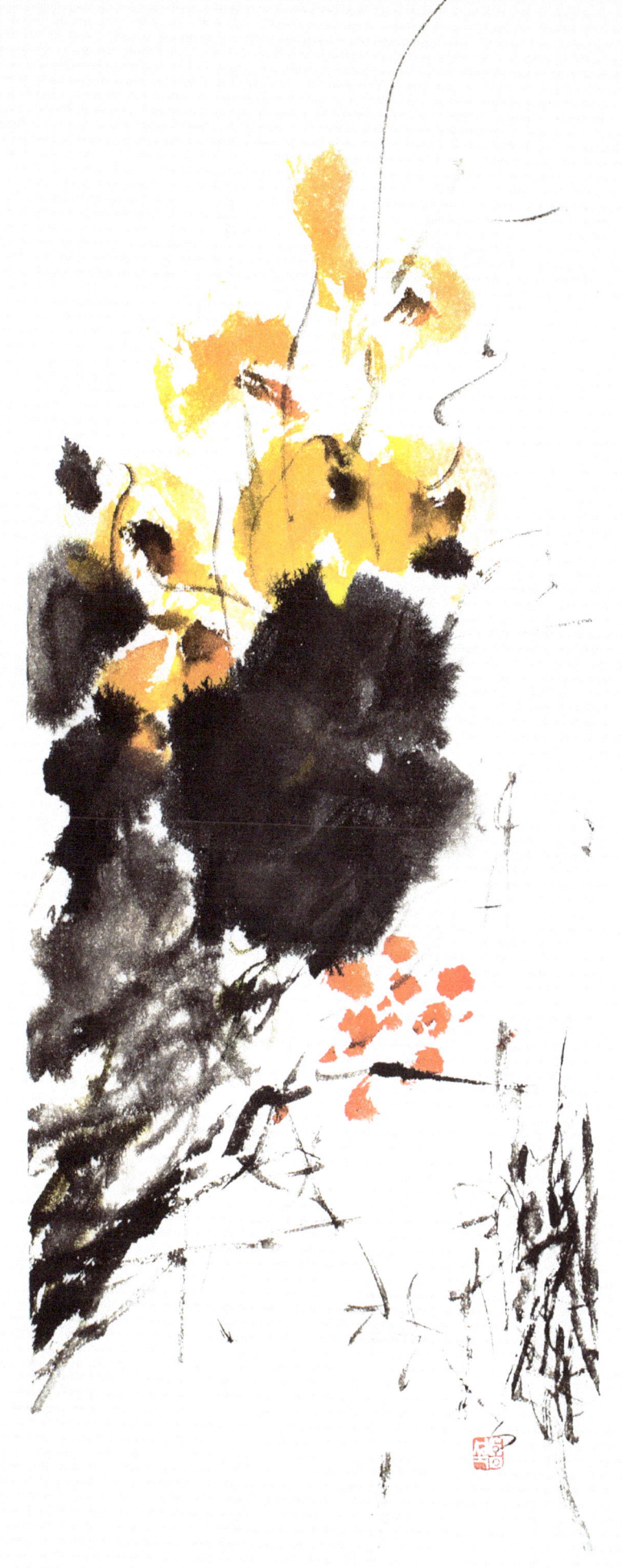

Spirit: In Search of Qi

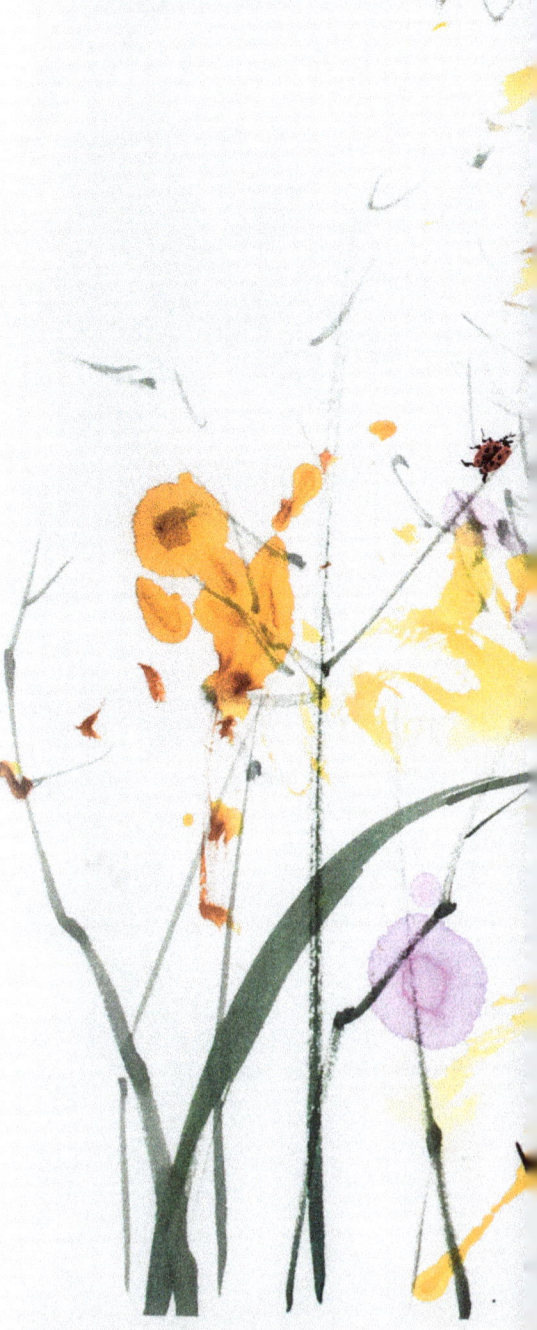

Whether I'm painting the bamboo flourishing outside my studio, a flock of ducks alighting on a pond, or a row of century-old buildings on a city street, my goal as an artist is to help my subject come alive on paper. To do so means harnessing the power of *qi*.

Qi shows up not only in discussions of water-ink painting, but in other disciplines, including calligraphy and martial arts. It's been defined as "breath," "spirit," "a vital force of heaven," and "the movement of life."

THREE KINDS OF *QI*

Perhaps it's best to think of it as all of those things because, according to contemporary brush artist Jia'nan Wang, there are actually three kinds of *qi*. One is the *qi* that enters your body at birth: Even as you take your first breath your spirit comes alive. It's the spark of who you are. One of the greatest secrets of the East Asian artist is related to how this first *qi* energy—the *qi* of the individual—is channeled and made manifest in a work of art.

The second kind of *qi* is similar, but instead of being located in the body, it fills the natural world. It exists in wind, in water, in rocks, in sky, and in all growing things. *Qi* is easy to feel when you're surrounded by nature. The reason we identify with it so strongly there is because the same *qi* exists inside us.

The third kind of *qi* is expressed when an artist experiences nature and interprets it on paper. A masterwork of brush painting represents the perfect meeting between the *qi* of the artist and the *qi* of nature. Each artist has a unique way of expressing this vitality with the brush. But how do you do that?

FINDING *QI* IN NATURE

I'm lucky to live in an area where I can enjoy nature all year round—the ocean, dunes, meadows, and my garden. Along with spending time surrounded by these places, I find it helpful to grow plants

"THOSE WHO ARE SKILLED IN PAINTING WILL LIVE LONG BECAUSE LIFE CREATED THROUGH THE SWEEP OF THE BRUSH CAN STRENGTHEN LIFE ITSELF, AS BOTH ARE ANIMATED BY QI."

The Mustard Seed Garden Manual of Painting
(Chinese, early Qing Dynasty)

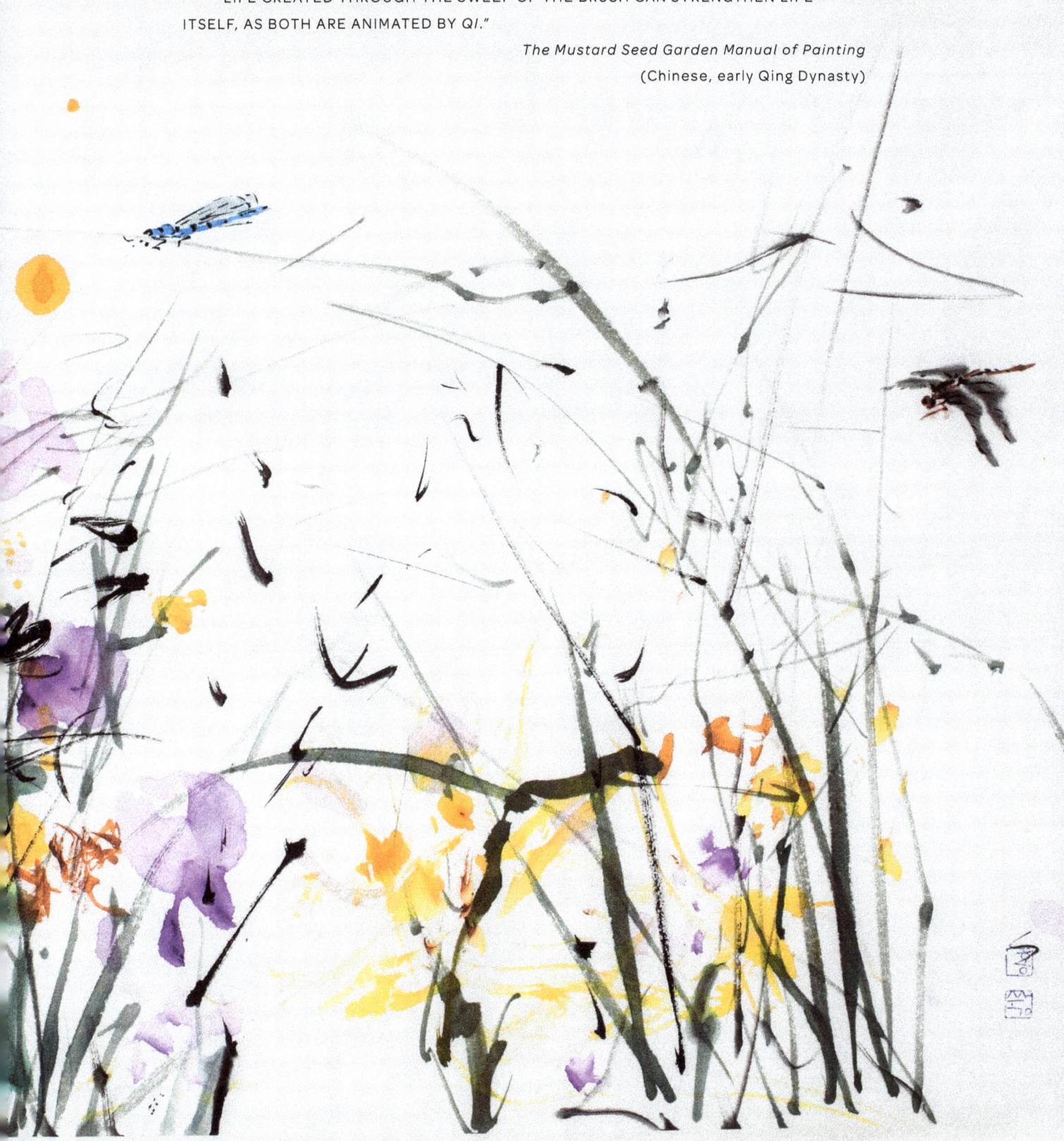

AVALON GARDEN

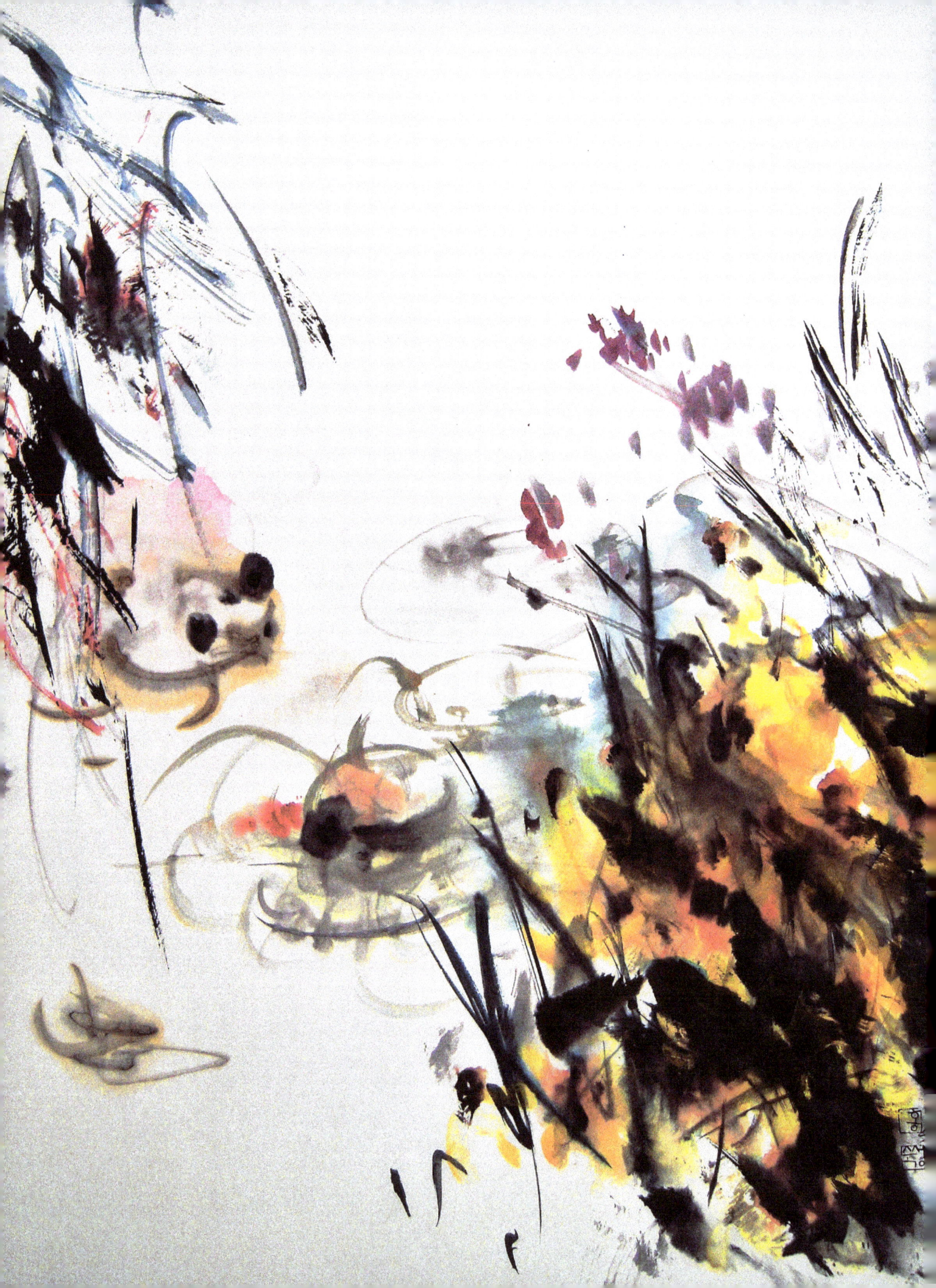

to observe their growth, which I do, in part, through sketching. Any extra resources, such as photos taken from different angles, are extremely useful for internalizing the subjects.

I like to observe the life cycle of subjects through the four seasons—the way stems bend, leaves curl, and petals move in the wind. I study flowers until I feel I've absorbed their character. That helps me with the visual aspect of capturing *qi*, but there's a physical aspect too. It's a mind-body discipline.

There is a reason to study brush painting as a true discipline, and to master the steps of painting a leaf, a petal, or the way that the branches of a particular tree grow. In order to capture the spirit of nature in a brush stroke, you need to *feel* the nature of the leaf or the branch as you paint it—growing, moving with the wind, or weighted with snow.

In order to express *qi* as you paint, your wrist, arm, and torso must become an extension of your brush. You paint with your whole body, whether you're sitting on the floor, or on a chair at a table, or standing. I prefer to stand when I paint, because it gives me more freedom of movement, keeping my waist supple, so that I can move with the spirit of the brush.

The *discipline* in this is to direct your body's energy through your arm, all the way to the tip of the brush, while you focus on the movement of the brush. The *balance* is to do these things without forcing the outcome in any way, so that the true *qi* of the subject appears through the expression of your own *qi*.

The key element in water-ink painting is the "ink flow," and guided accidents often produce the most beautiful results. Learn the method so that it becomes second nature, so that you no longer have to think about it while you paint, and then get out of its way. The beauty is the happy surprise of what the brush does. Even a master painter can't completely control what the brush will or will not do. You master the discipline so that you can allow your brush to lead.

The more I paint, the more I discover that my intentions and my brush strokes are united. My paintings are most successful when this synergy is coordinated. It requires a balance between decisiveness and sensitivity. I like the challenge of swiftly putting what I have in my mind on paper before it disappears—but that is why it's so important for me to fully absorb the *qi* of my subject before I begin to paint.

CULTIVATING NATURE

What I like especially about this form of art is the attitude toward nature, especially in landscape painting. My husband, who doesn't paint, but who teaches East Asian philosophy, pointed out to me that while Western philosophy traditionally aims at self-discovery, the path of East Asian philosophy leads to self-cultivation. The word for "nature" in Chinese comes from Daoism and means "things as they are" or "things as they are spontaneously." So "nature" is a philosophical principle in a way, rather than just the things you perceive in the landscape. The language in *The Mustard Seed Garden Manual*—the most influential classic of the Chinese water-ink tradition—indicates that the artist's polished skills lead to a deeper appreciation of the wonders of nature. The treatise is full of allusions to the Daoist concepts of yin and yang, of spontaneity, and the yin values of emptiness, simplicity, and flexibility.

The longer I've painted in this style, the more I've become attracted to a minimalist approach and a search for the essential nature of things. In moving away from representational expression, I try to use suggestion in my brushwork to interpret forms in their simplest state, without losing their vitality. In paring back, I hope to reveal and capture the *qi* of my subject, instead of restricting myself to describing the external form.

Tools & Materials

The four basic tools of East Asian brushwork—brush, ink stick, ink stone, and paper—are known traditionally as the Four Treasures of the Studio (for painting) and the Four Treasures of the Study (for calligraphy). Good-quality art materials are treasures that will serve you well, if you take care of them.

Your choices of ink, brush, and paper, and the way you combine them, can lead to widely different results. Once you familiarize yourself with them—the dilution of the ink, the size and softness of the brush, the absorbency and texture of the paper—you can, at least partially, determine the look of the painting.

These materials are available at many art supply stores, Asian specialty stores, and online. See the Resources section in the back of the book for more information.

BRUSHES

While it's always wise to choose the best art materials, this is especially true when selecting your brush. The bristles of East Asian brushes are made from animal hair: wolf, weasel, and bear (for trees, landscape, and calligraphy); horse and badger (for textured landscape), and squirrel, sheep, rabbit, and goat (for flowers). A good brush comes to a fine point when it's wet.

Brush shafts are usually made of bamboo, wood, or horn. However, they can also be made of ceramic, jade, lacquer, or ivory (for emperors).

The three basic brushes are hard hair (usually brown or black), soft hair (pale color), and mixed hair (combination), plus specialty brushes, such as a brush made from bamboo, and a broad, flat *hake* brush, used for washes.

Brushes come in three or four sizes: extra-large, large, medium, and small, and the length of the brush hair and shaft varies. If you are a beginner, consult your teacher about what to buy. Three brushes are usually recommended: the bamboo/orchid brush is so called because it is traditionally used to paint bamboo and orchids. It's made from wolf hair. A combination brush (where the inner bristles are hard and the outer soft) is a good choice for other types of flowers and leaves, as well as for calligraphy. This is an all-purpose brush and useful to have on hand. A badger or horsehair brush, as stated, is good for textures in landscapes.

When I began basic stroke training, my teacher recommended a large long-bristle combination brush—what we call a Four Noble Plants brush—which I trained with for several years. Learning to paint with a large brush is more challenging and takes longer, but it is one of the secret weapons of good spontaneous brushwork.

Many Western students switch from a large brush to a smaller one when painting fine lines. This interrupts the flow of the painting. Once you learn how to use a large brush well, you will be able to make fine lines with it, as well as thicker lines. The amount of ink that a large brush holds can even allow you to complete an entire painting without reloading.

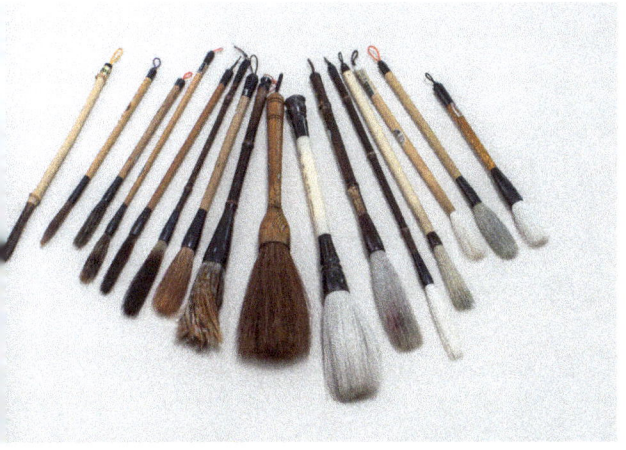

PALER COLORS INDICATE SOFTER BRISTLES.

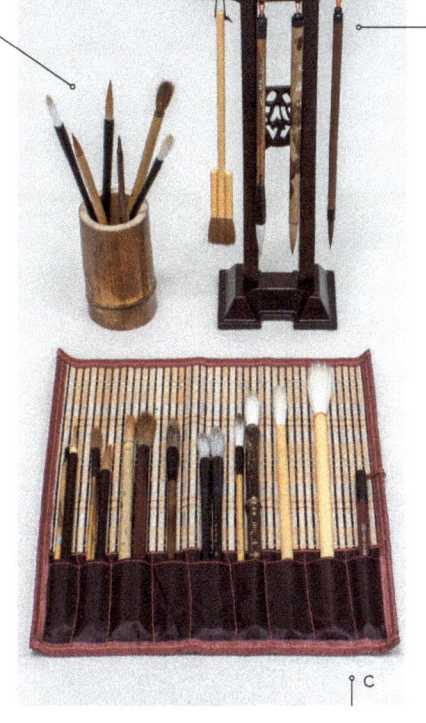

A: BRUSH HOLDER FOR DRY BRUSHES
B: BRUSH HANGER FOR WET BRUSHES
C: BRUSH CARRIER

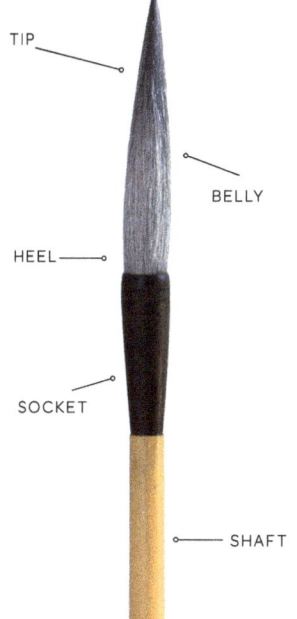

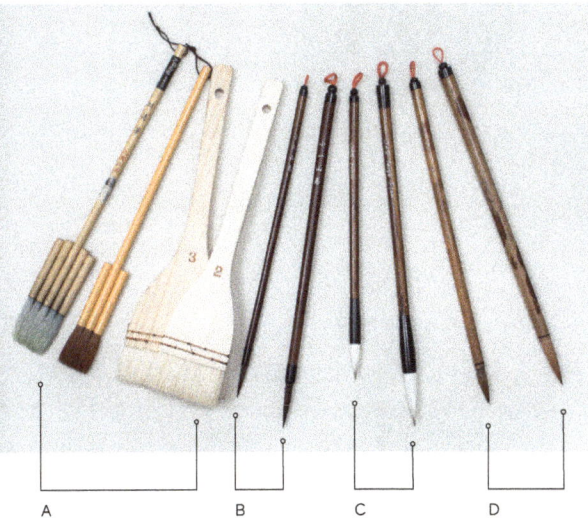

A: HAKE BRUSHES
B: HORSE HAIR BRUSHES
C: MIXED HAIR (COMBINATION) BRUSHES
D: ORCHID/BAMBOO BRUSHES

PREPARING A NEW BRUSH & BRUSH MAINTENANCE

The bristles of a new brush are protected by a coating of glue. Use your thumb and forefinger to bend and separate the bristles. Then place the bristle section of the brush (but not the shaft) in cold water until the glue softens. Wash the bristles thoroughly in clean water. Do not use soap or detergent.

Each time you finish using your brush, wash it in clean, cold water. Squeeze out excess water with a paper towel. Then smooth the bristles with your fingers and bring them to a point at the tip. Hang the brush, tip down, from a hook or lay it on a flat surface until it is dry. Then store it, tip up, in a jar or hang it with the tip down. If you ruin a brush by forgetting to wash it properly, don't throw it away. A rough brush can be used to paint interesting textures, particularly in landscapes.

Compromise is not easy. Because my students in the West have resisted learning with the largest brush, I've gradually adapted to teaching with the use of a smaller brush—but there are definite trade-offs. With a small brush it doesn't take long to create an attractive spontaneous painting, but once you learn how to wield a large brush, you can do impressive paintings with less effort. And, if you learn to paint with a large brush, you can easily work with a small one when you want to—but if you learn to paint with a small brush, it will be extremely difficult to ever work with a large one and truly master the discipline.

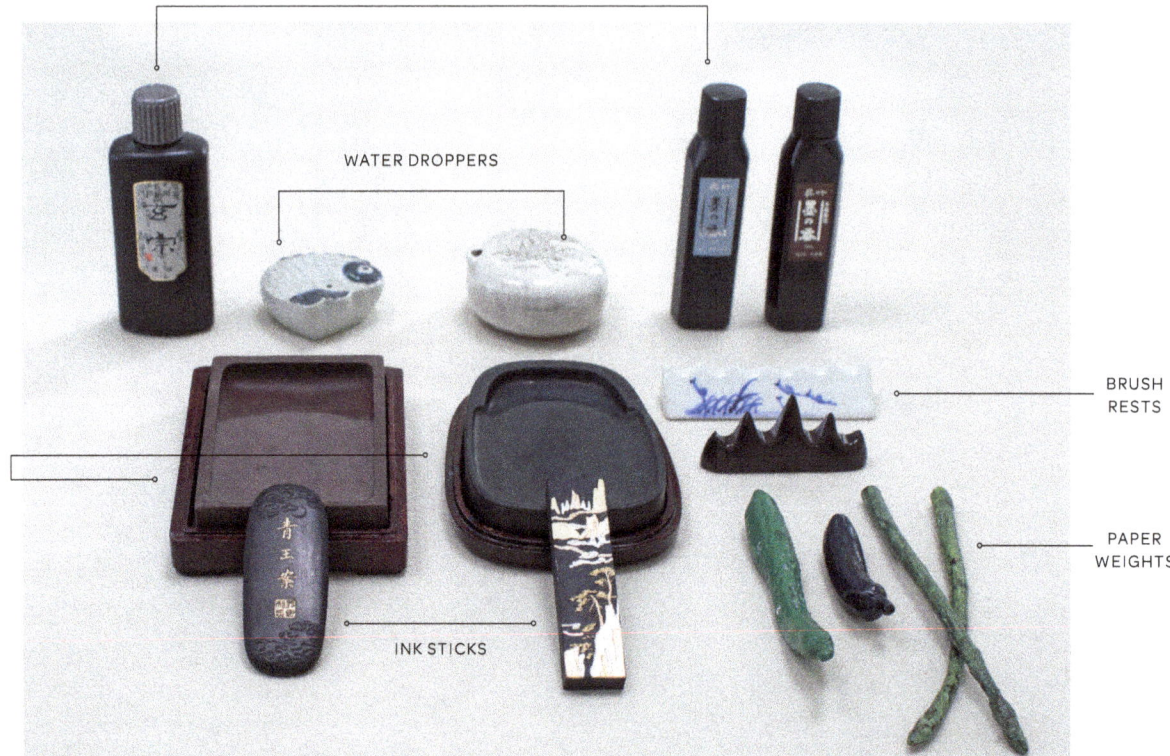

INK STICKS AND INK STONES

Ink sticks are made from soot combined with animal glue. There are two kinds of ink sticks: one made from pine soot and the other from burnt vegetable oil. The first produces better-quality ink, with a deep, clear, bluish tinge. The rich color of ink comes from very fine soot. The coarser the soot, the grainier the ink.

Ink stones are made from natural rock and are commonly shaped into a rectangular or round palette. There are many beautifully carved ink stones on the market. Choose one with a smooth surface and a wooden lid.

GRINDING INK

Grinding an ink stick on an ink stone can be a meditative experience, and a good way to prepare yourself before beginning to paint. Pour a little water into the well of the ink stone, dip the bottom of the ink stick in the water, hold it vertically, and grind it gently but firmly over

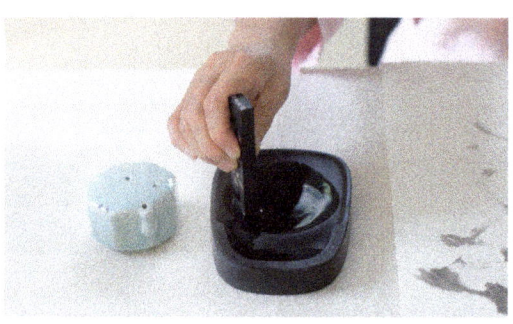

the surface of the stone in small circles. Dip it back into the water occasionally, and continue grinding until the ink is a rich black. While you are grinding ink, think about the painting you want to start. When you are done painting, clean the ink stone with warm water. It will serve you for a long time.

Despite the ink-stick tradition, most painters use bottled ink, which has more preservatives. If you choose this route, be sure to buy liquid Chinese, Japanese, or Korean black ink—not India ink. If you start a painting in the morning and return to your painting table later in the day, you can use any ink that is on your plate, but do not leave it overnight, because it will not be usable the next day.

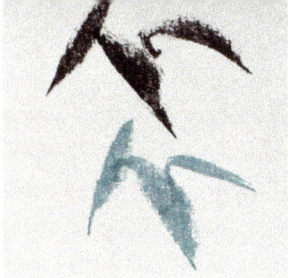
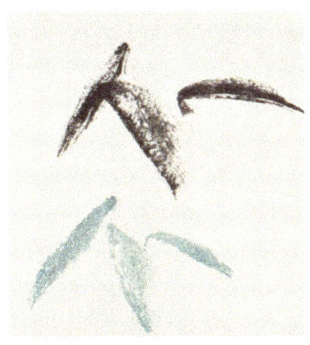
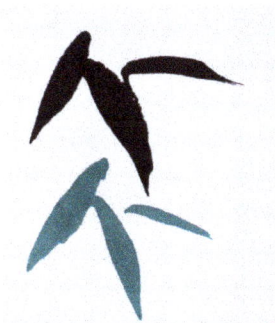

PAINT QUALITY ON FOUR DIFFERENT TYPES OF PAPER. **TOP LEFT:** BEST, OR SINGLE SHUEN, PAPER. **TOP RIGHT:** MULBERRY PAPER. **BOTTOM LEFT:** SIZED PAPER. **BOTTOM RIGHT:** PRACTICE PAPER (MACHINE MADE)

PAPER

In a broad sense, two kinds of paper are used in brush painting: raw and sized. The paper's absorbency produces specific effects.

Raw paper is known in the West as *shuen* or "rice" paper, but it's not made from rice. It's made from bamboo pulp or mulberry bark. Raw paper has no sizing, which is used to make paper more water-resistant. Without sizing, paper is extremely sensitive and absorbent. Ink and color used on unsized paper are difficult to control and apt to blur until you've had experience using them, then they show the brush strokes most clearly. I suggest beginning with single or best *shuen*, and later try double *shuen*. You may find best *shuen* with a red star marking, which means that it's government-approved as the highest quality. If the room you work in is very dry, *shuen* may dry out, so store it rolled in plastic to preserve it.

Sized papers have added alum and glue, and are less absorbent. They are good for detailed work, when you don't want the edges of brush strokes to blur. When using sized paper, you'll need to use more water.

Other papers, such as mulberry, *ma,* and *pi*—are slightly absorbent, but not as absorbent as *shuen*. I enjoy using these and you'll find that they facilitate smoother washes. They can also be used as the backing for mounting finished works.

Although I experiment with different kinds of paper for different subjects, including Western watercolor paper, which is similar to sized paper, my favorite is thin, raw paper (best *shuen*). My experiments with color variation, moisture control, and brush technique are most successful on raw paper, and have led to some wonderful surprises.

OTHER ACCESSORIES

- Felt (thick, white felt to place under the paper)
- Brush wrap (to carry and store your brushes)
- Brush rack and brush rest
- Paperweights, stones, or traditional weighted bars for keeping the paper in place
- Seal paste and T-square
- Ceramic or plastic water container
- Water dropper
- Spritzer bottle (for washes)
- Flat white plate (for ink and paint)—porcelain is best. Plastic does not work well.
- Paper towel (to place under your brush and brush rest to keep the white felt clean)

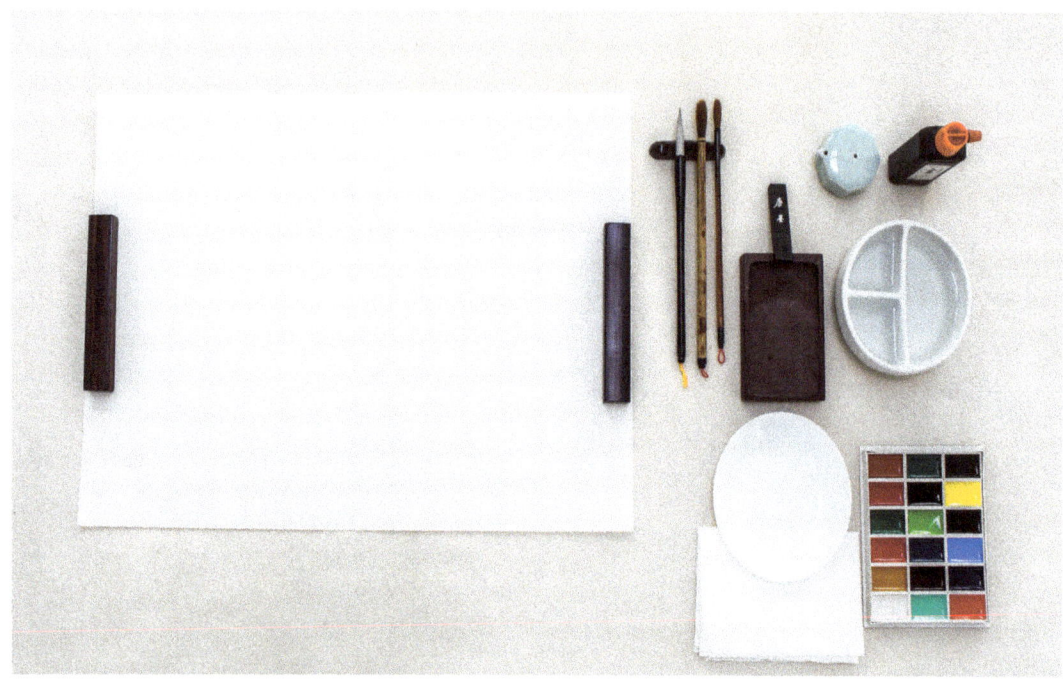

HOW TO SET UP THE TABLE FOR RIGHT-HANDED PAINTERS. REVERSE THE ARRANGEMENT FOR LEFT-HANDED PAINTERS.

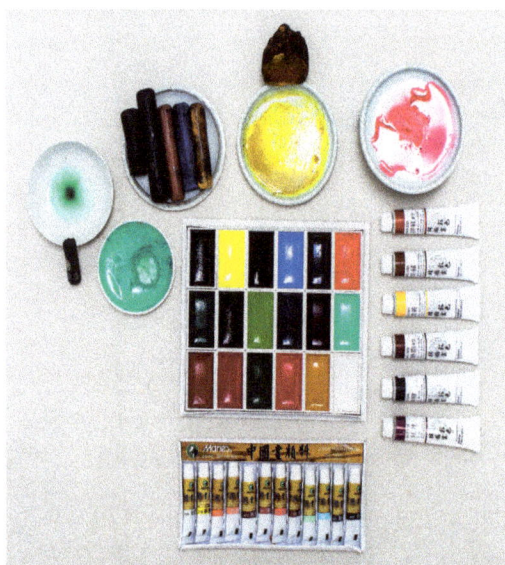

PAINT

Ink is the primary medium for water-ink painting, but you can also use watercolor mixed with ink. Color is rarely used by itself, especially in landscape painting. Asian watercolors are made from mineral and vegetable pigments, and have more binding glue than Western varieties. Many ink painters prefer to use Asian watercolors because they are less likely to run during the mounting process when the paper is spritzed with water.

You can choose paint that comes in chips, sticks, powders, or tubes. The more concentrated colors, particularly in powder form, have a gouachelike effect. I prefer tubes of transparent watercolor.

HOW TO SET UP A TABLE

See the photo above for an example of a table set up for a right-handed person. If you are left-handed, set up the materials on the left side.

Basic Techniques

HOLDING & LOADING THE BRUSH

Ink painting is a balance between the close study of nature and brush technique. To master the techniques, you need to begin by holding the brush correctly and loading it with good ink and color tones. The tendency when learning to paint is to hold the brush tightly. With experience, you'll learn to relax your hold.

Moisture, pressure, and speed play important roles in making good brush strokes. You'll learn to adjust these, depending on the paper you use. Load your brush, then practice with it until it runs dry before reloading it. This way, you'll learn how much ink the brush can hold and how long it will last. Mastery of ink control and the appropriate brush strokes for each purpose are only learned through practice—much practice. A teacher can help you shorten the time it takes to become familiar with the brush, but practice is vitally important.

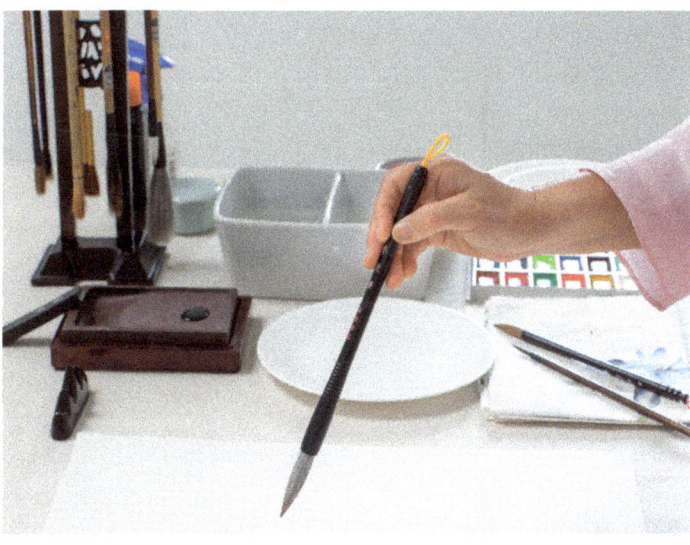

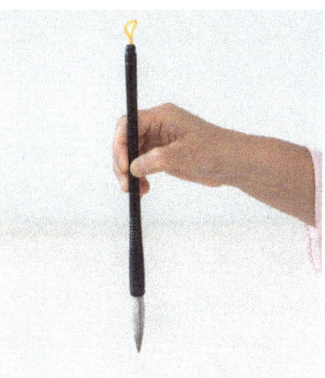

HOW TO HOLD THE BRUSH

Holding the brush for painting is much freer than for calligraphy. Painters work from many angles and use different textures: wet, medium, and dry.

You can paint while standing or seated. I prefer to work while standing, as it allows for more freedom of movement and more energetic brush strokes. When you paint while standing, you hold the brush a little higher on the shaft than you do when you are seated.

1. UPRIGHT HOLD: Hold the brush in a vertical position in the middle of the shaft, or higher. Use your thumb, index finger, and middle finger to grasp the brush. Your other two fingers provide stability. Imagine that you are holding an egg in the palm of your hand while you hold the brush.

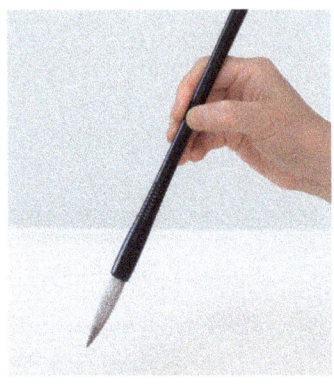 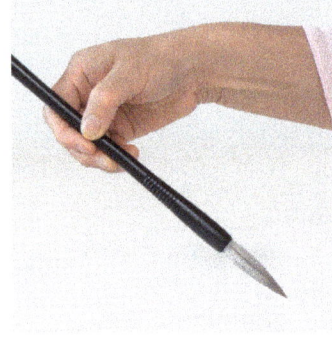 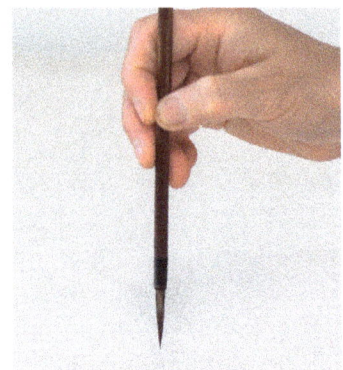

2. TILTED BRUSH A: Hold the brush at a 45-degree angle with the tip pointing away from you.

3. TILTED BRUSH B: Hold the brush at a 45-degree angle with the tip pointing toward you.

4. DETAIL BRUSH: Hold the brush closer to the bristles.

If you wish, support the hand holding the brush with your other wrist resting on the table.

LOADING THE BRUSH

Loading the brush is just as important as the brush strokes themselves in ink painting. So much of a painting's success depends on just the right balance of ink to water and the resulting tones. You can learn to control that balance only by experimenting with loading the brush. I strongly recommend experimenting extensively.

There are several ways to load a brush, but the three-tone loading technique is the most common. Be sure to use a large plate for this loading technique; you will need to keep part of it wet and part of it dry.

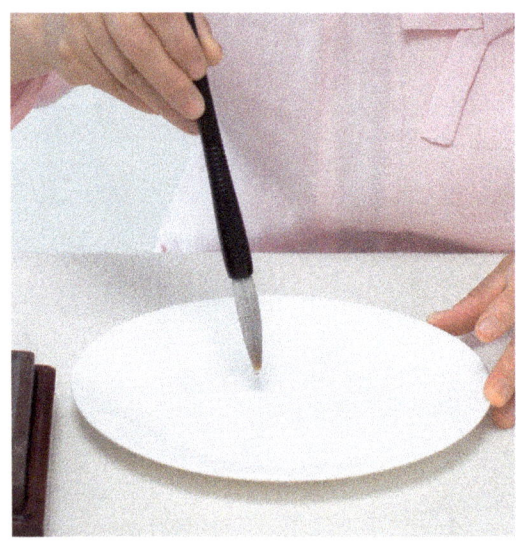

1. Wash the brush in cold water. Use it to transfer a little water to a large plate.

2. Prepare the dark ink in an ink stone or on a separate small plate.

 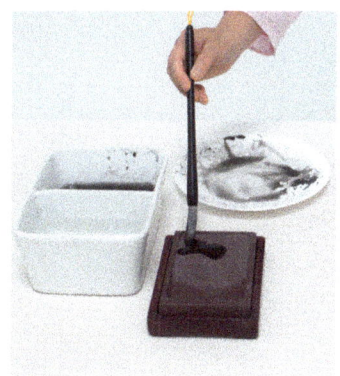

3. Dip your brush into the ink and transfer a small amount to the larger plate. Roll and move the entire length of the brush back and forth in the water so that the bristles are fully saturated and the ink is diluted.

4. Remove the excess liquid from the brush by pulling it across the rim of the plate, moving from the shaft to the tip, while rotating the brush a few times. You want the brush to be wet on the inside and almost dry on the outside.

5. Place your brush back in the ink and, again, transfer a small amount of ink to the plate. Roll and move only half of the length of the brush back and forth in the water.

6. Remove any excess liquid again.

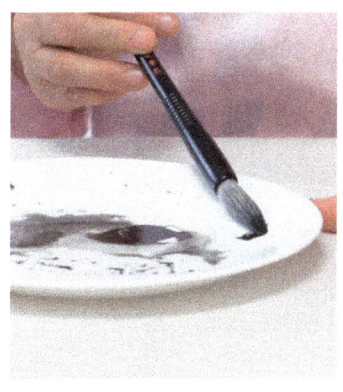 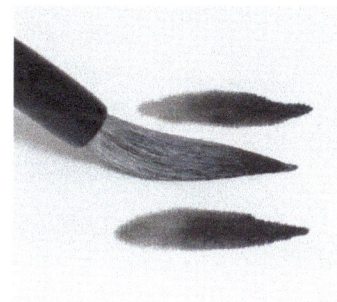 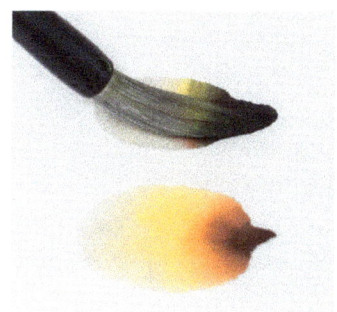

7. Now dip only a small portion of the brush in the ink. Go back to the large plate and gently roll that section of the brush back and forth on the dry side of the plate two or three times. You are now ready to paint.

8. Here are the three-tone results.

Once the water inside the brush is used up, the brush will not move well on the paper. You'll need to wash it in the water container and reload it. Make sure you do not get water into the brush shaft as this will eventually loosen the glue inside the shaft.

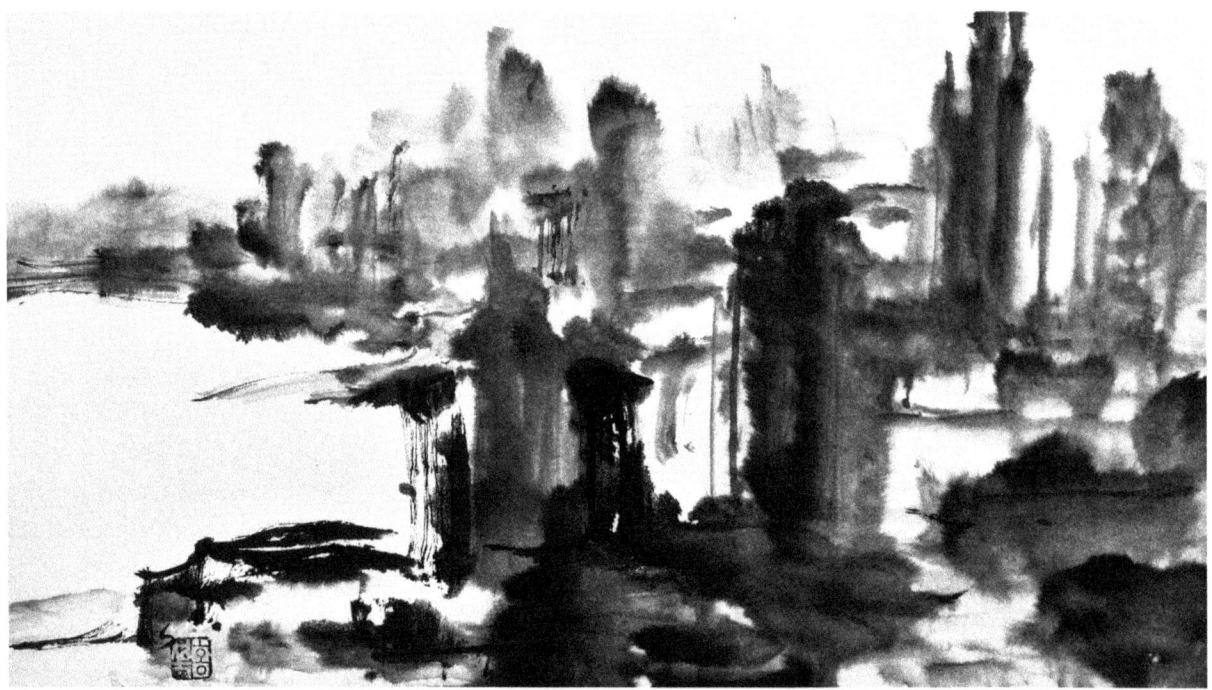

INK TONES

The Ming dynasty master Shitao once said, "Within the darkness of the ink lies the whole cosmos." Truly, half of a painting is done on the plate where you load your brush with ink.

There are endless shades of ink, from the palest gray to deep black. Beginners should try to distinguish at least five tones by creating five small pools of ink on a large plate and adding a little water to the first, a little more water to the second, and so on. Those five ink colors are known as heavy black, light black, dry black, wet black, and dark black. (Some sources name them charred black, heavy black, strong black, light black, and pale black.) Ink tones depend not only on how you load the brush, but also the pressure you place on it and the speed of the brush stroke. Once you learn how to control ink tones, you can easily manipulate color as well.

The simplest and most powerful painting can be accomplished purely with ink. The key is to master the required amount of water and ink on your brush. Great care is needed with undiluted ink, which should be used only to accentuate the main elements in a painting. For the beginner in landscape painting, it's best to begin with paler ink tones, adding darker tones as you progress.

Landscape painting is perfected through a mastery of dark and light, wet and dry, hard and soft. Dark and light can be used to create a sense of distance. With wet and dry techniques, you can capture the feeling of the four seasons. And through the contrast of hard and soft strokes, you can draw the viewer's attention to where you want it. Hard strokes are made with more pressure and speed than soft strokes.

Although I often combine color with ink, I sometimes feel color is not necessary. The simpler the tones in a painting, the more I like it. In a way, black ink provides the full spectrum.

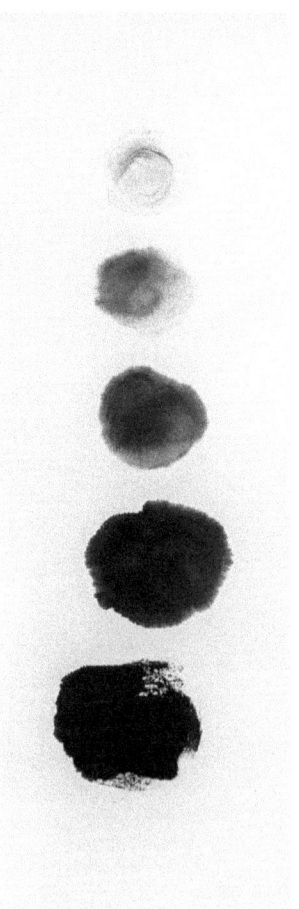

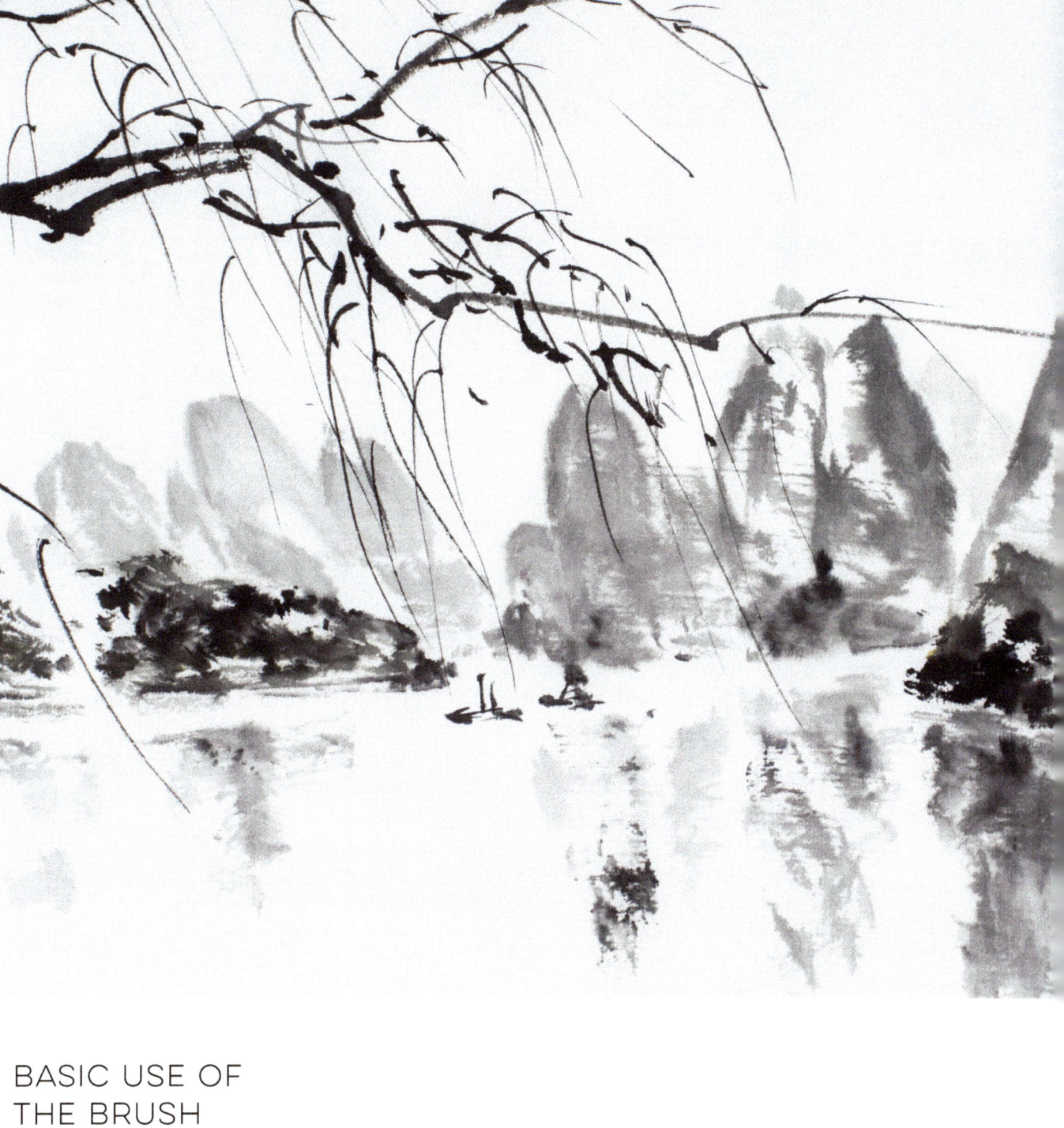

BASIC USE OF THE BRUSH

The many techniques for brushwork are traditionally handed down from masters to students, but ultimately every artist needs to figure out the most comfortable and effective way to make each brush stroke. The movement comes from the shoulder, which needs to be relaxed. (Think of playing tennis or golf.) When you make a stroke, the whole arm moves and the brush is an extension of the arm.

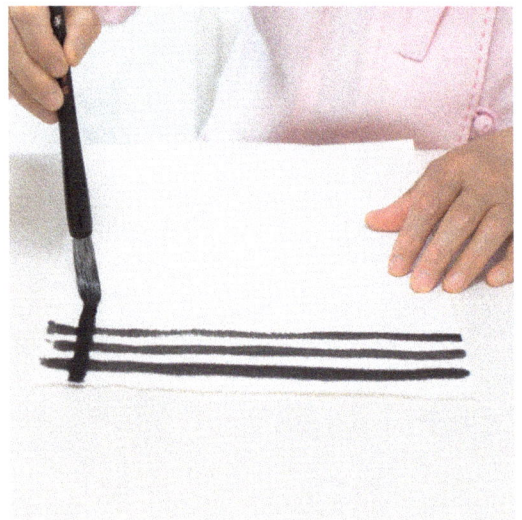
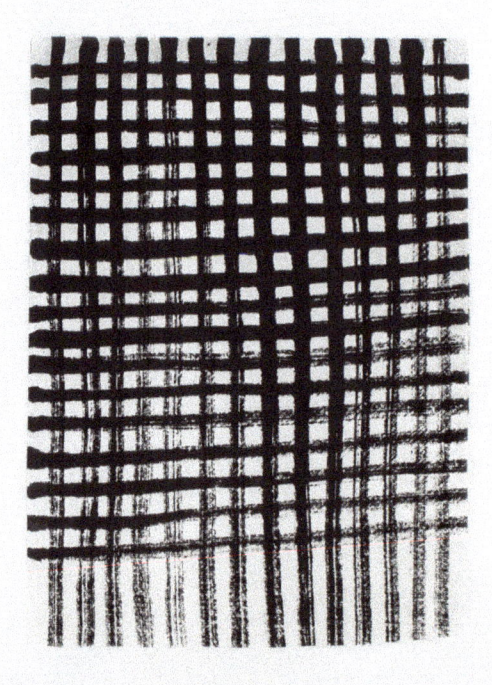

CENTER BRUSH STROKE

A brush held in a vertical position is called "center brush," because the tip is aligned with the shaft. This is the most important hold for beginners to learn. It channels the artist's energy in a powerful way. Calligraphers mainly use vertical brush strokes. According to the amount of pressure applied, strokes made with a center brush can create lines of any width. A larger brush will create wider center-brush strokes. Here are three useful exercises for beginners:

1. FOR EVEN LINES: Paint horizontal lines across a page, making sure that the brush remains vertical and the pressure steady. Make the lines as close together as possible, painting from left to right, or from right to left. If a line wobbles, it means that your attention is not steady. Repeat this exercise with vertical strokes, and also at an angle.

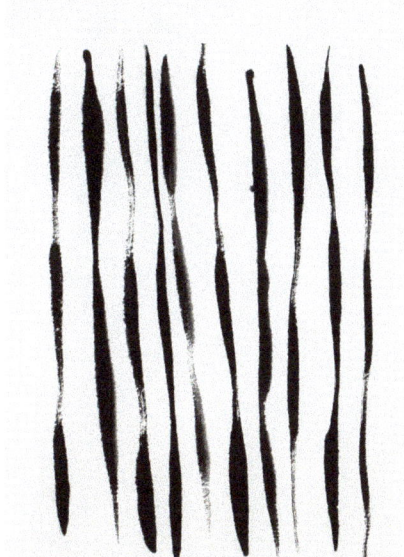
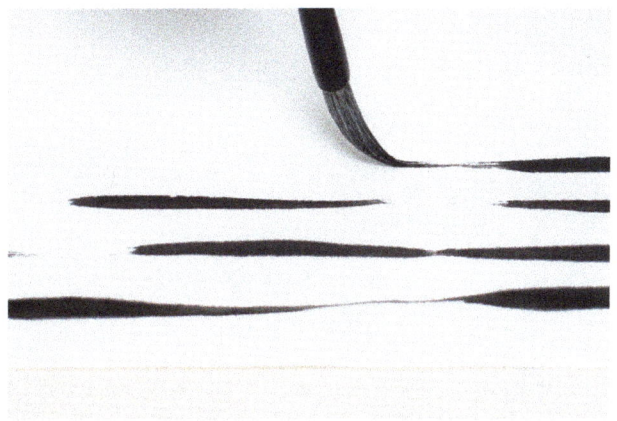

2. FOR THICK-THIN LINES: You will use this often for stems and leaves. Glide the tip of the brush onto the paper, beginning with a fine line. Gradually increase the pressure on the brush to thicken the line. Then release the pressure, creating a fine line again. Do this in a continuous stroke across the page, for lines of varying width. Then try this exercise with horizontal strokes.

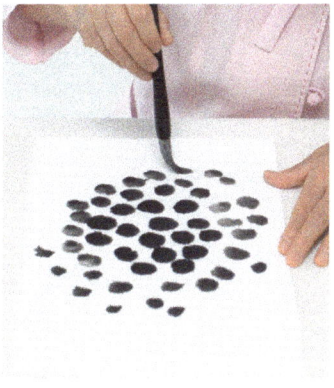
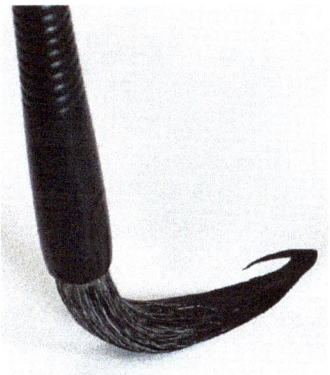

3. FOR DOTS: Begin a stroke by reversing the tip of the brush. Move the brush in a small circle and then lift it off the paper.

REVERSE STROKE

The purpose of a reverse stroke is to soften or hide the beginning or end of a stroke. Begin a stroke, moving the brush in the opposite direction you intend for the completed stroke. Immediately reverse the direction, completing the stroke and hiding its beginning.

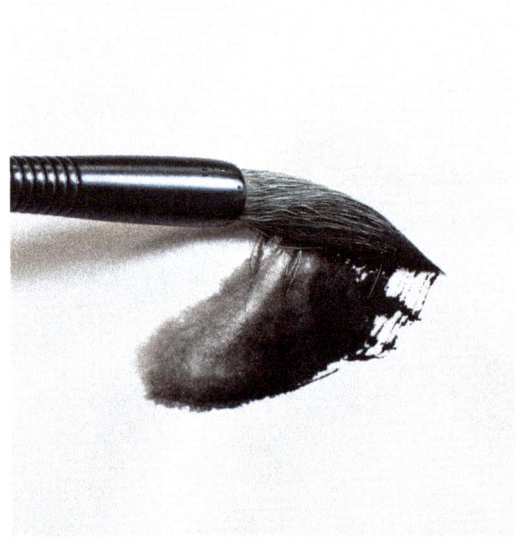
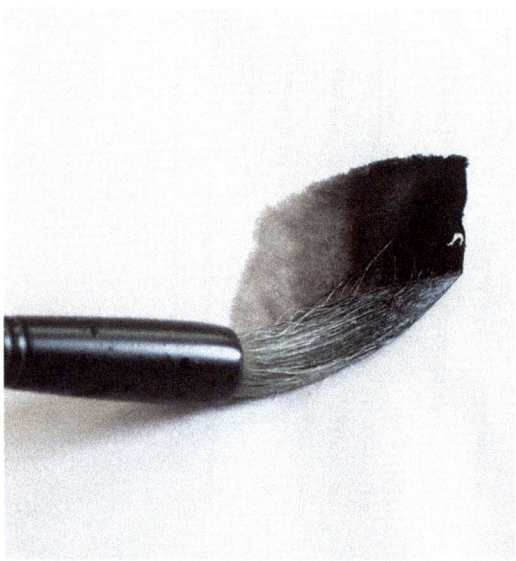

SIDE BRUSH STROKE

The look and character of brush strokes change with the angle of the brush and the amount of pressure you use. Use the side of the brush to make wider strokes. The lower the angle of the brush, the more bristles are in contact with the page.

Experiment with the side brush method, using different angles. Then change the angle while making the stroke, so that more or fewer bristles are in contact with the paper.

Total side brush stroke: This creates a wider stroke. The brush is almost parallel to the paper as the bristles move sideways.

Half side brush stroke: This stroke creates ink surfaces of medium width. The angle can change according to the subject. The bristles are only partially in contact with the paper.

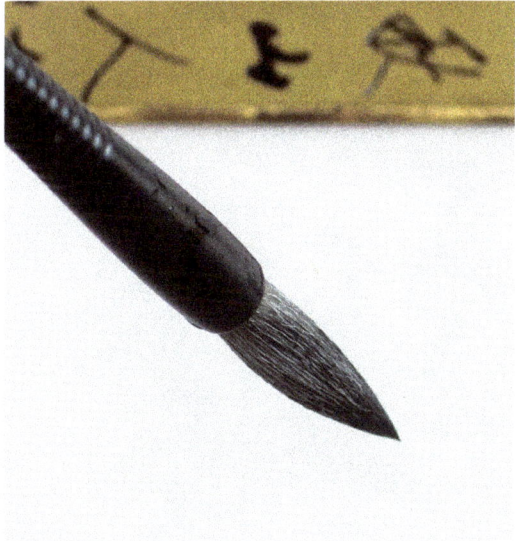
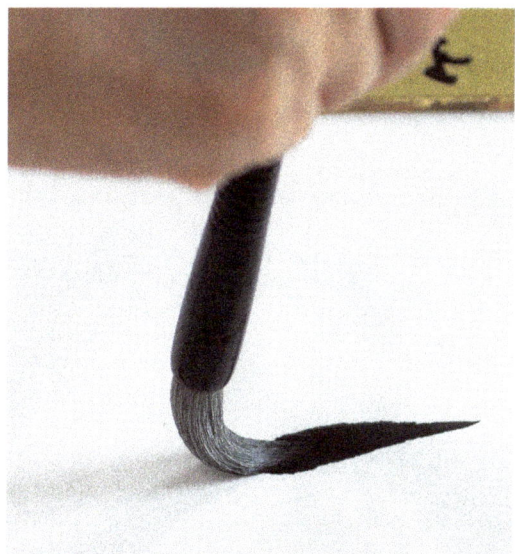

ORCHID FLOWER OR BAMBOO LEAF BRUSH STROKE

This stroke is used frequently, most famously for orchid flowers and bamboo leaves, as its name suggests. It is the same stroke that you practiced in "thick-thin lines" on page 27.

Hold the brush in a vertical position, and gently move the tip on the paper to create a thin stroke. Increase the pressure gently to widen the stroke. End by narrowing the stroke again and gradually lifting the brush off the paper.

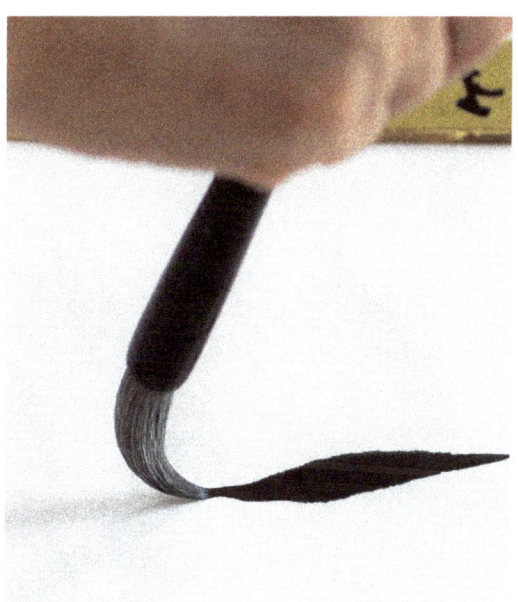

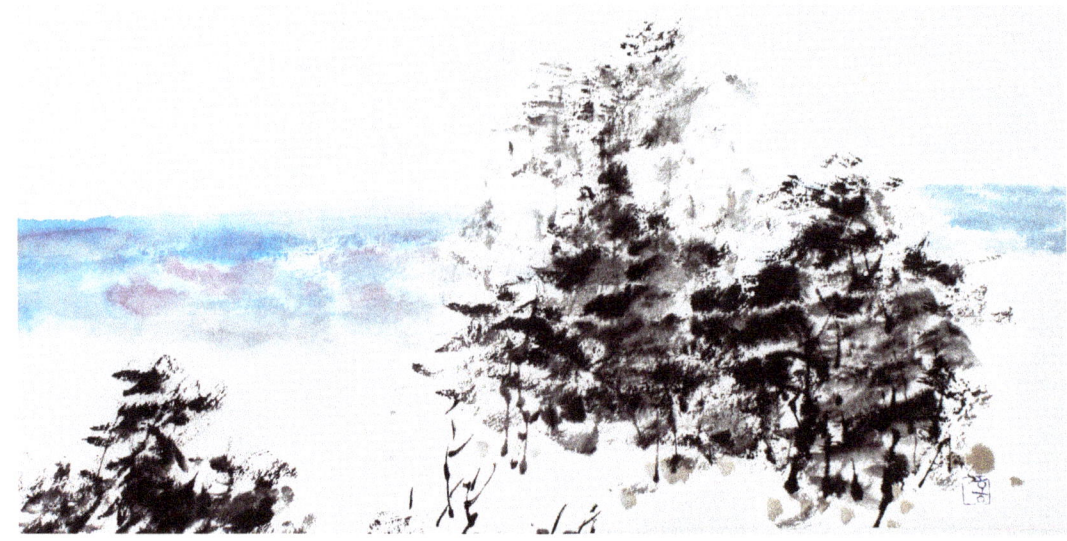

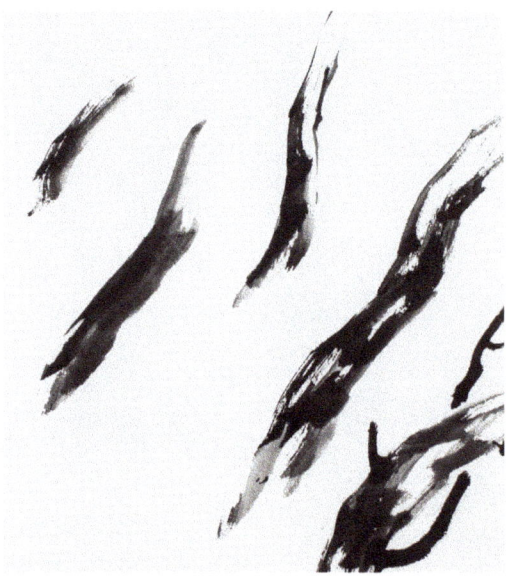

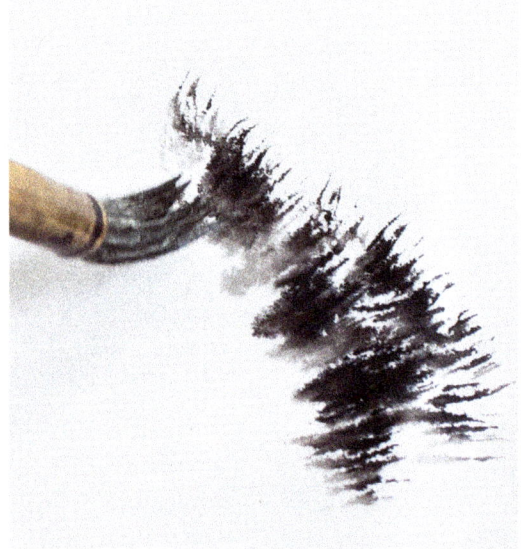

FLYING WHITE STROKE

This stroke is made with a nearly dry brush in order to create white breathing space within the stroke, by nearly lifting the brush off the paper.

 You'll find this stroke useful when you paint delicate dried leaves or a winter landscape, but you can also use it for weightier subjects. I painted this tree trunk, for instance, by rolling and dragging the nearly dry brush across the paper in some areas, then adding lines of definition here and there.

SPLIT BRUSH STROKE

The bristles of a brush can be gently pulled apart to make many different shapes, including a fan shape. Load the brush, then separate the bristles with your fingers before beginning to paint. You can create a variety of textures with this stroke by varying the amount of pressure and the way you load the ink or color tones.

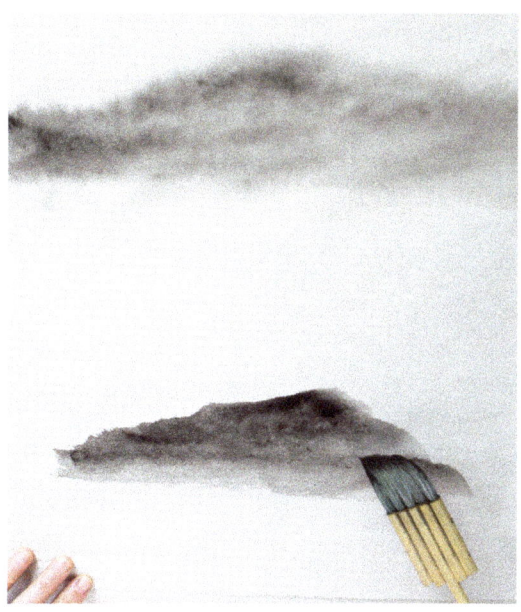

HAKE BRUSH STROKE

The soft, wide *hake* brush is used for background washes. In landscape painting, I use it to make wide strokes to create bodies of land, water, sky, or even a wide building.

DANCING BRUSH STROKE

When you become comfortable with the basic brush angles, try the dancing brush strokes. This technique is rhythmical and flexible, allowing you to use the brush at different angles, and with different pressures and stroke speeds while in a dancing mode. This is an advanced stroke that gives a painting a freer and more spontaneous look. It's especially effective in creating abstract works, and it's my favorite stroke.

Let your arm be flexible with a sense of rhythm as you change the pressure and angles of the brush, without lifting it off the paper. This is what makes it perfect for painting music. Experiment with moving the brush in different directions while varying the pressure and varying how much the bristles come into contact with the paper. When I paint with this stroke, I use a large brush and hold it loosely. Try it. You might have fun with it.

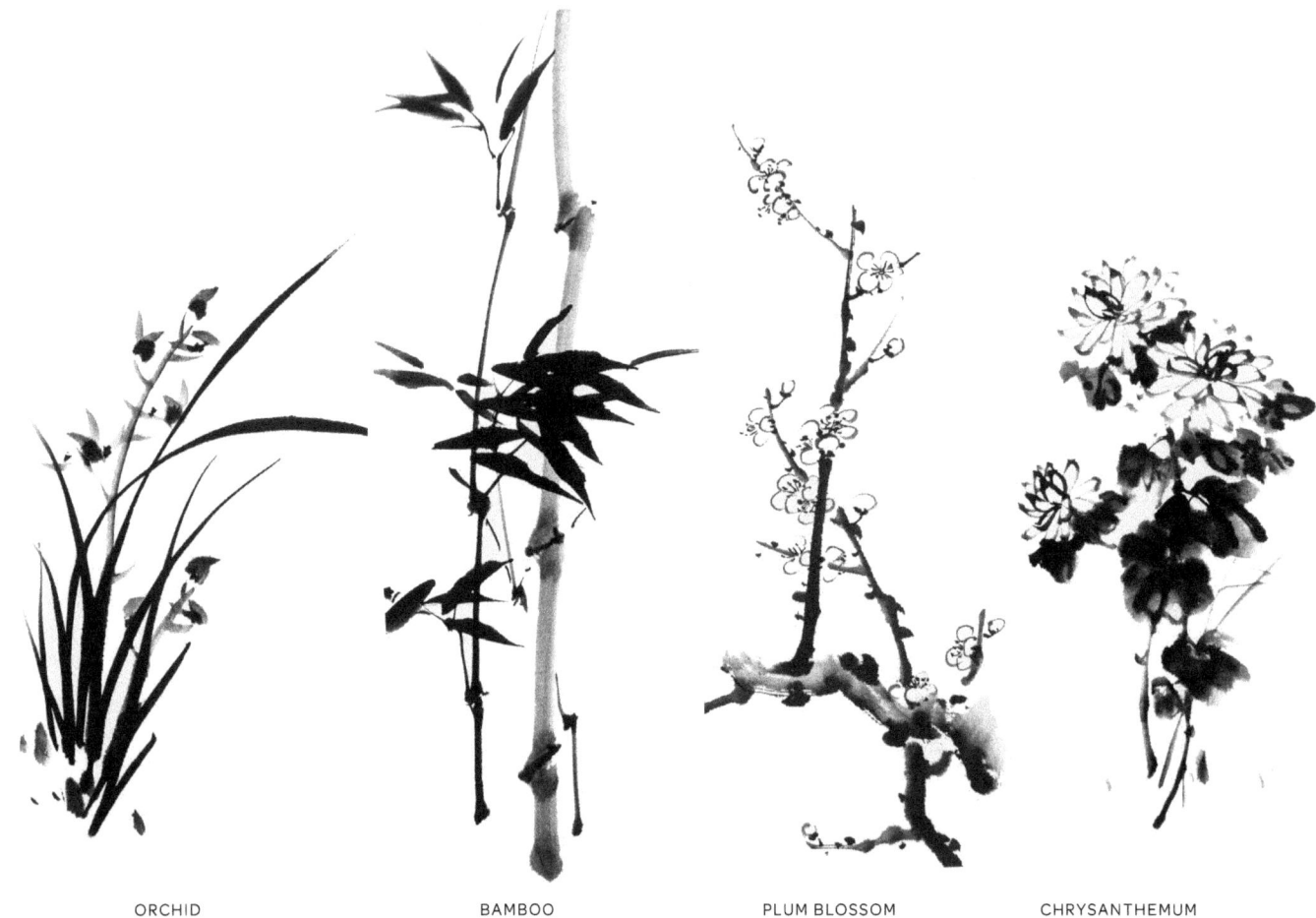

ORCHID BAMBOO PLUM BLOSSOM CHRYSANTHEMUM

THE FOUR NOBLE PLANTS

The Chinese developed the technique of water-ink painting during the eighth century. By the tenth century, it had become their principal art form and, in time, the categories within it grew to encompass the brushwork used in creating the Four Noble Plants: orchid, bamboo, plum blossom, and chrysanthemum. In Confucian ideology, the plants are compared to four gentlemen, which became their name in poetry as well as painting. In time, the tradition spread to Korea and Japan where the style was influenced by Ch'an (Zen) Buddhism.

Each of the plants has symbolic meaning, while also suggesting the rhythm of the seasons and passage of time. The orchid evokes a world of beauty and fragile, delicate, harmony. Bamboo, always green, bends without breaking, and symbolizes loyalty and fidelity. The plum tree bears flowers before the snows melt and suggests the rebirth of Spring. Chrysanthemums blossom when other flowers have finished blooming, in the fullness of Autumn.

The four plants became the foundation of brushwork, as well as embodying East Asian principles of aesthetic philosophy. Once you master the strokes for these plants, you can use them to paint anything. Carefully observe the structure of each of the noble plants before you begin to paint. You can use either an orchid/bamboo brush or a combination brush.

ORCHIDS

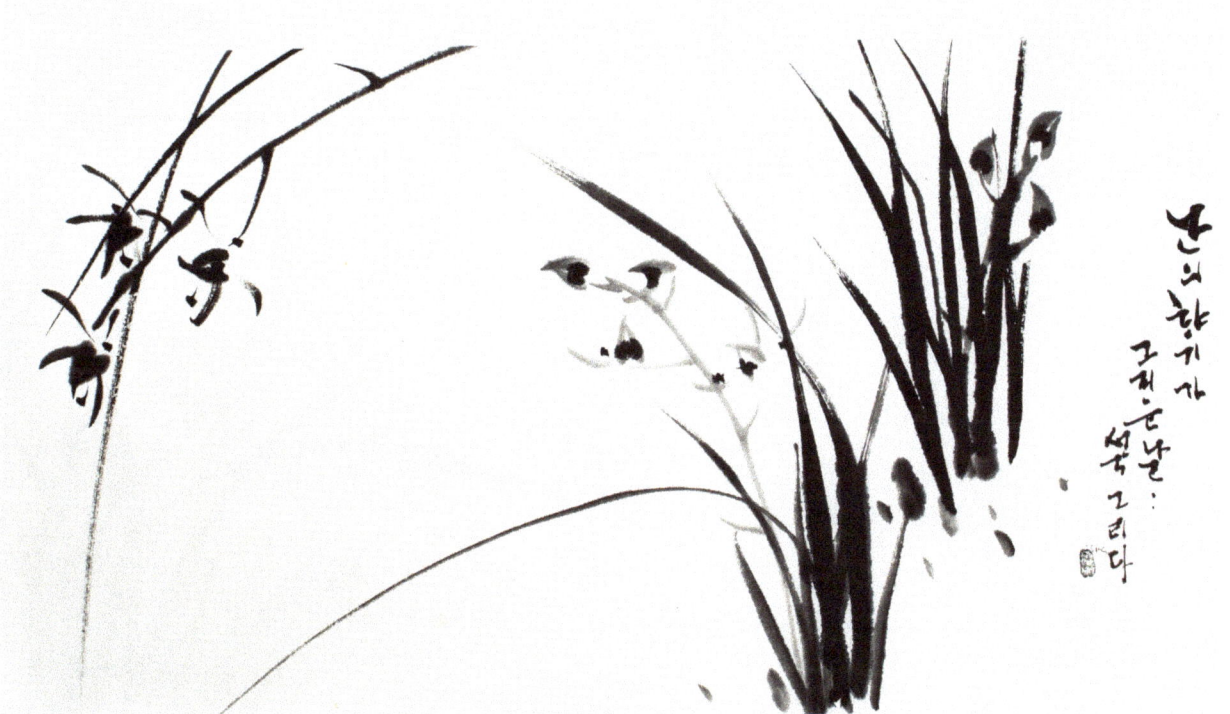

ORCHID TECHNIQUE

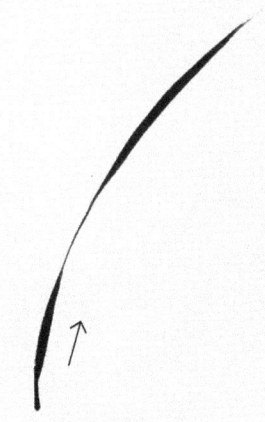
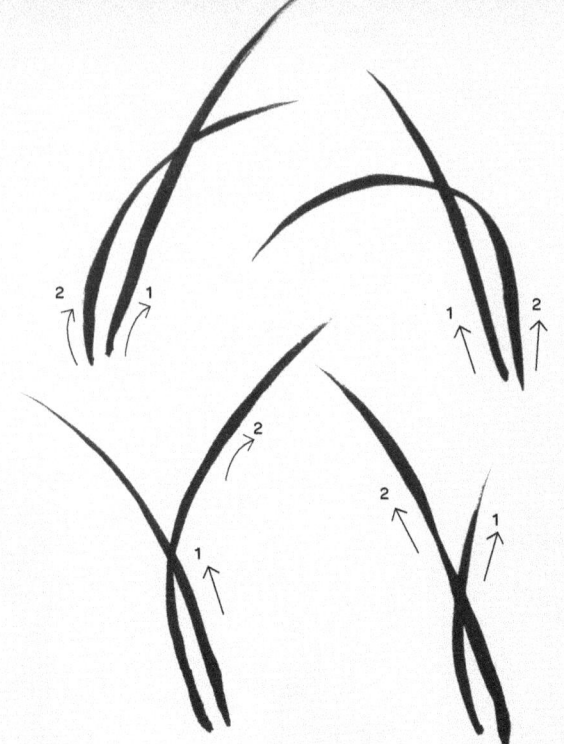

LEAVES

1. Leaves are usually painted in black ink, even if the rest of the painting has color. The first three leaves should be painted rhythmically. The first stroke curves like a crescent moon.

2. The second leaf crosses the first, creating what is known as a "phoenix eye." Make sure that the thin section of the second stroke crosses the first stroke where it is wide. Avoid painting a thin stroke crossing another thin stroke, or a thick stroke crossing a thick one.

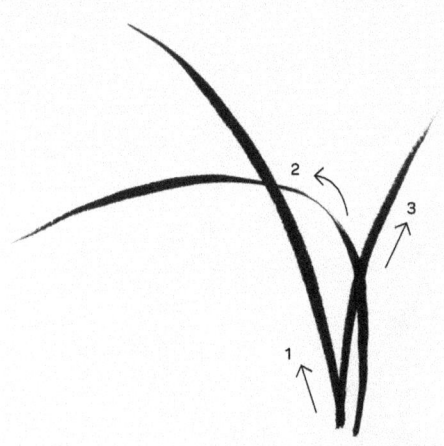
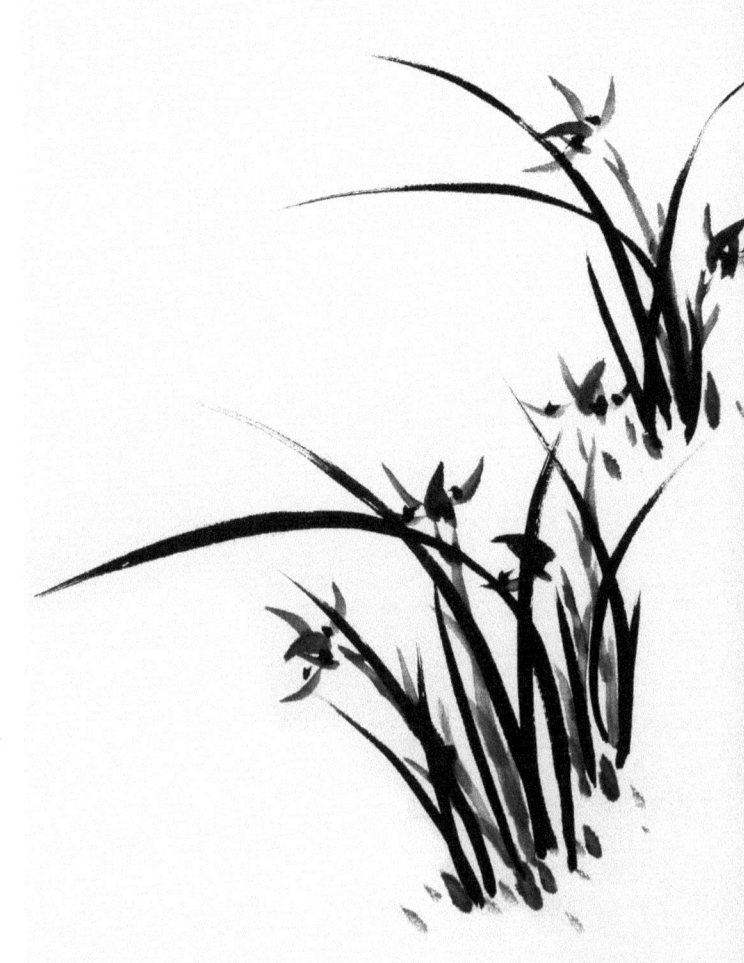

3. The third leaf divides the phoenix eye, one-third/two-thirds.

4. The short strokes of the fourth and fifth leaves have a supporting role. Paint the leaves in groups, with unequal spaces between them, but leaves from one group can cross those of another.

FLOWERS

There are two varieties of wild orchid: Spring and Fall. Both varieties have five petals. The Spring orchid has a single bloom. The Fall orchid has many flowers on the same stalk. Be sure you don't combine the flowers from different seasons in the same painting.

When you're painting the clustered flowers of Fall orchids, you can choose from three different groupings: fully open flowers, flowers in different stages of blooming, or buds only.

Paint the flowers paler than the leaves, and the stalks paler than the flowers. You can use color for the flowers, or pale ink. The flowers and buds at the top of the stalk are younger and darker.

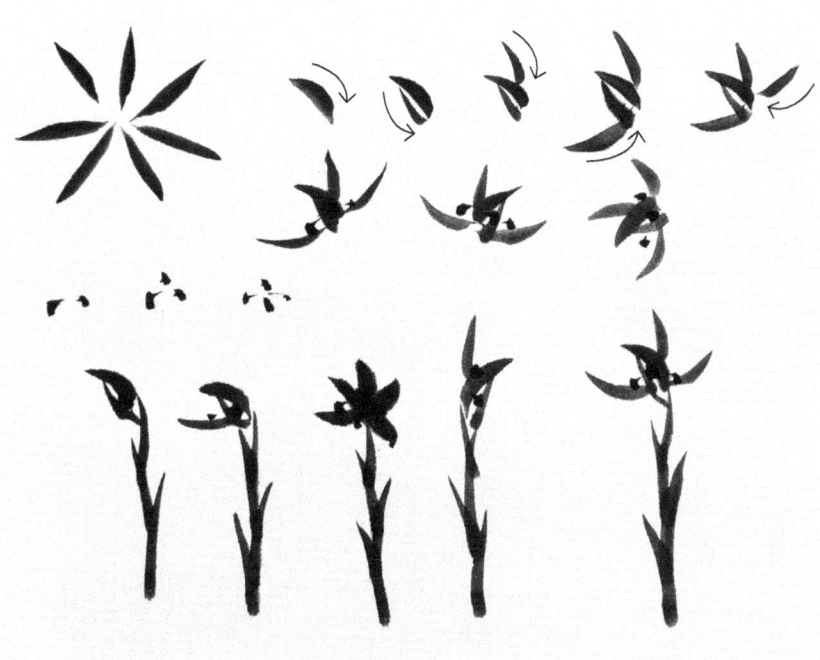

THE SPRING ORCHID'S FLOWERS

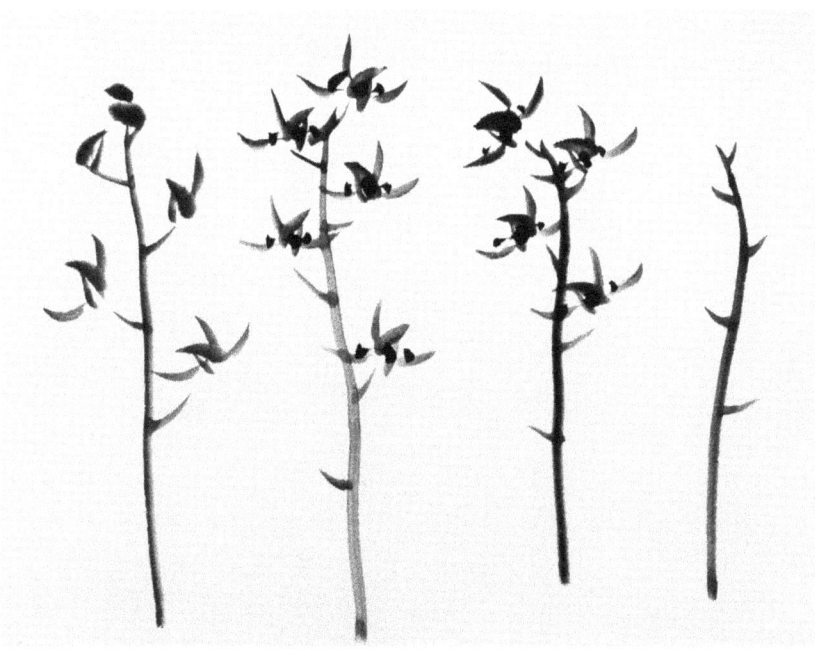

THE FALL ORCHID'S FLOWERS

BAMBOO TECHNIQUE

I grow bamboo in my garden and marvel at its changing face all year round in the wind, rain, and snow. Not surprisingly, it's the most popular subject among the Four Noble Plants. Many water-ink painters spend a great deal of time perfecting bamboo's basic brush strokes, because they provide a solid foundation for their craft. The Chinese master Zhao Mengu (1254–1322) once said, "To draw bamboo requires knowledge of the eight strokes of calligraphy." I often paint bamboo as a warm-up before focusing on other subjects.

STALKS AND BRANCHES

Observe bamboo and you will notice that—beginning at the bottom of a stalk—each section gets longer until the middle of the stem; then the sections grow shorter again. Use a center brush stroke (see page 26) for the bottom section of the stalk, reversing the stroke to hide the end. The more pressure you apply to the brush, the thicker the line becomes.

To create the bamboo sections, pause briefly at the beginning and end of each stroke, and pull off diagonally to the left as you lift the brush. Bamboo will seem to spring to life if you paint the stalks at a slight angle. Paint thinner side branches with a slight curve.

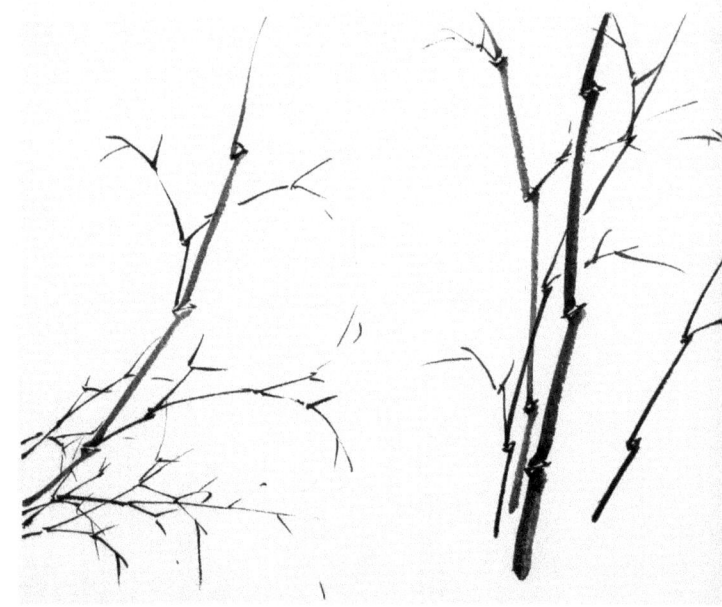

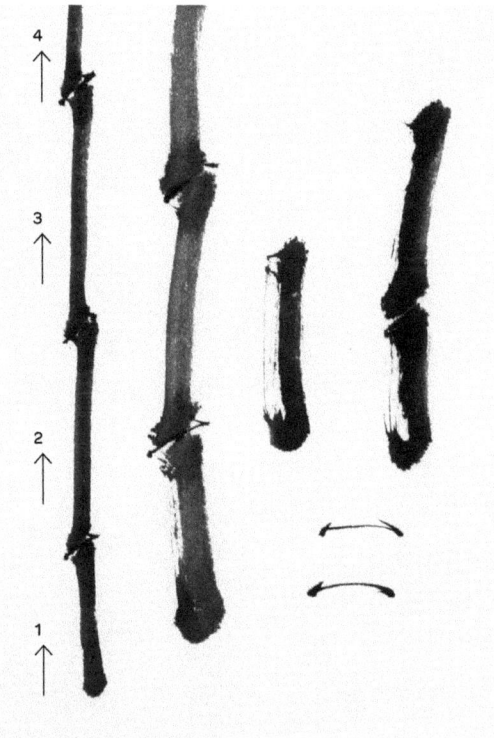

JOINTS

Paint the joints between the sections of bamboo quickly, with a center brush technique, using just the tip of the brush. The motion of the brush creates a notch on each side, lifting the brush off the paper as you move from one side of the stalk to the other.

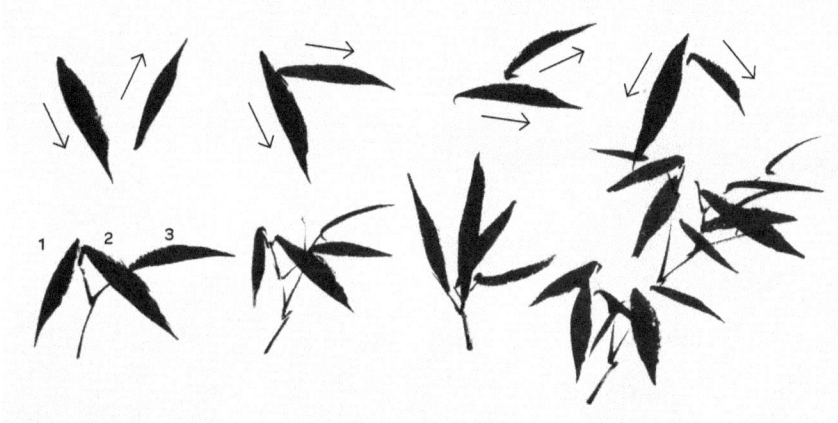

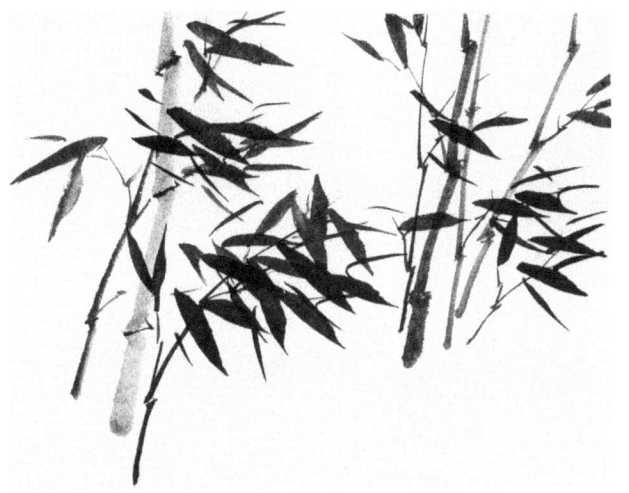

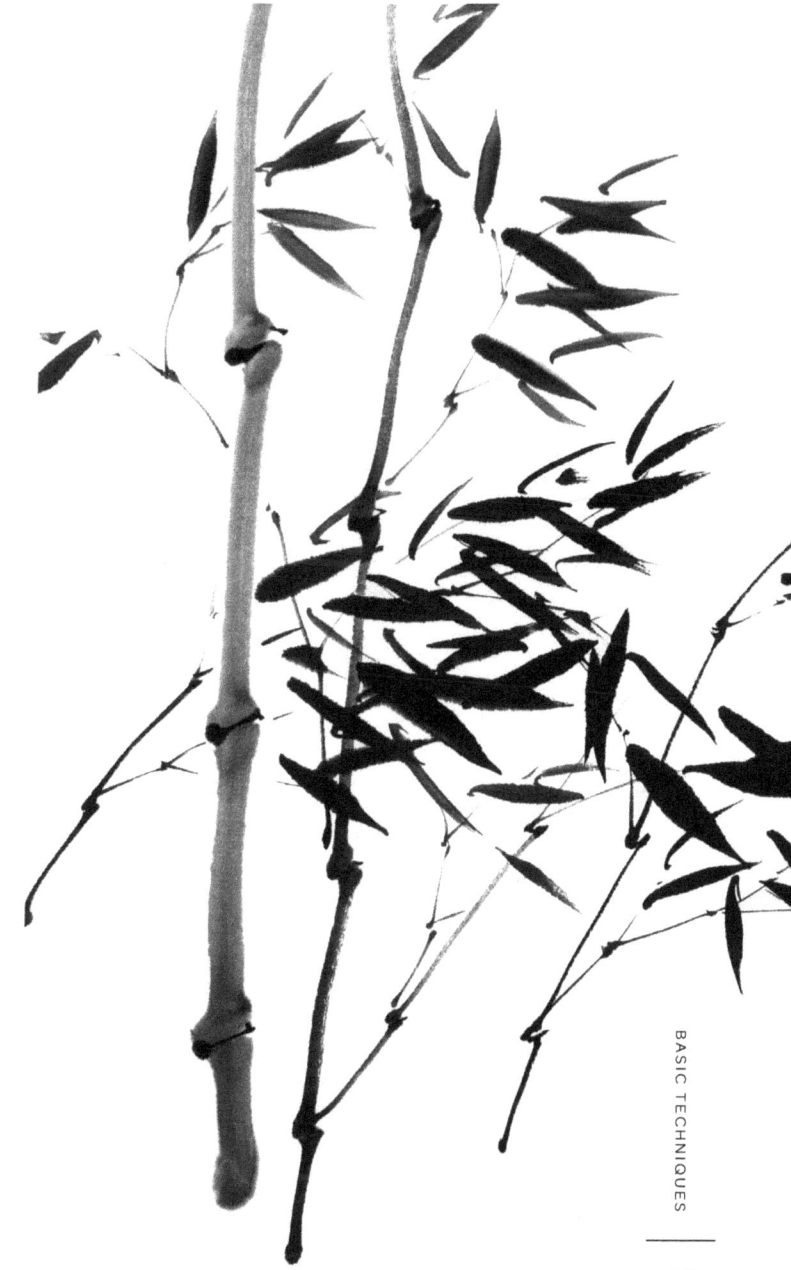

LEAVES

Arrangements of bamboo leaves have lovely names such as "flying swallow," "goldfish tail," and "landing geese." Practice depicting bamboo leaves as a group. This is useful as you create overlapping clusters.

When you observe bamboo plants, you'll notice that young leaves grow upward and older ones hang down. The leaves in front are larger and wider; those at the sides are thinner. In your compositions, arrange leaf clusters at different angles and heights. Add water to the brush after you've done the first cluster of leaves so that subsequent clusters are paler. This will help to create depth.

(LEFT TO RIGHT): HERE ARE MY OBSERVATIONS OF BAMBOO ON A WINDY DAY, ON A SNOWY DAY, AND WITH IRIS.

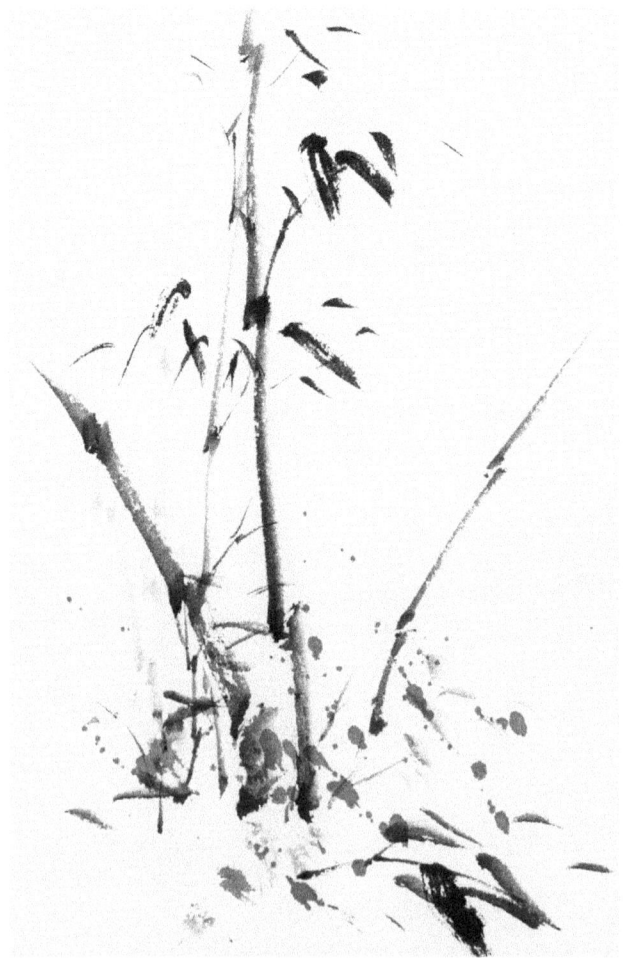

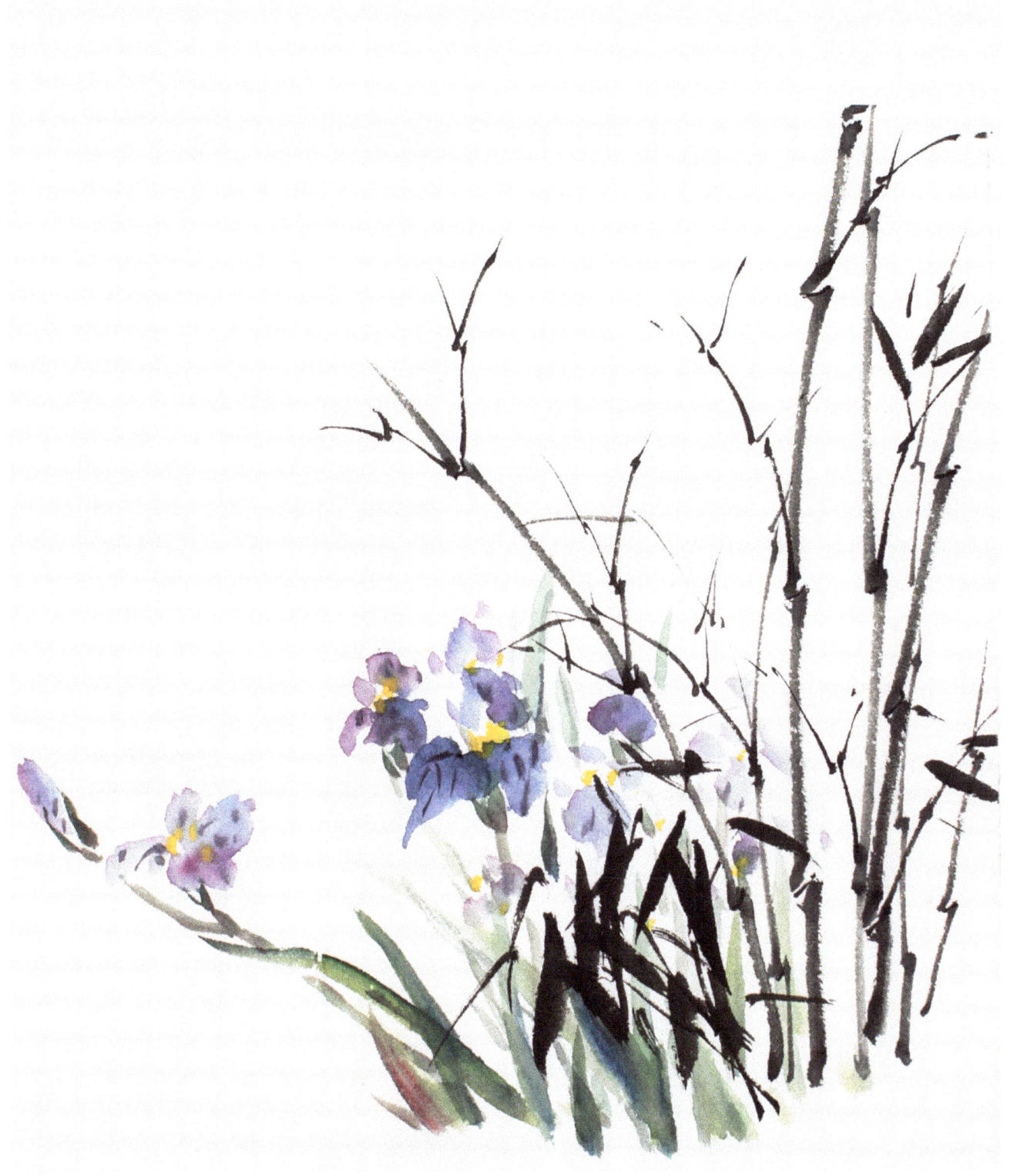

PLUM TECHNIQUE

Plum blossoms bring news of Spring, blossoming in March, while the snow has still not quite melted. The reasons that plum is regarded as a symbol of the uprightness of the Confucian gentleman is because it puts down roots in the frozen ground despite the snow, and it spreads its fragrance as if it were transcending the difficulties and obstacles of the harsh secular world. That is why it is said that "even if you are poor, you can't exchange the fragrance of plum for money."

The striking element of the plum tree is the contrast between its delicate flowers and its ancient-looking trunk, which reaches out with gnarled branches.

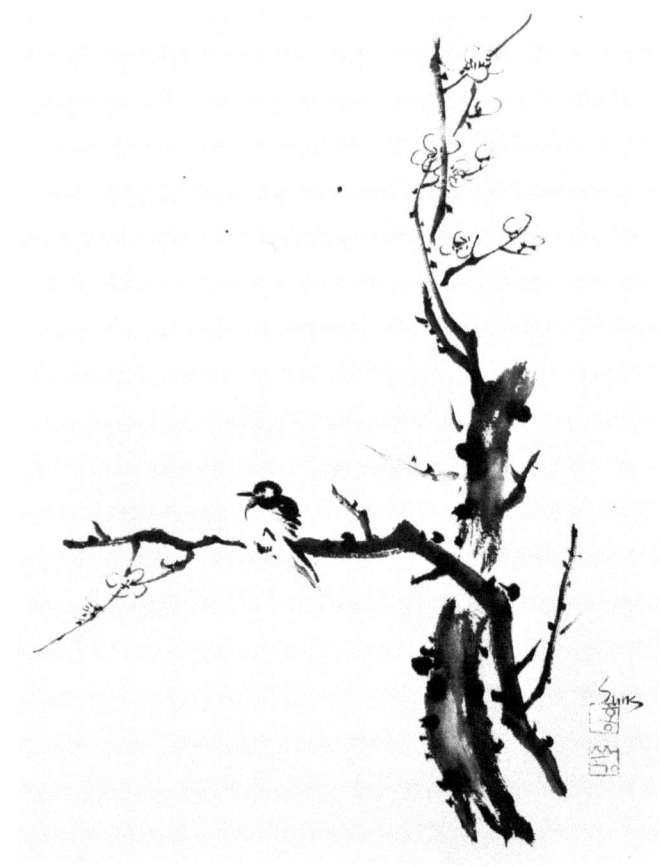

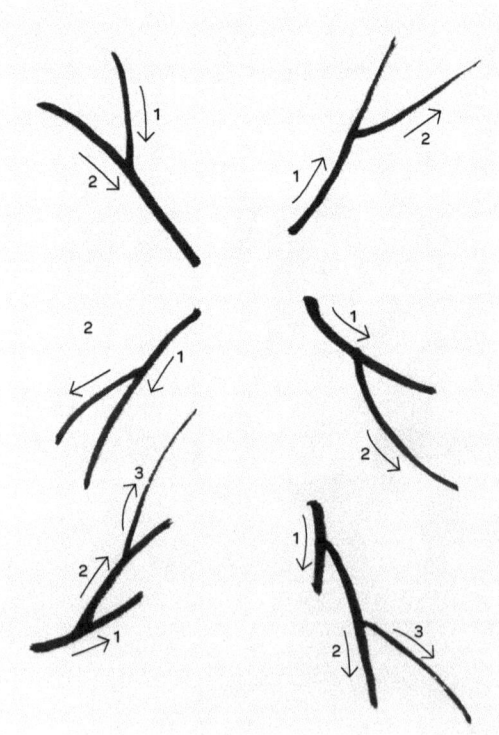

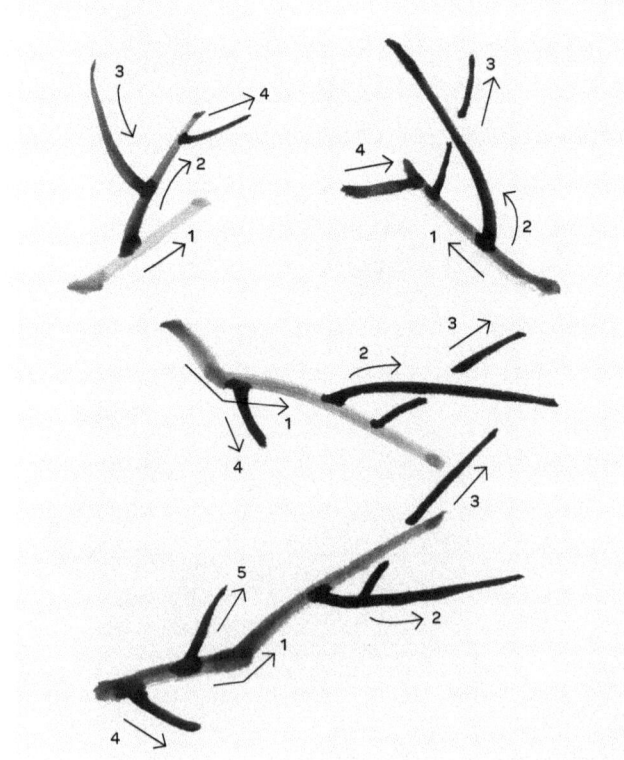

BRANCHES

Plum branches are more twisted than those of other fruit trees. The staghorn shape (opposite, bottom), for instance, has two branches of different lengths on one side of the main branch, and one on the other. Branches frequently cross one another. Practice with a single branch first, then gradually increase the number of branches.

To paint a branch growing off of a trunk, align your brush with the trunk, with the tip facing away from you. Press down to start, then release the pressure as you move outward. This is also the way to paint twigs growing from branches.

As you paint, gently turn the direction of the brush, changing the angle and length of each section of the branch. Thick, older branches are more curved than younger ones.

TRUNKS

An orchid/bamboo brush or a badger-hair brush is good for tree trunks. Keep the brush as dry as possible. Scrape most of the water from the outside of the brush. Side-load the brush with pale ink, then draw the bottom third of the brush through dark ink. Remove the excess water near the shaft, then paint—pulling, rolling, and lifting the brush occasionally. (See "flying white" stroke, page 30). Use the heel of the brush to create the rough texture of the bark. Use the tip of the brush to define and add detail to the trunk.

Add dots of moss to the trunk and branches before the trunk dries. Moving the tip of the brush toward the branch as you work, paint a medium-sized dot and a smaller one next to it, then a larger one farther away—all in one dancing motion. Leave some breathing spaces when you compose your arrangement of trunk and branches.

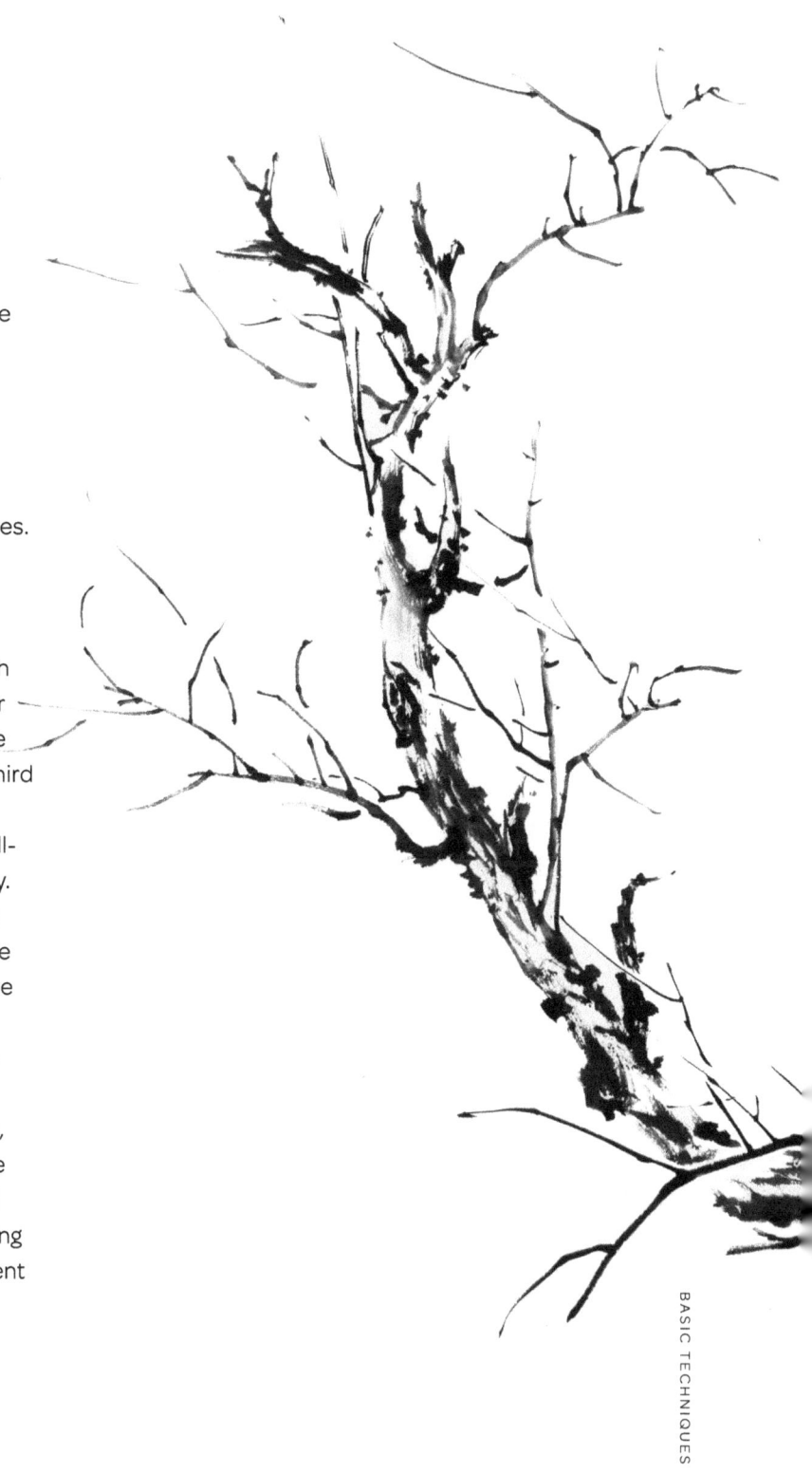

FLOWERS

Two different strokes are used to paint plum flowers: an outline and a dotted stroke. Place the flowers where the branches cross, and paint them in ink, or in colors such as pink, red, green, yellow, and white.

Outlined petals are painted with curved strokes. Use different perspectives for each group of flowers (create at least three to a group). Use a fine brush for the stamens. Attach the flowers to the branch with three dots for the sepals. Flowers grow on the sides of the branch and there are fewer of them toward the top of the branch.

Paint the flowers in a lighter ink than the branches, adding the stamens and sepals in darker ink unless they are in the background. Paint flowers that are closest to the foreground larger and in a bolder tone. Then add more water to the brush to paint the background flowers.

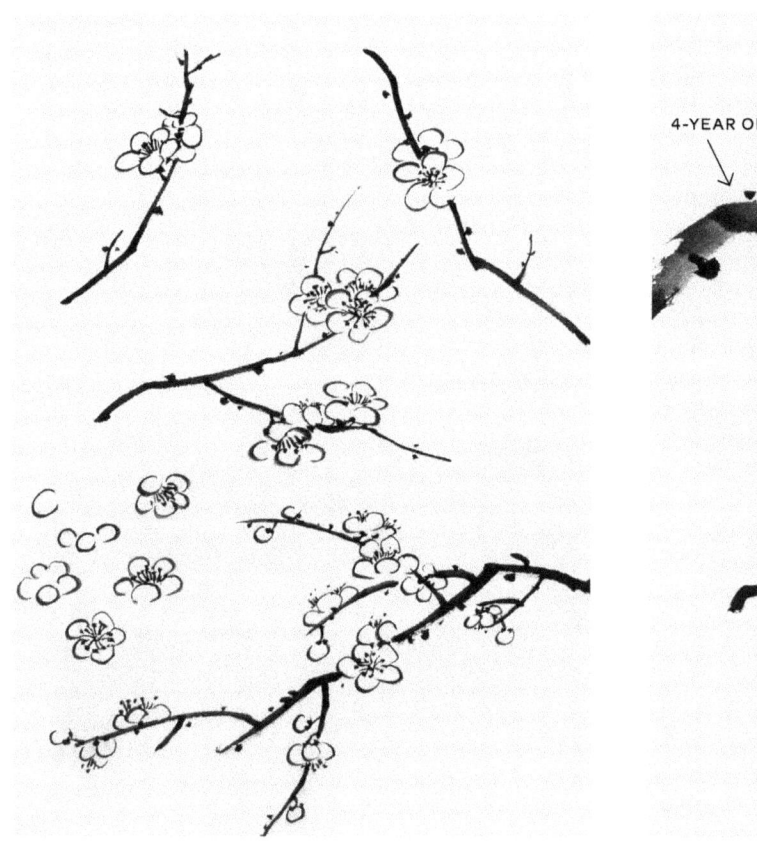

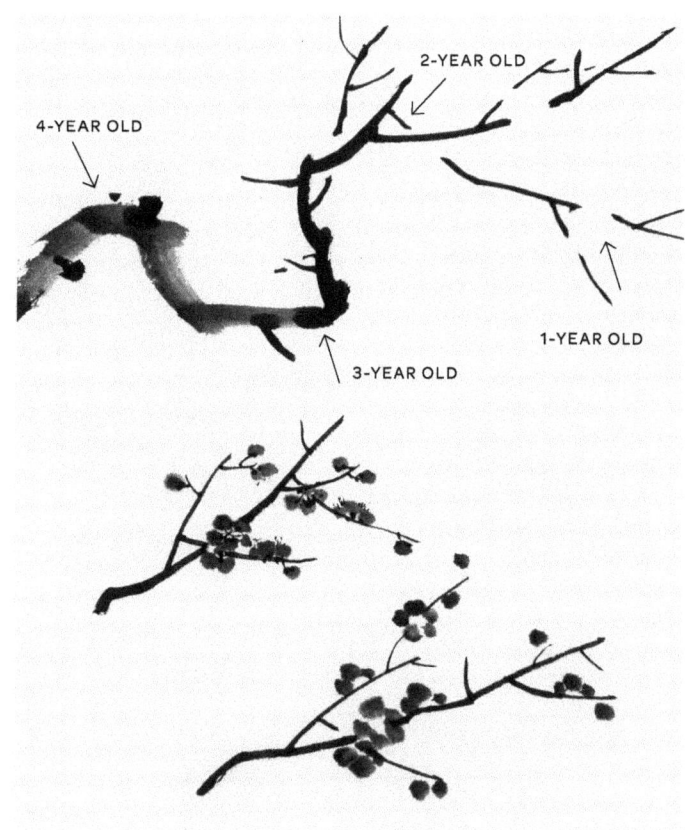

EACH SECTION OF A BRANCH REPRESENTS A YEAR'S GROWTH AND IS THINNER THAN THE PREVIOUS SECTION. LEAVE A GAP ON THE BRANCHES FOR THE FLOWERS, OR PAINT THE FLOWERS FIRST.

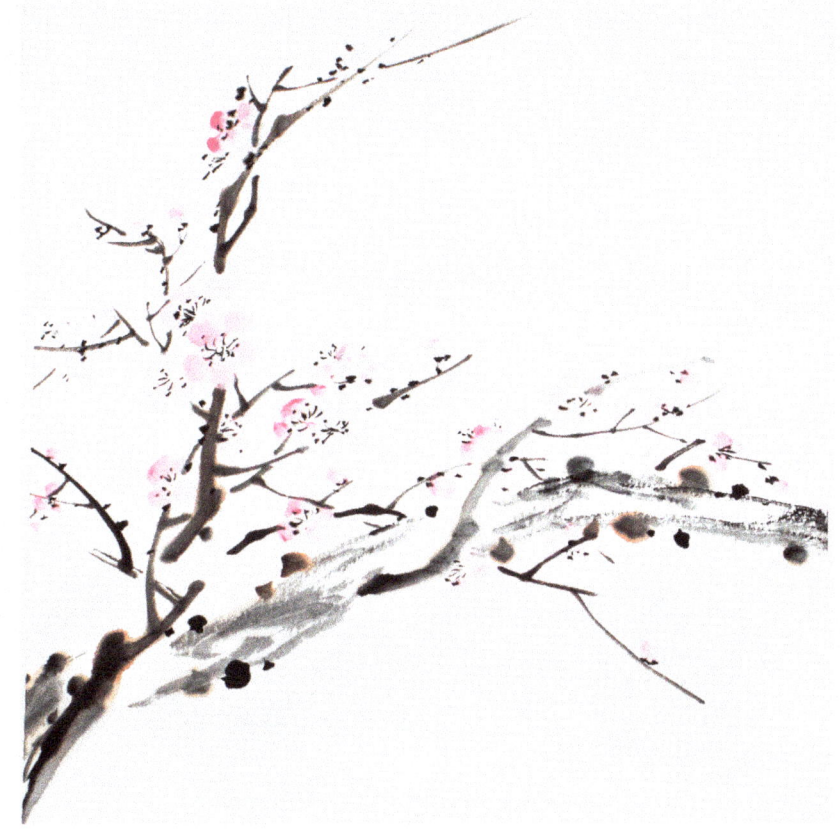
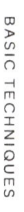

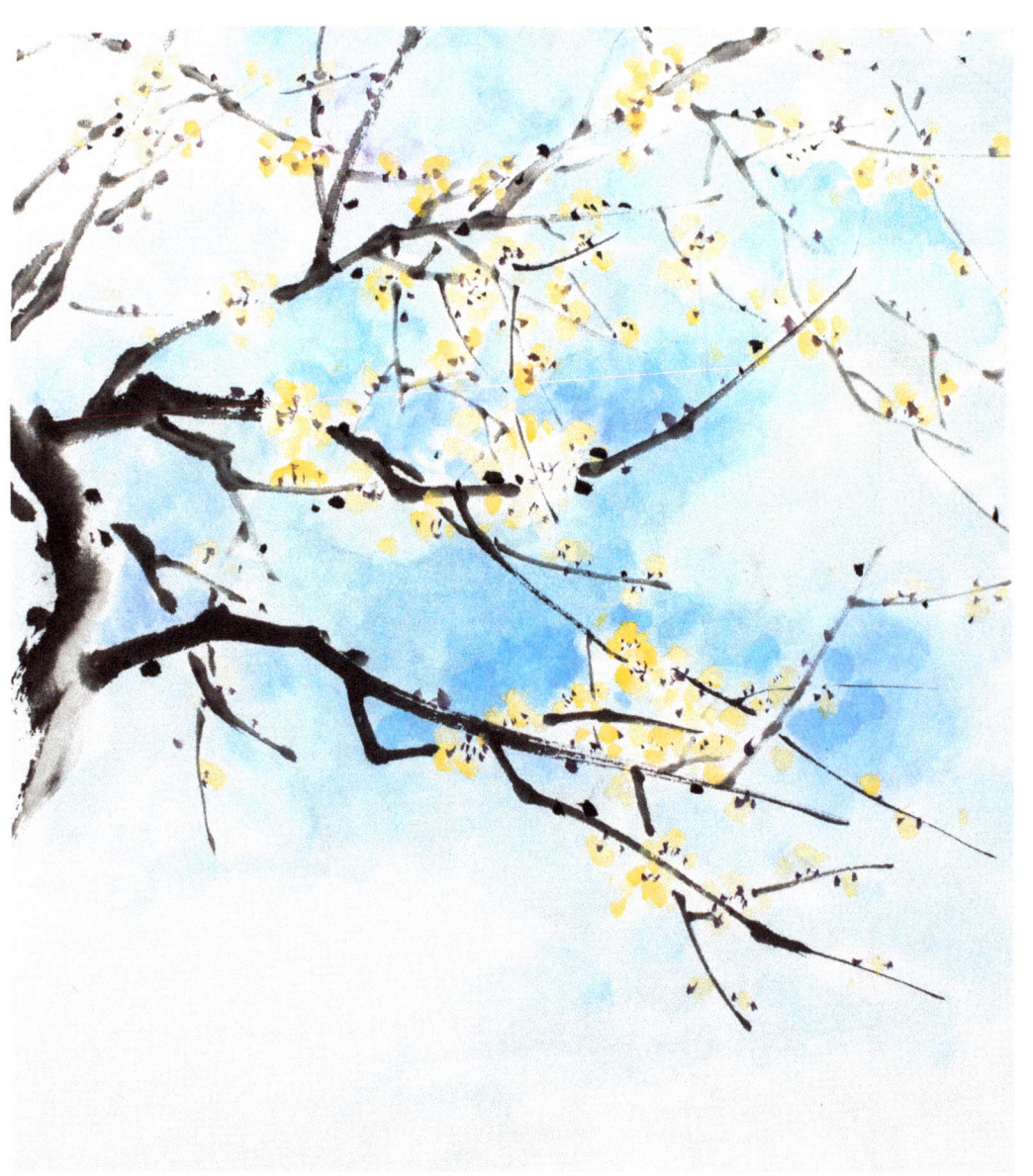

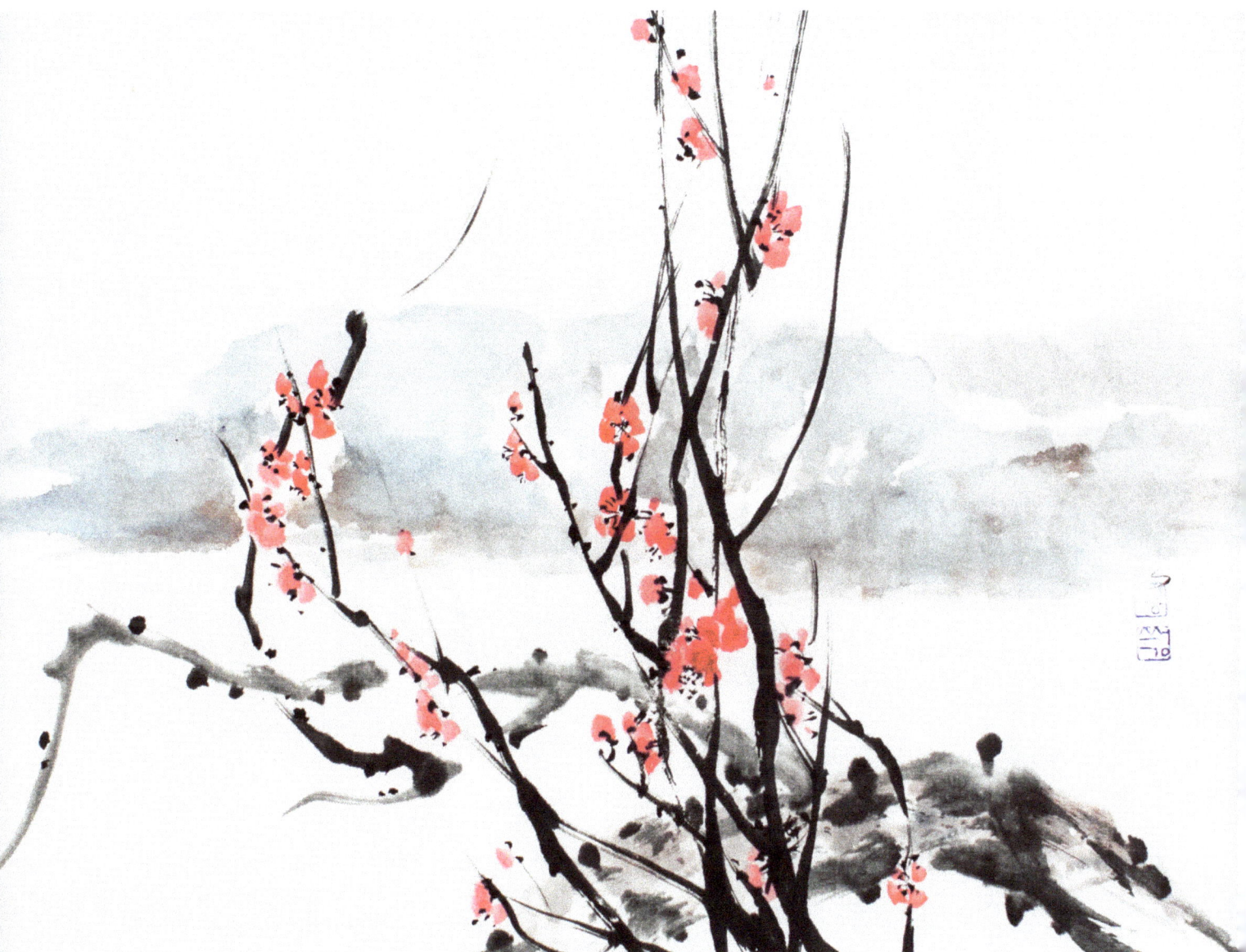

CHRYSANTHEMUM TECHNIQUE

Students are generally taught to paint the chrysanthemum last. The main reason for this is that by painting bamboo, orchid, and plum blossom, they learn the basic dot and line strokes. The chrysanthemum, however, requires more rhythmic and complex strokes. By painting the chrysanthemum, especially its leaves, you'll learn how to portray them from different angles.

As the "flower of the East," the chrysanthemum is said to shine on the earth like the sun. In Japan, the sixteen-petaled chrysanthemum has been the symbol of imperial sovereignty for the last 600 years, because of its reputation for longevity. In Confucian symbolism, the chrysanthemum reflects how the noble person conducts him- or herself in the world: self-reliant, waiting patiently through the Spring and Summer until Autumn turns cold in order to bloom in its full glory.

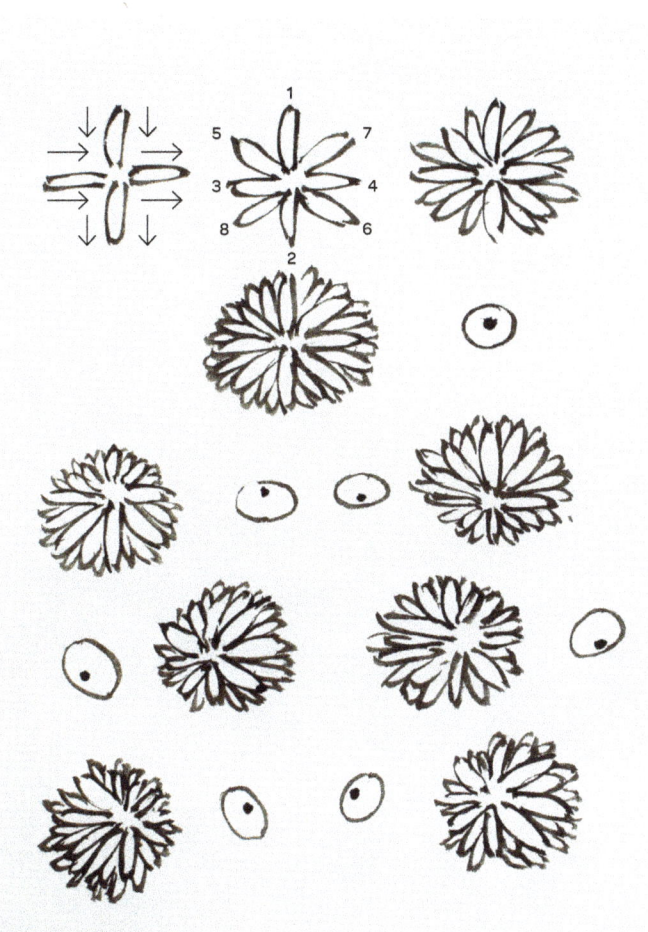
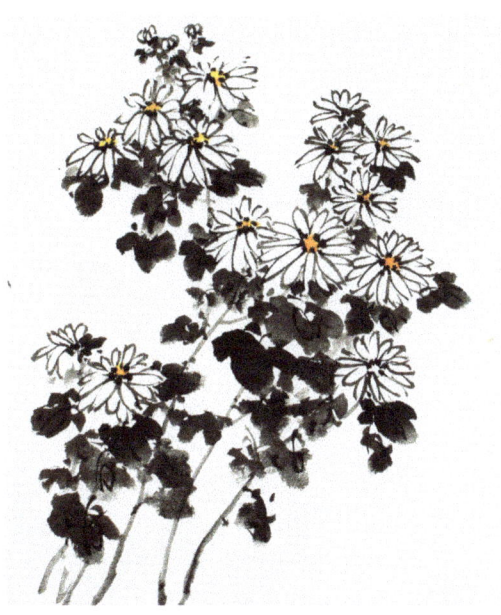
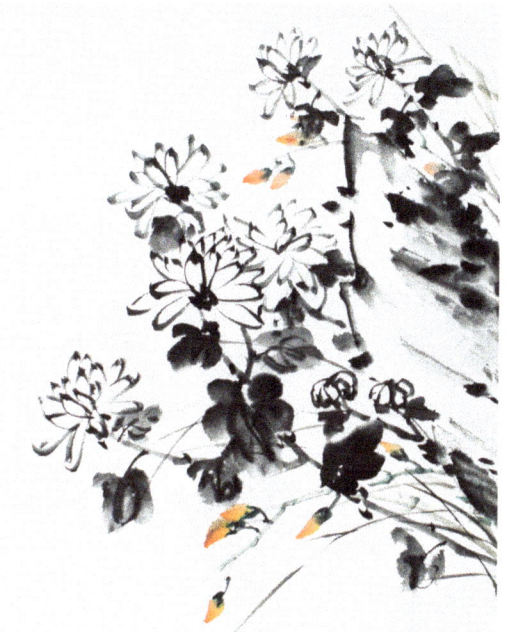

TECHNIQUE

Here are the basic techniques of different styles of flowers and a variety of angles:

Arrange the flowers in irregular triangular clusters of three. Each flower should be a different height and size, and facing in a different direction. Place two close to each other, and the third a little farther away.

The flowers can be outlined in ink first, with color added later, not necessarily precisely inside the lines. They can also be painted in color, with the outlines added afterward, not necessarily precisely, and not necessarily painting every petal. If you paint without outlines, add a pale ink tone to the paint.

For both the petals and the leaves, load pale ink on the brush, then add a small- or medium-sized amount of a darker tone to the tip. When you begin the third bloom, leave out the darkest color. In general, one loading of the brush is sufficient to paint a whole flower.

PETALS

Load the whole brush with the palest color first, add another color to a third of the brush (on all sides), then add the darkest color only on the tip (this is the three-tone loading technique).

When you paint the outline of the flowers, press, lift, press, and make a hook at the end of the stroke. The petals in the center are painted darker and smaller. Always start from the center of the flower and work outward. Make the petals of unequal thickness and shape. Buds are painted with just a few small strokes. Occasionally try black blooms and green foliage, or petals with a dry brush.

LEAVES

Sketch a thin line suggesting the curve or the direction of each leaf with a pale color before painting the leaf itself. Paint the smallest leaf with an almost upright brush, and angle the brush more as the size of each leaf increases. For the largest leaves, one-third of the brush should be on the paper. The leaves next to each flower are usually stronger and darker.

The bottom leaves on the stalk are lighter. Use a dryer brush for the lower leaves in order to express their age. Add veins in ink with a dryer brush just before the leaves are completely dry. You can also use color or white paint for the veins. Press and lift the brush as you paint the veins.

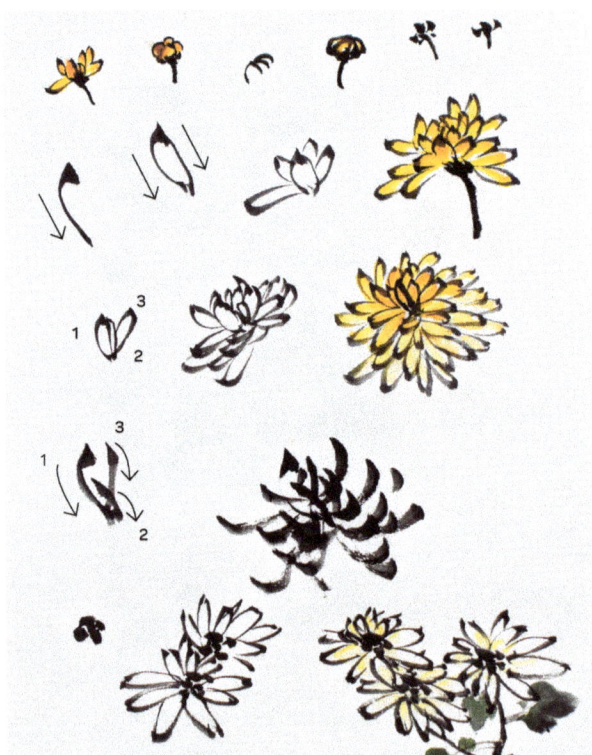

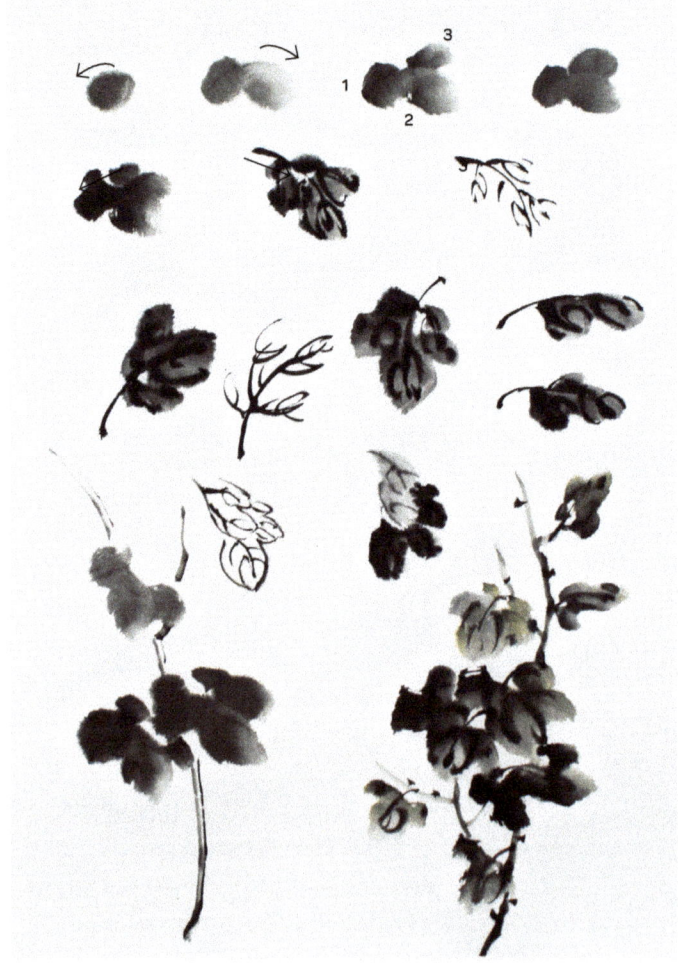

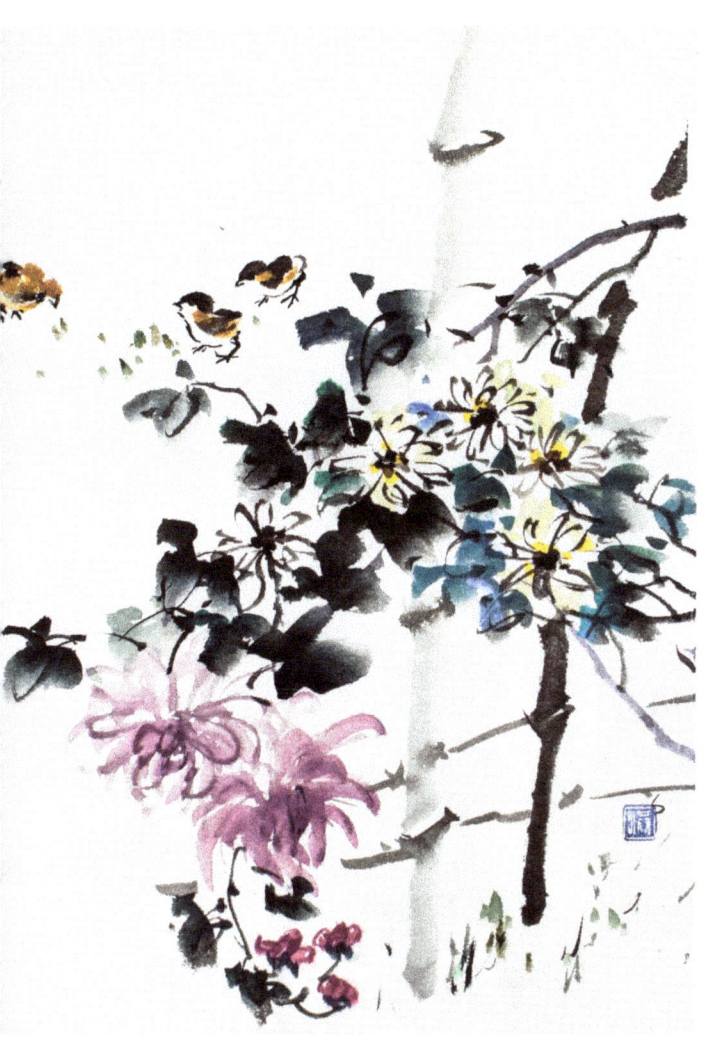

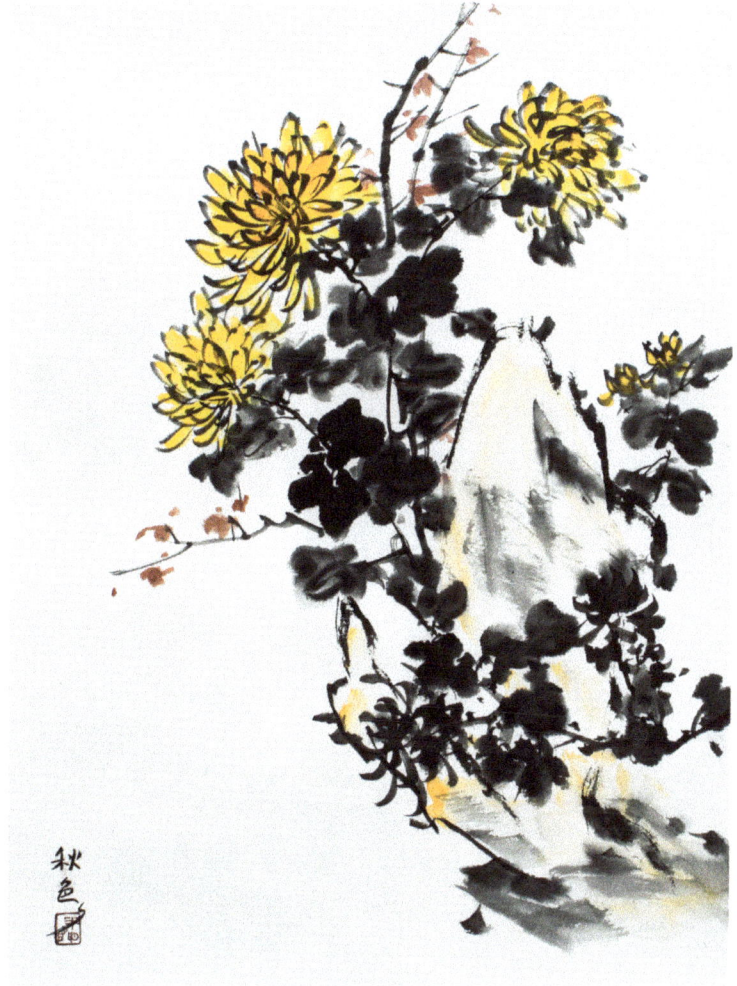

STALKS

Once the stalks have been painted, add more leaves if necessary. If you paint the stalks first, remember to leave spaces for the leaves, especially just below the flowers.

In your composition, think about creating an environment for the chrysanthemum, such as a bamboo fence, rocks, and some grasses, as well as a few insects, or some birds or chicks.

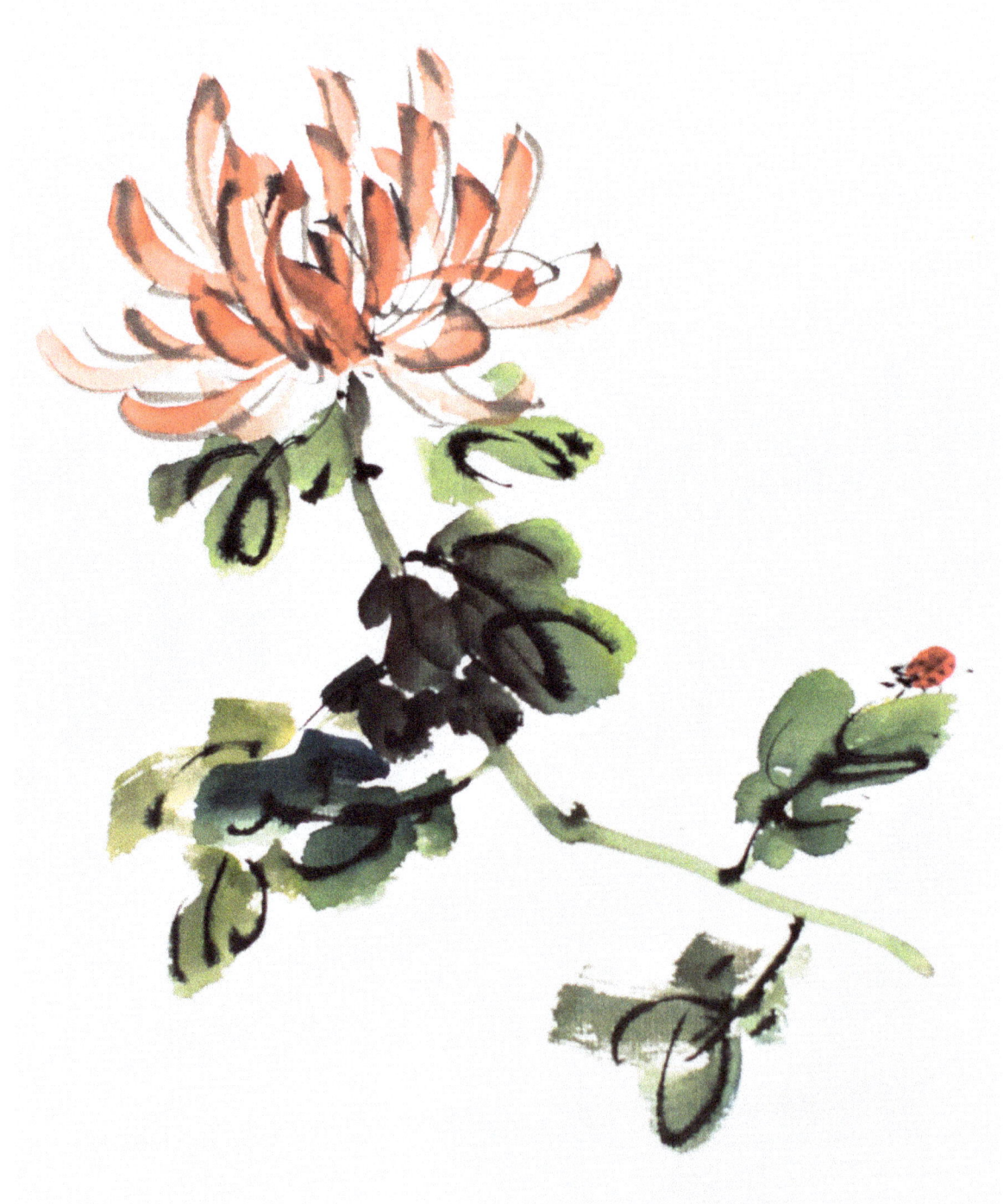

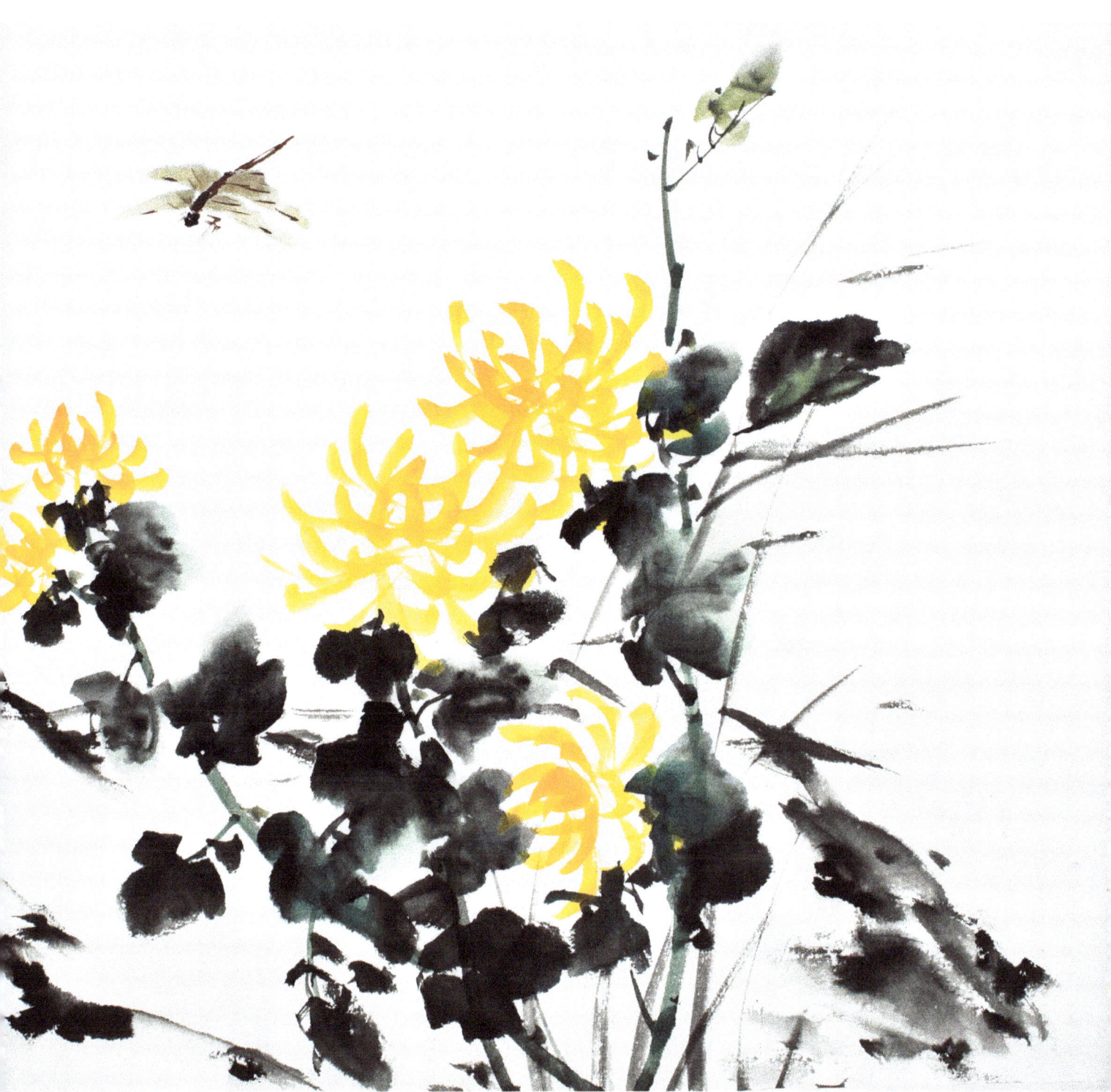

LANDSCAPE PAINTING

When I'm engaged in painting a landscape, it's almost a kind of spiritual nutrition for me. Surrounded by nature, my mind is calm and clear and I can focus my creative energy. It's probably clear: Landscape is my favorite subject.

As I mentioned in my introduction to the book, in Chinese, the word "landscape" means "mountains and water." These are the main structural elements of the genre, but they also symbolize yin and yang—the soft and the hard, the masculine and the feminine in nature.

Historically speaking, the fifteenth-century artist Dong Qi Chang (1555–1636) distinguished between two major schools of Chinese painting: the Northern school was known for its fine brush style and the Southern school focused on a spontaneous, free style of painting. In the early twentieth century, a group of Southern Chinese artists traveled to Japan and were exposed to Western styles of painting. They emphasized softer brushwork as well as more extensive washes, and were later called the Lingnan school. Among the three schools, I am more influenced by the spontaneity and free style of the Southern school, which served as a springboard for more eclectic techniques.

There are two ways to learn Chinese landscape painting: by emulating the masters and by direct observation and experimentation. In the East Asian tradition, copying the work of masters is regarded as a sign of respect, not plagiarism; it teaches you valuable tools. In my own work, I combine emulation and direct experimentation.

Water-ink painting is not the easiest technique to do on-site outdoors. Although I do most of my work in the studio, I sketch and paint outdoors too. If you paint outdoors, take along pencils, brush pens, and sketchbooks. I often take brushes, ink, and a folded rice paper screen book. If I paint near my home, I use a board covered with white felt and secured with clips under my drawing paper. You may find, as I do, that sketching on location is the best way to enrich your style and skills. Here are some exercises to work on—they're not just for beginners. No matter how long you've been painting and drawing, nature has things to teach you.

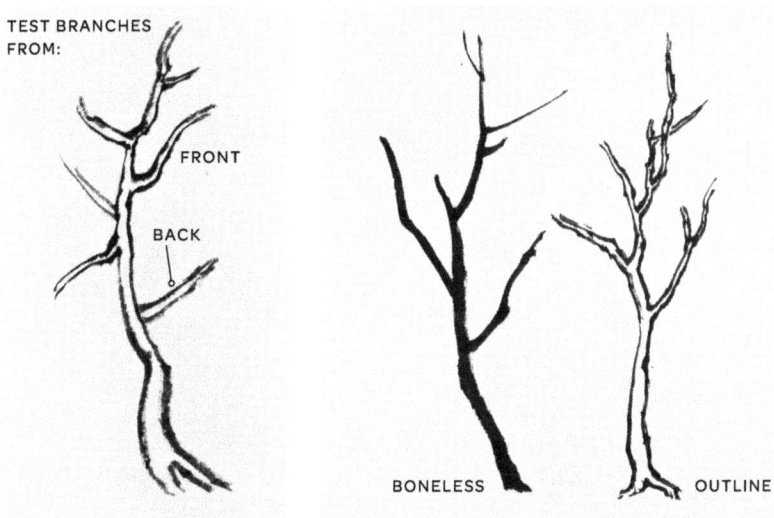

TREE BRANCHES AND TRUNKS

Experiment by painting trees with at least four branches stemming from the trunk in different directions. In this way, try to capture the three-dimensional quality of the tree. When you study trees, it's useful to practice two different styles: boneless and outline.

THE BONELESS STYLE

Without worrying about too much detail, try to capture the basic shapes of several varieties of branches. You can often find different varieties on the same tree.

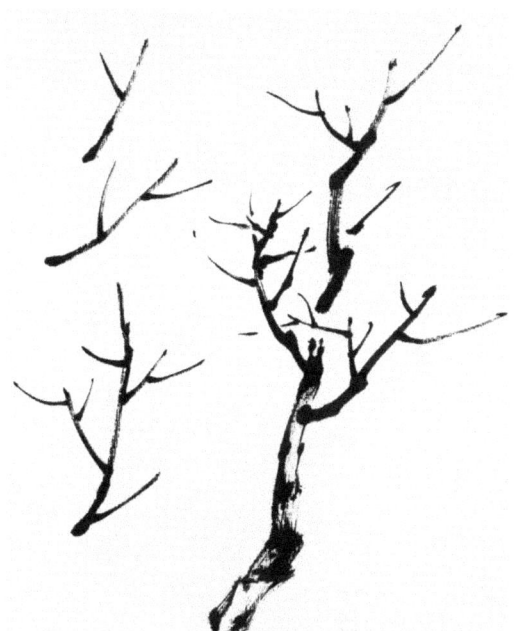

Staghorn style. Upward strokes.

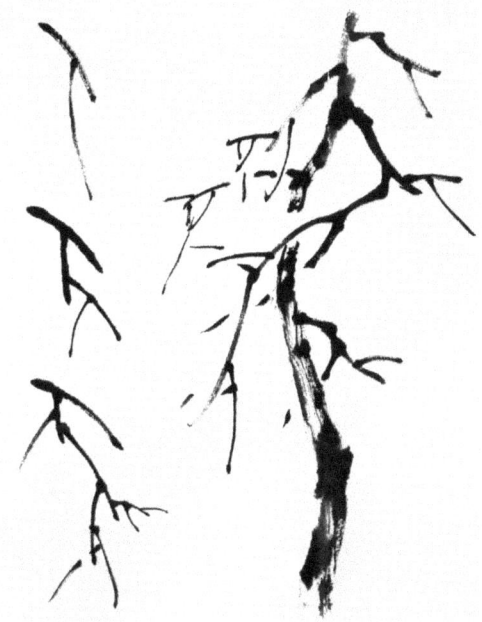

Crab-claw style. Downward strokes.

THE OUTLINE STYLE

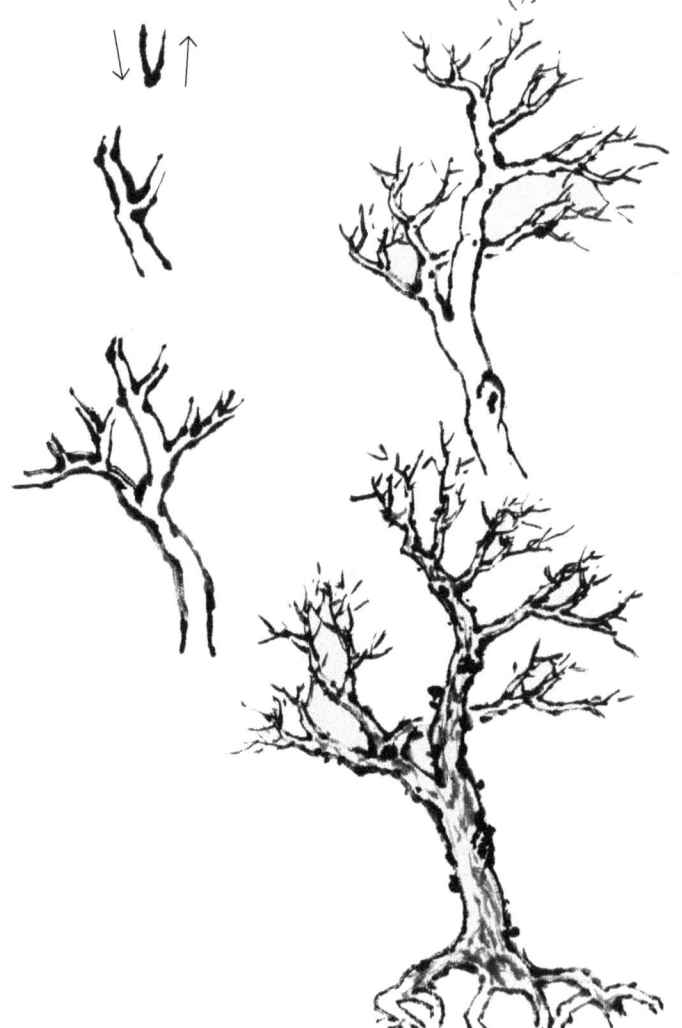

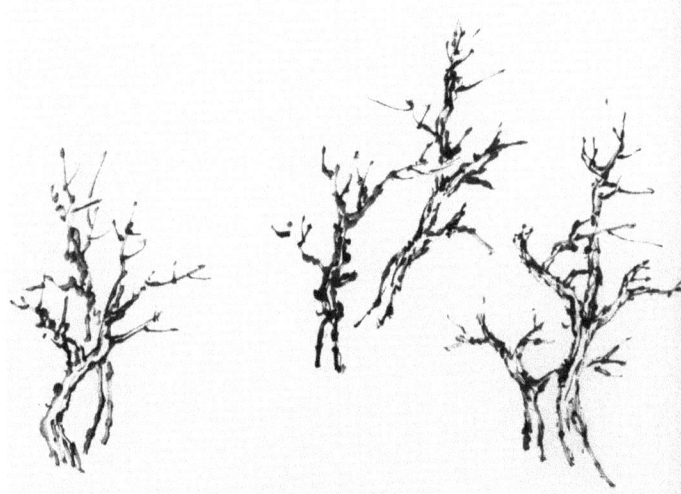

Always paint the foreground tree first.

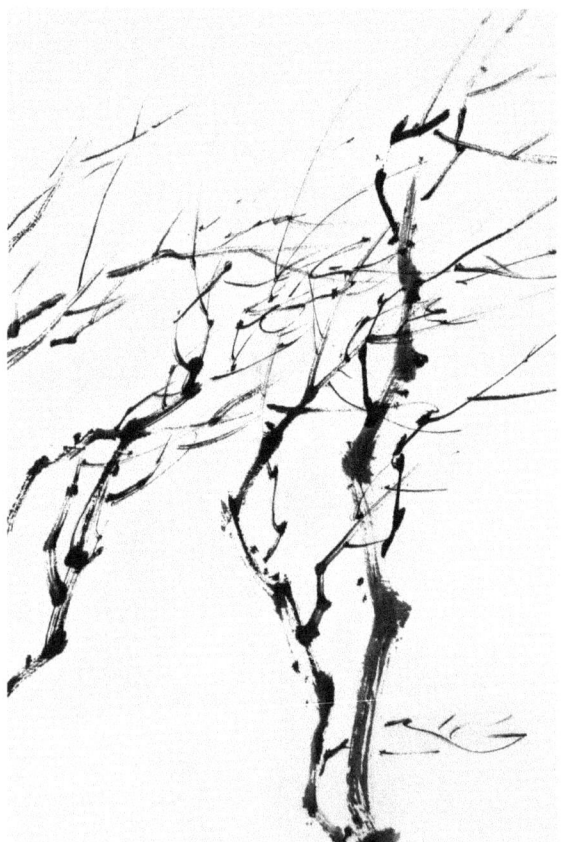

To suggest wind, apply the strokes quickly.

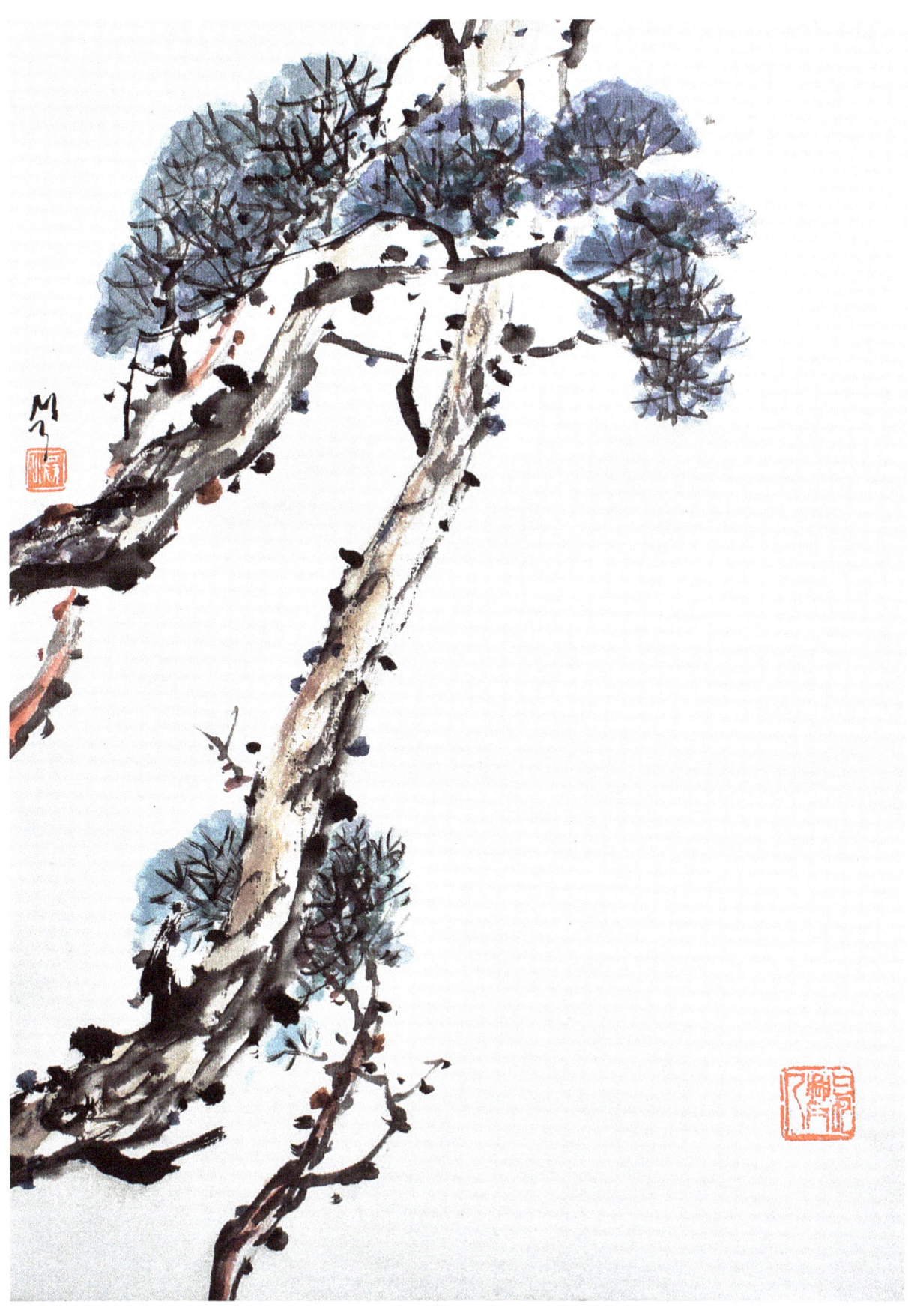

PINE TREE

DIFFERENT FOLIAGE SHAPES AND FORMATIONS

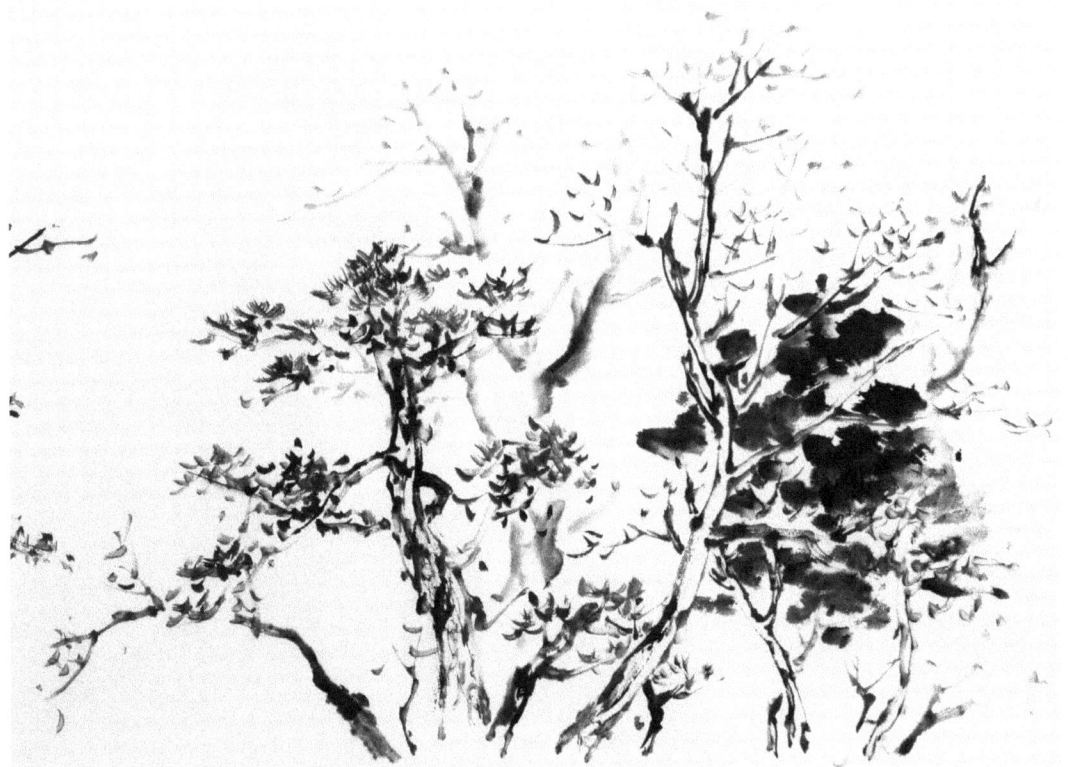

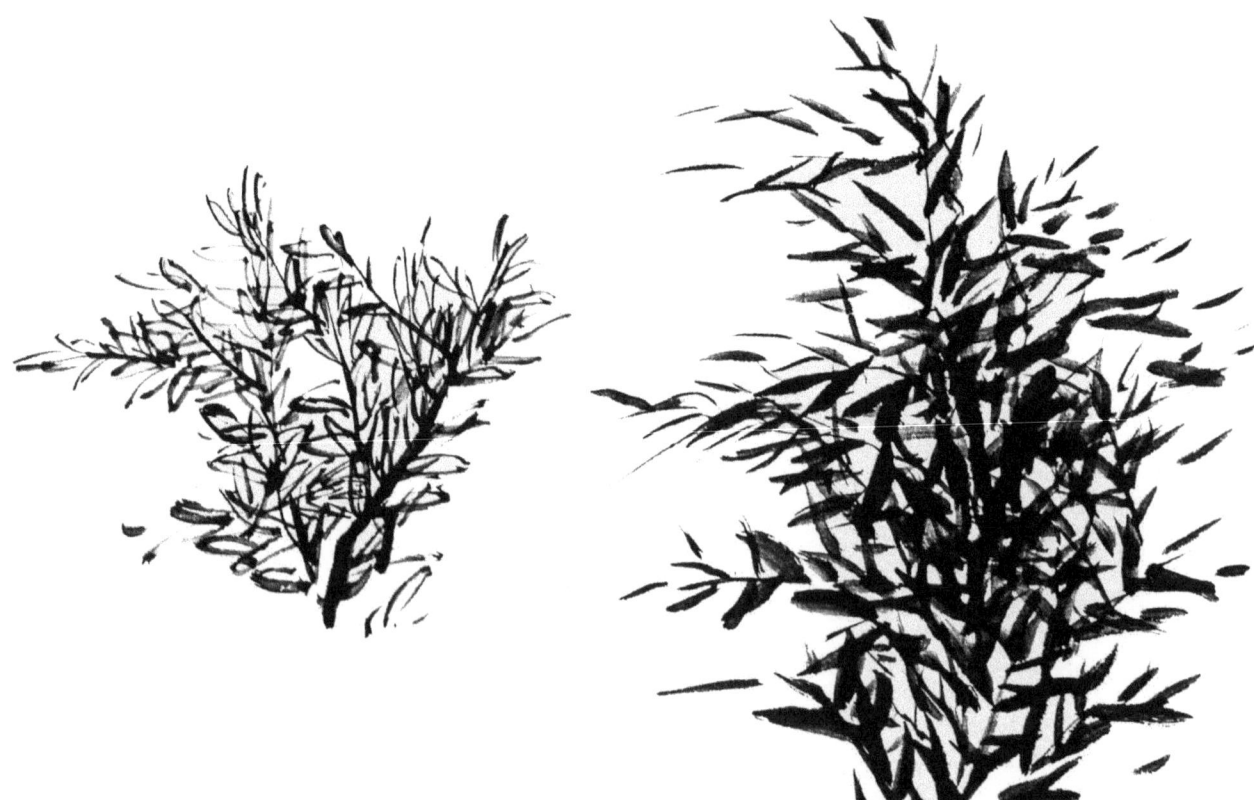

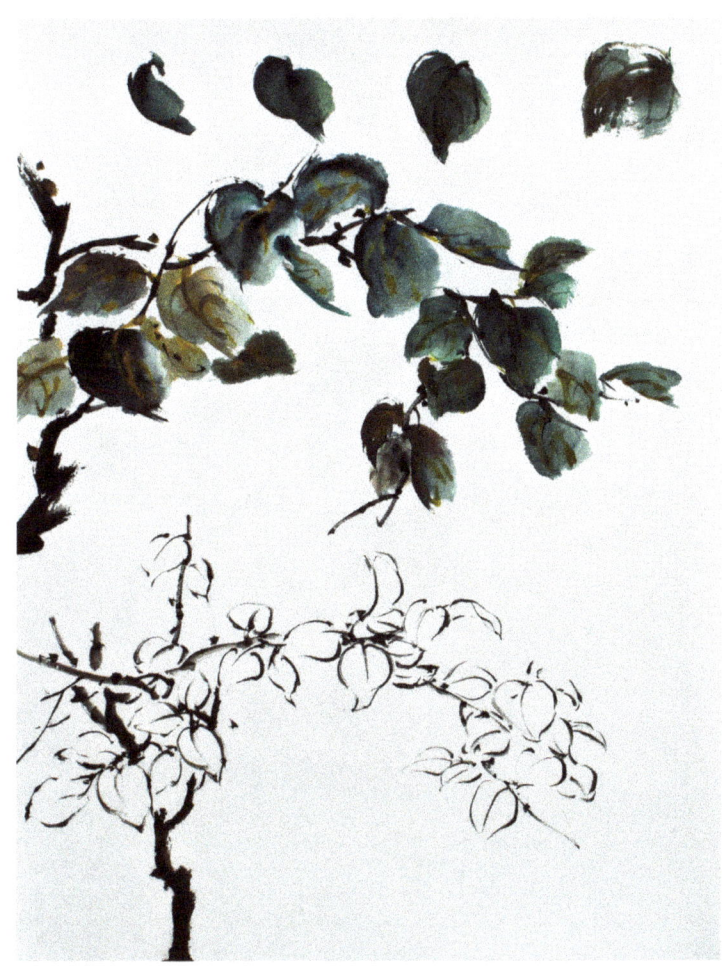
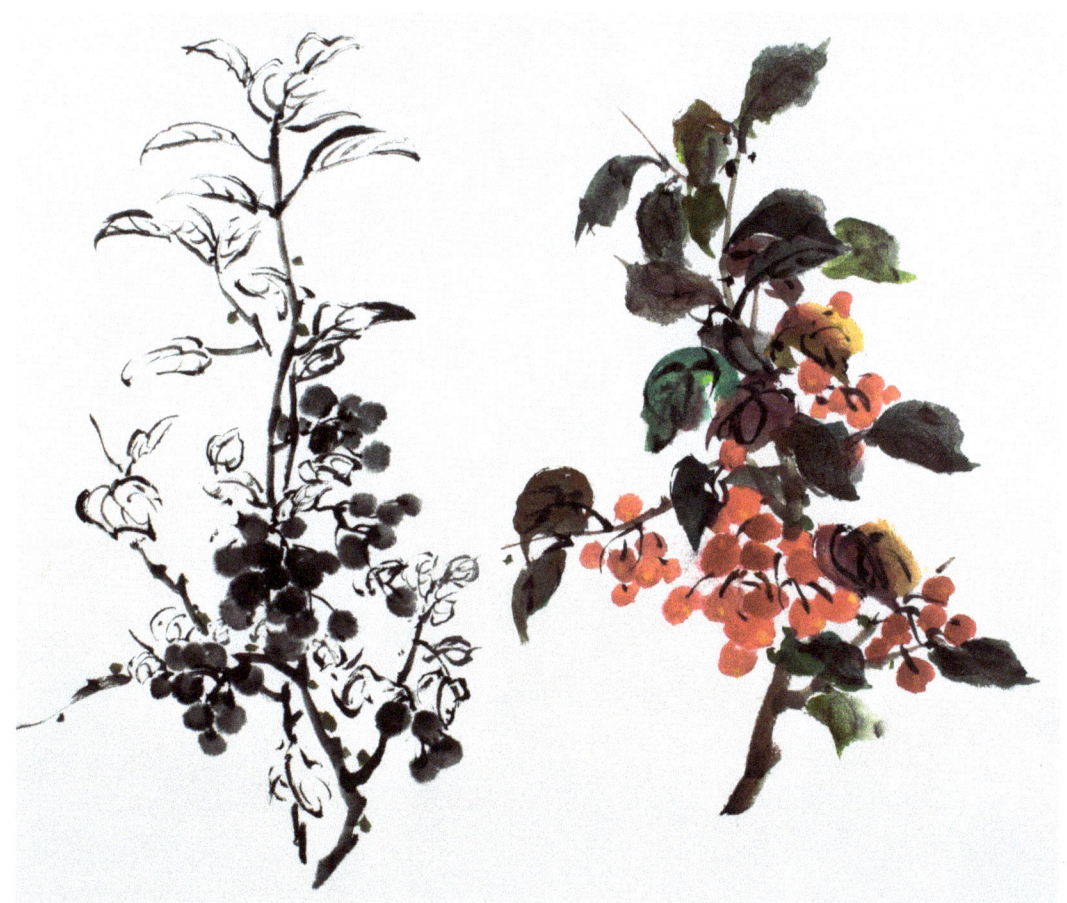

DIFFERENT FOLIAGE SHAPES AND FORMATIONS

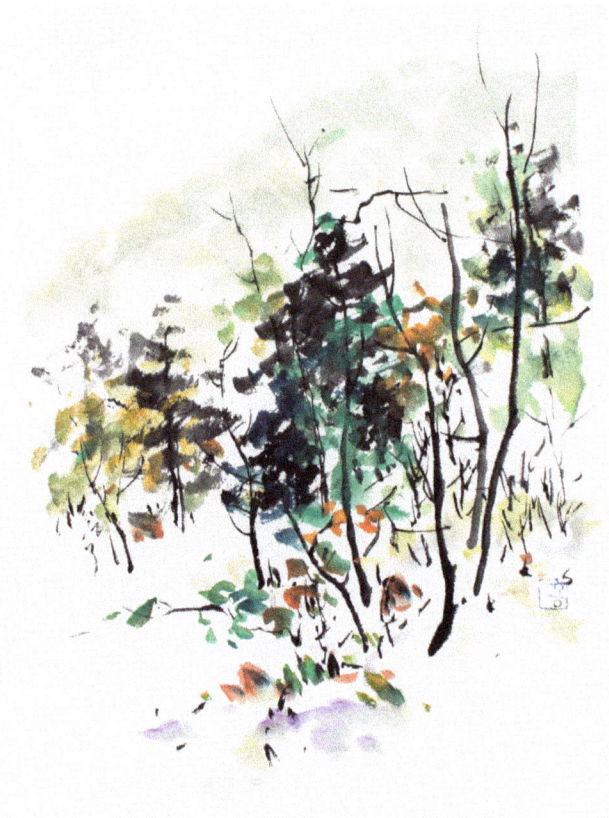
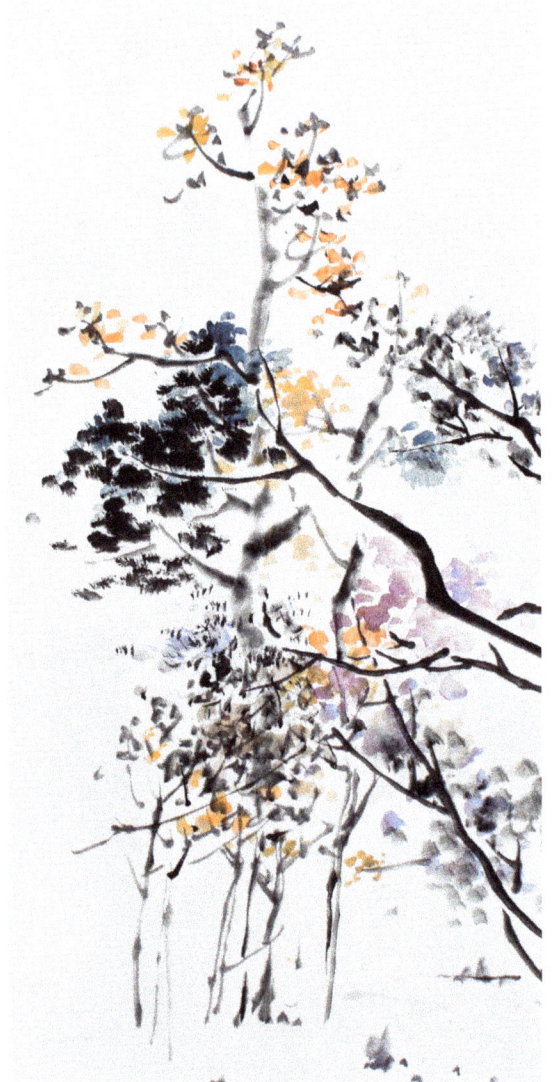

EXAMPLES OF DIFFERENT GROUPINGS OF TREES

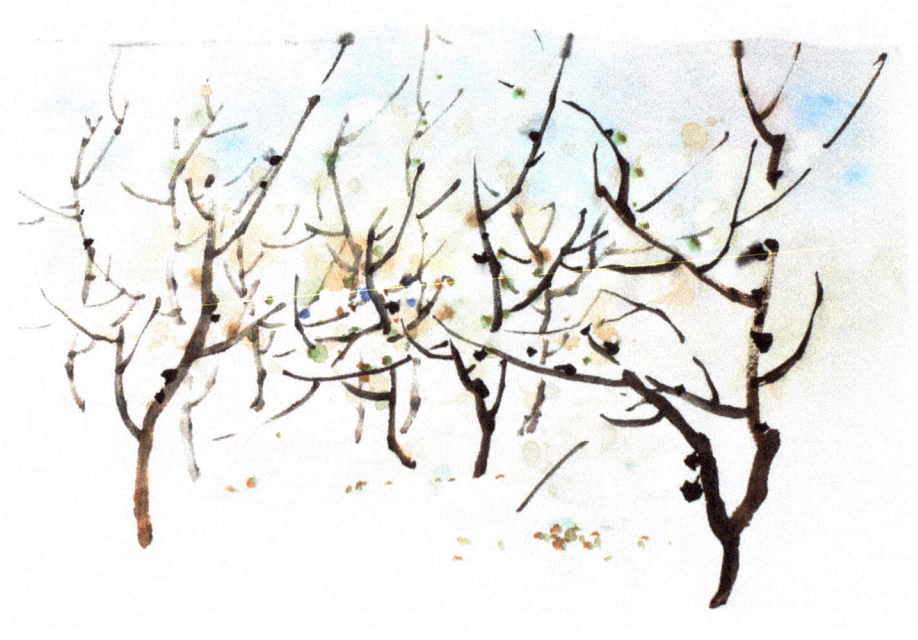

TREES IN THE DISTANCE

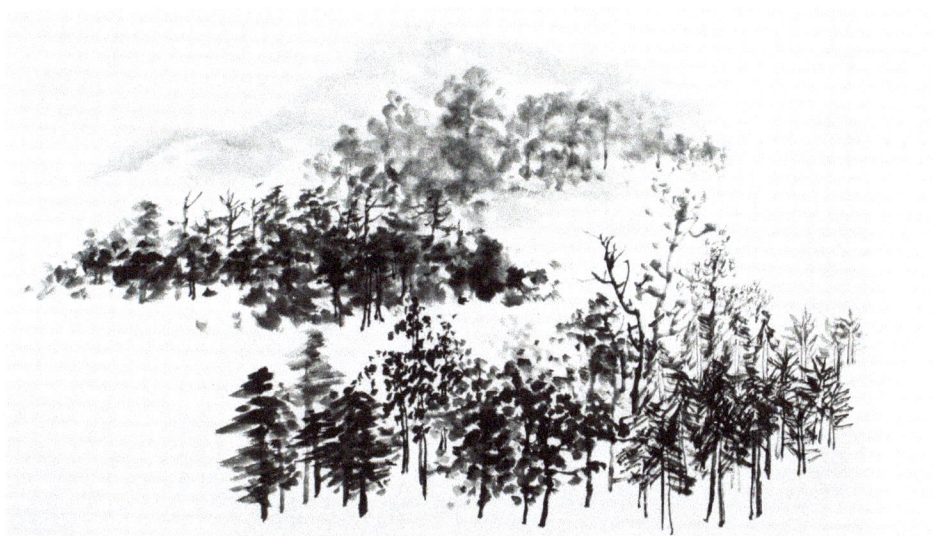

DISTANT TREES ARE EXPRESSED WITH LESS DETAIL AND LESS FOCUS.

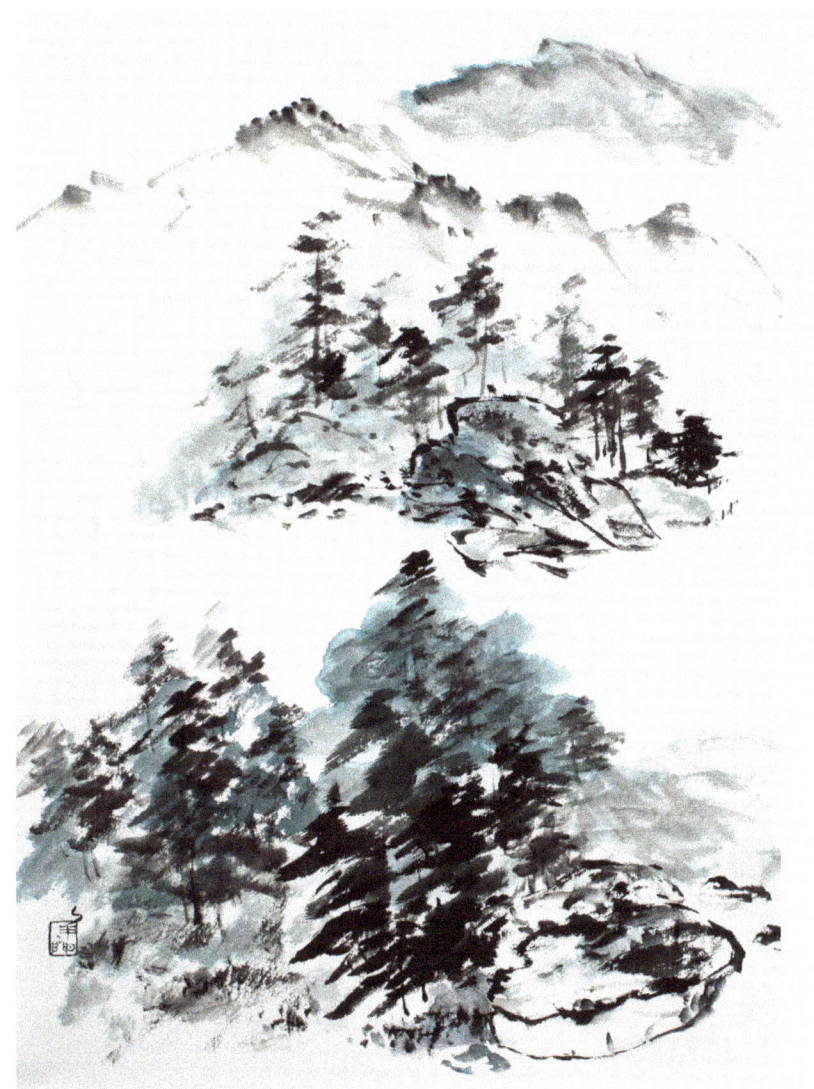

ROCKS AND MOUNTAINS

Study rocks and you'll be able to paint river banks and mountains. Mountains are depicted by aggregating groups of rocks. Each mountain has its own nature and character—but before you get that far, you need to learn the basic brush strokes, which include outlining, texturing, and shading with dots and washes. The most important thing to remember when painting rocks is that they have three faces: front, top, and side, which give a three-dimensional look.

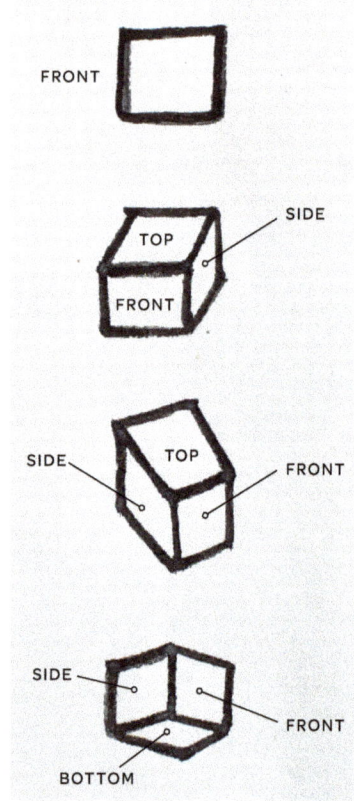

TO PAINT A ROCK

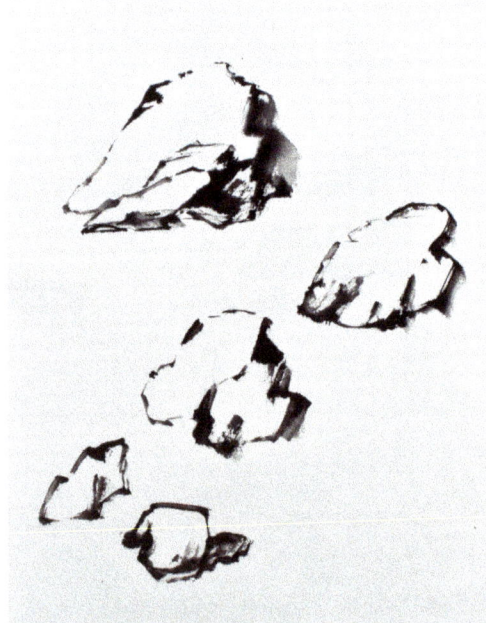

1. Create the outline first, then apply textured strokes.

2. I prefer to create the outline and texture simultaneously, because it allows for more spontaneous brushwork.

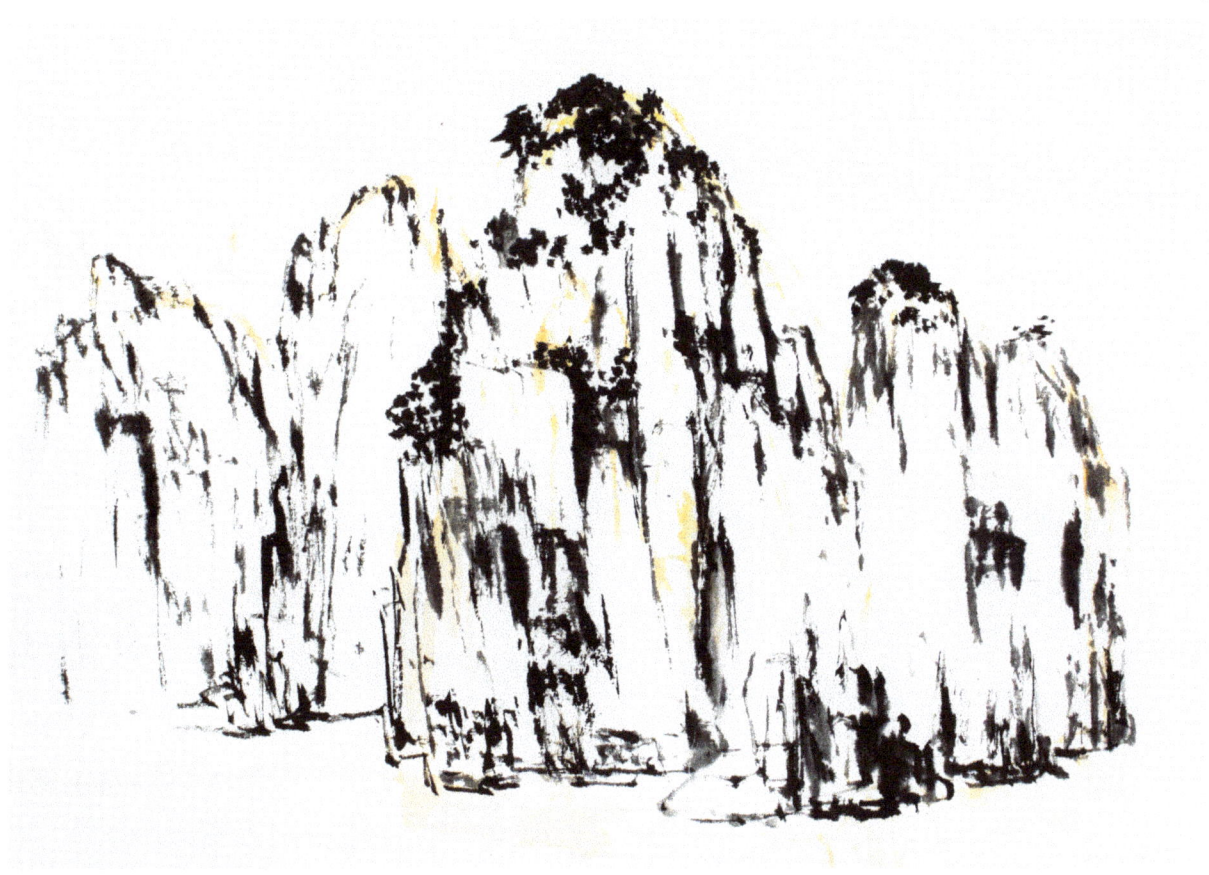

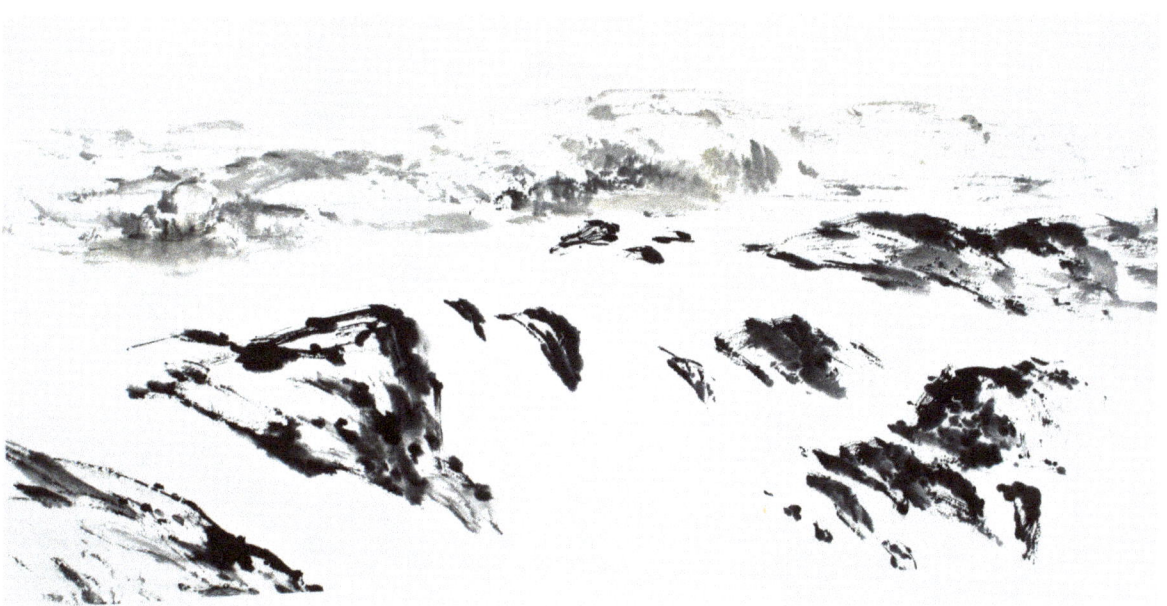

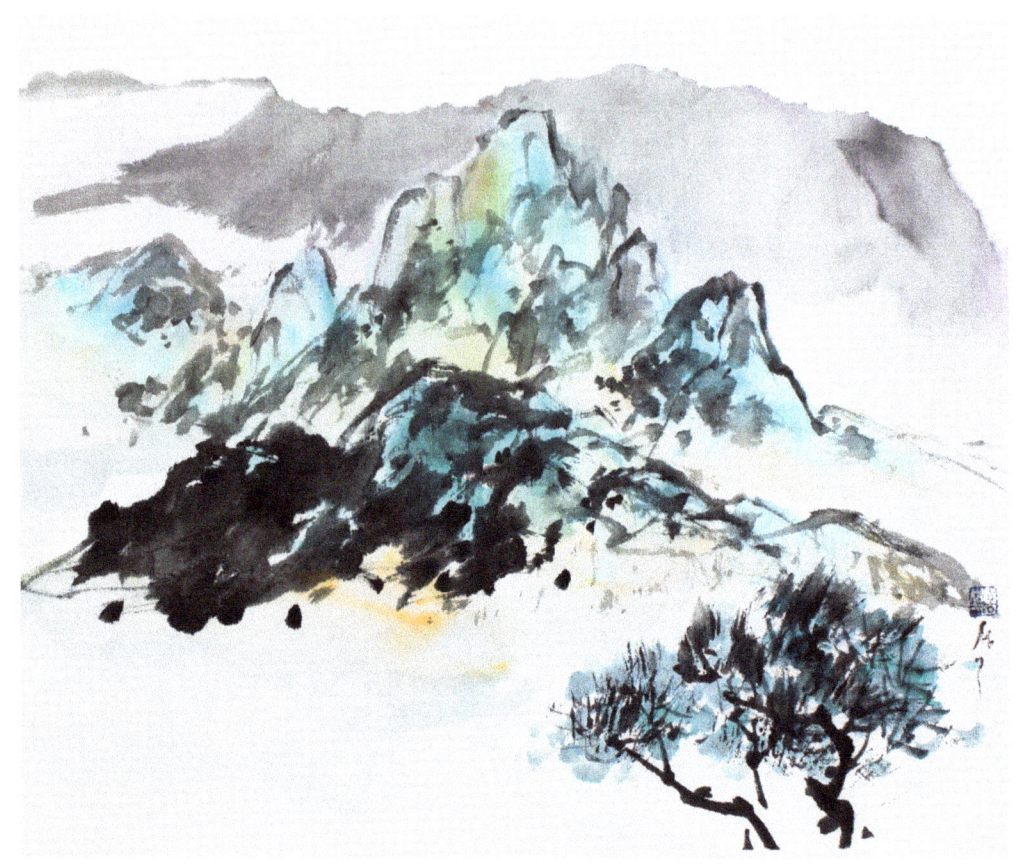

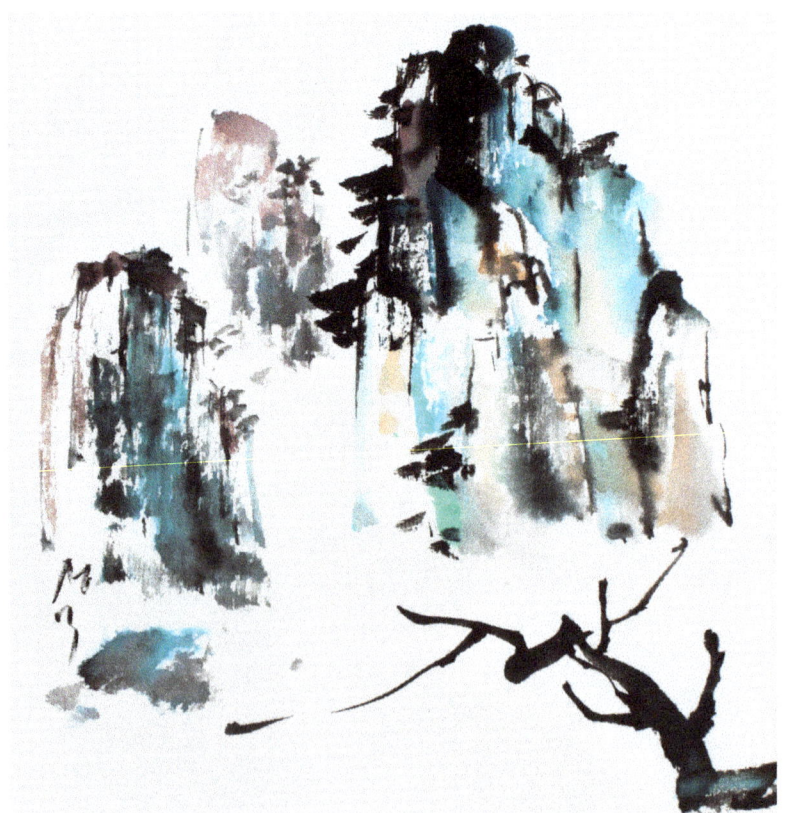

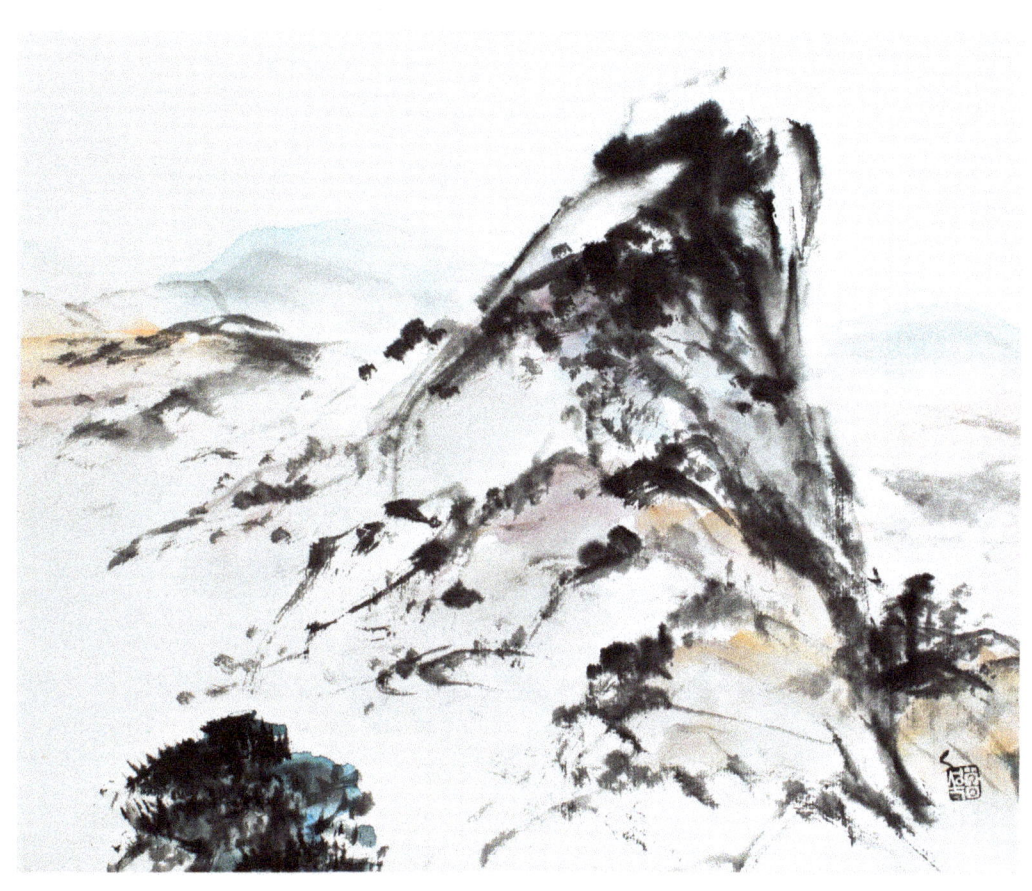

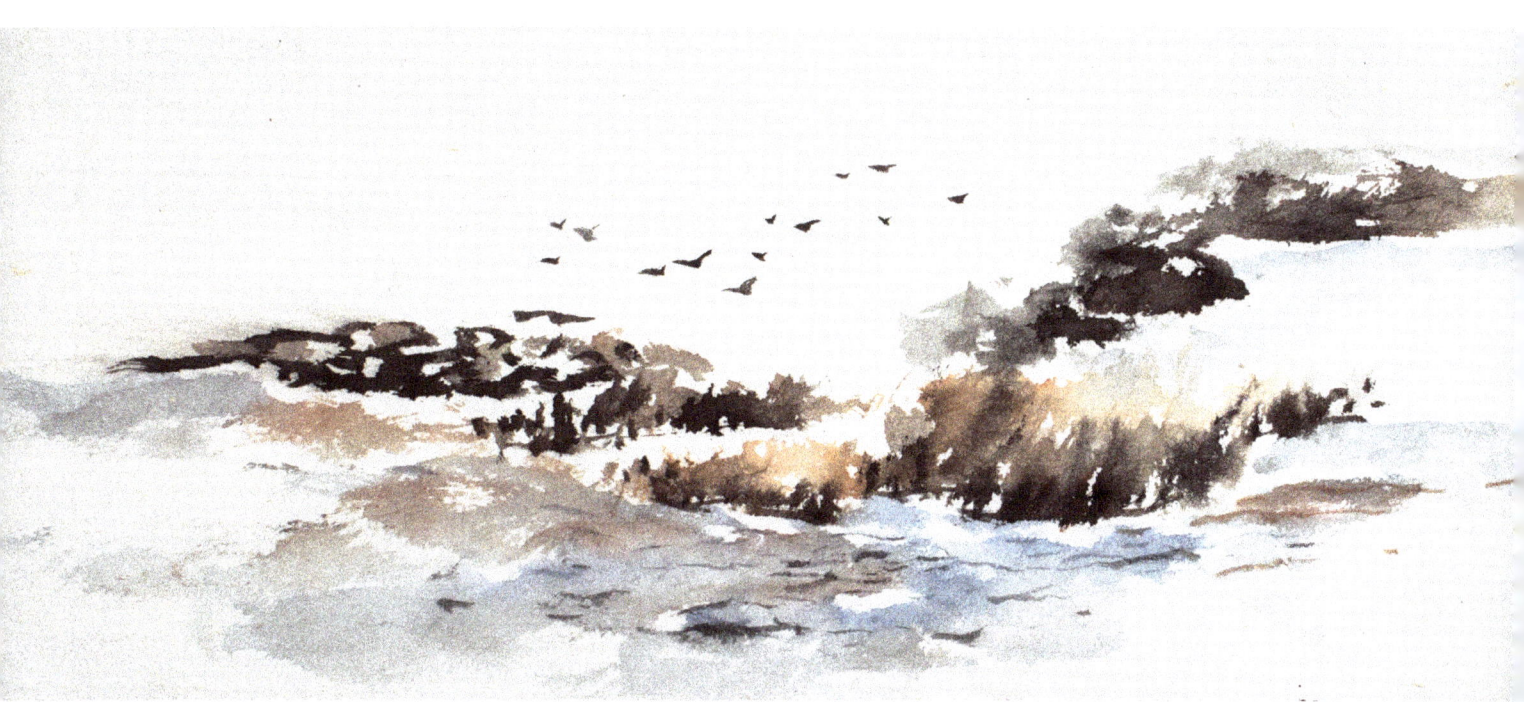

WATER AND WATERFALLS

I have lived close to water for over twenty years and I paint it often in all its natural forms. Water plays a major role as the yin of Chinese landscape painting. It symbolizes most of the key virtues in Daoist philosophy, such as simplicity, flexibility, and humility.

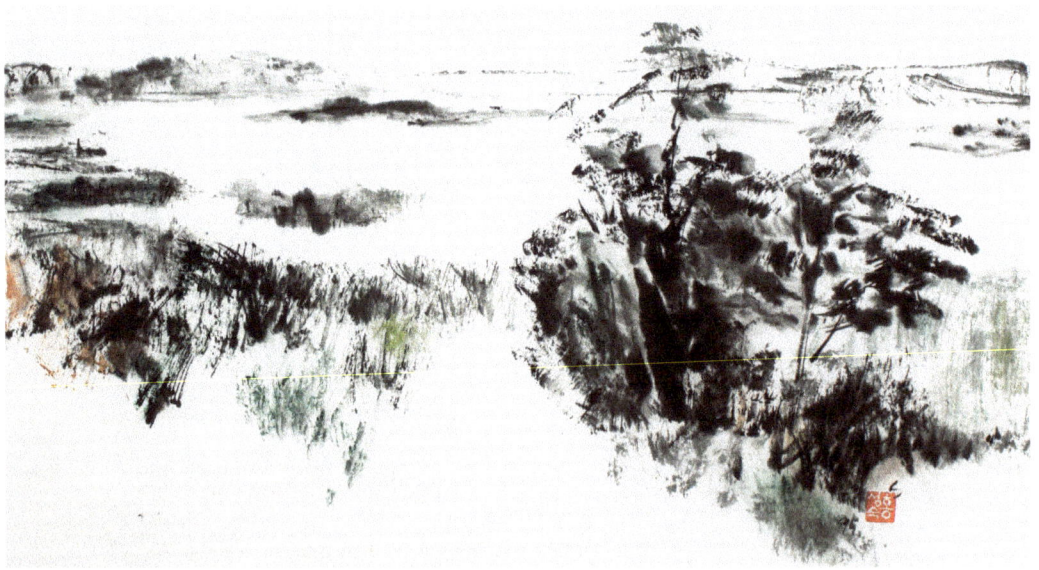

1. I often depict water and waterfalls as empty space by leaving a blank on my paper. In particular, leaving space between the cliffs gives waterfall paintings a striking look.

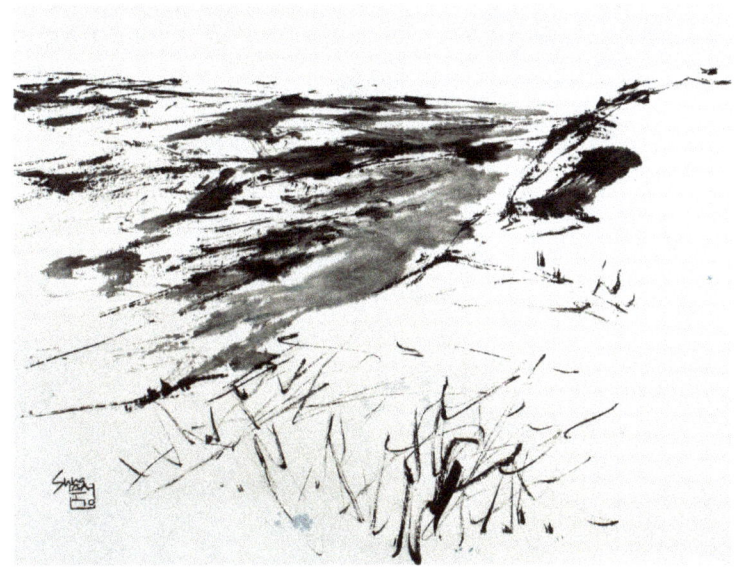
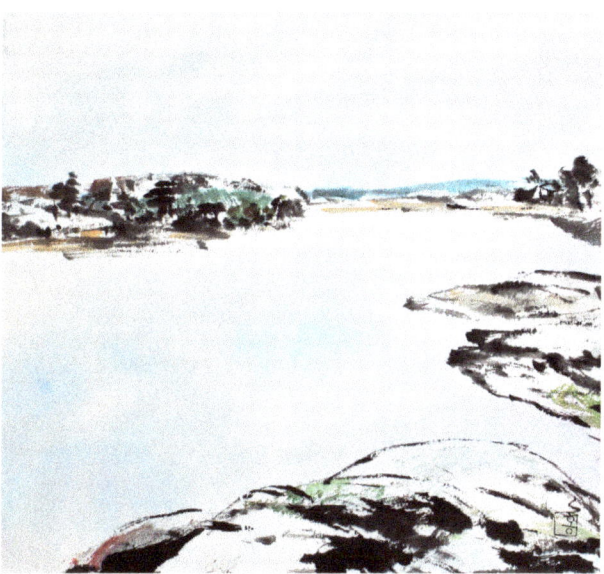
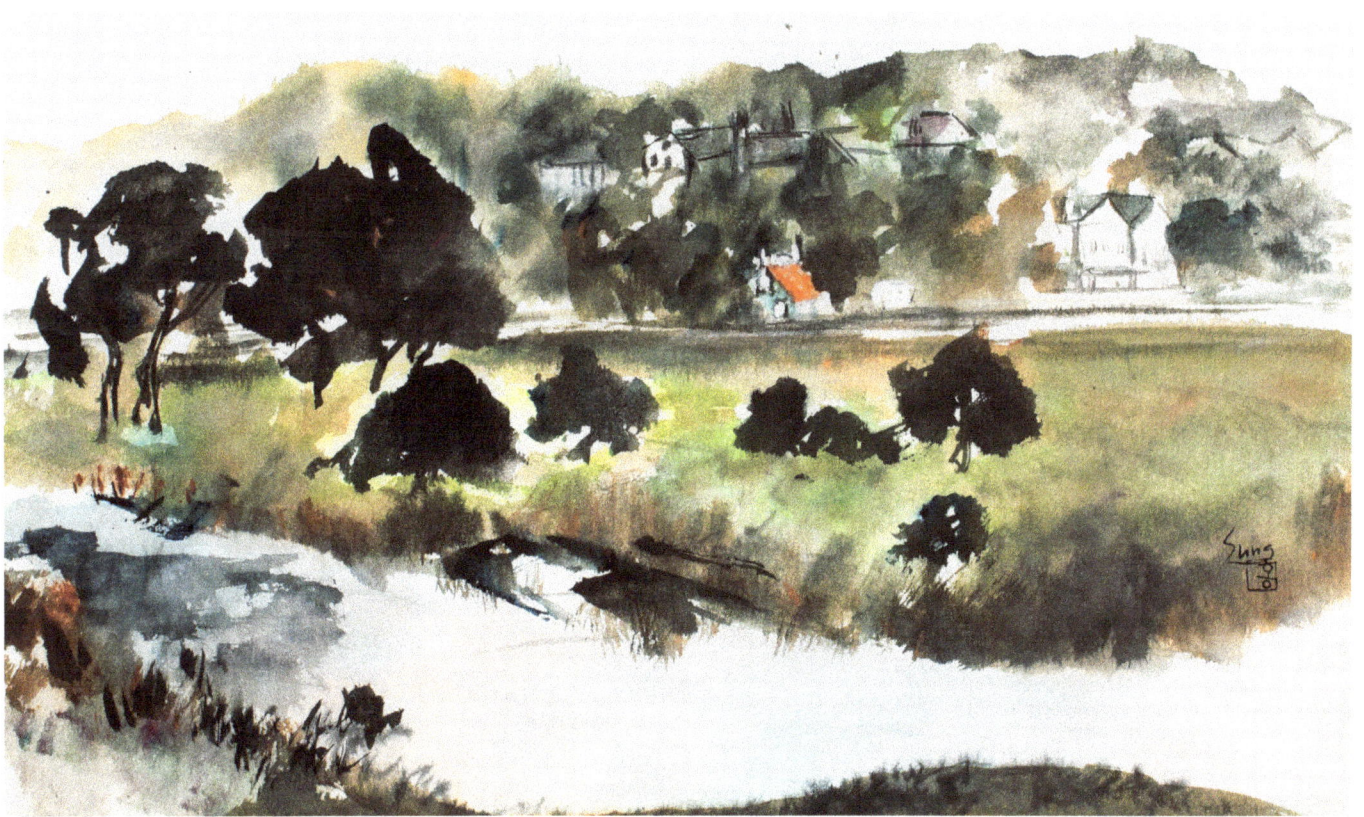

2. Occasionally I feel that I need to accentuate the appearance of water through various decorative strokes and color.

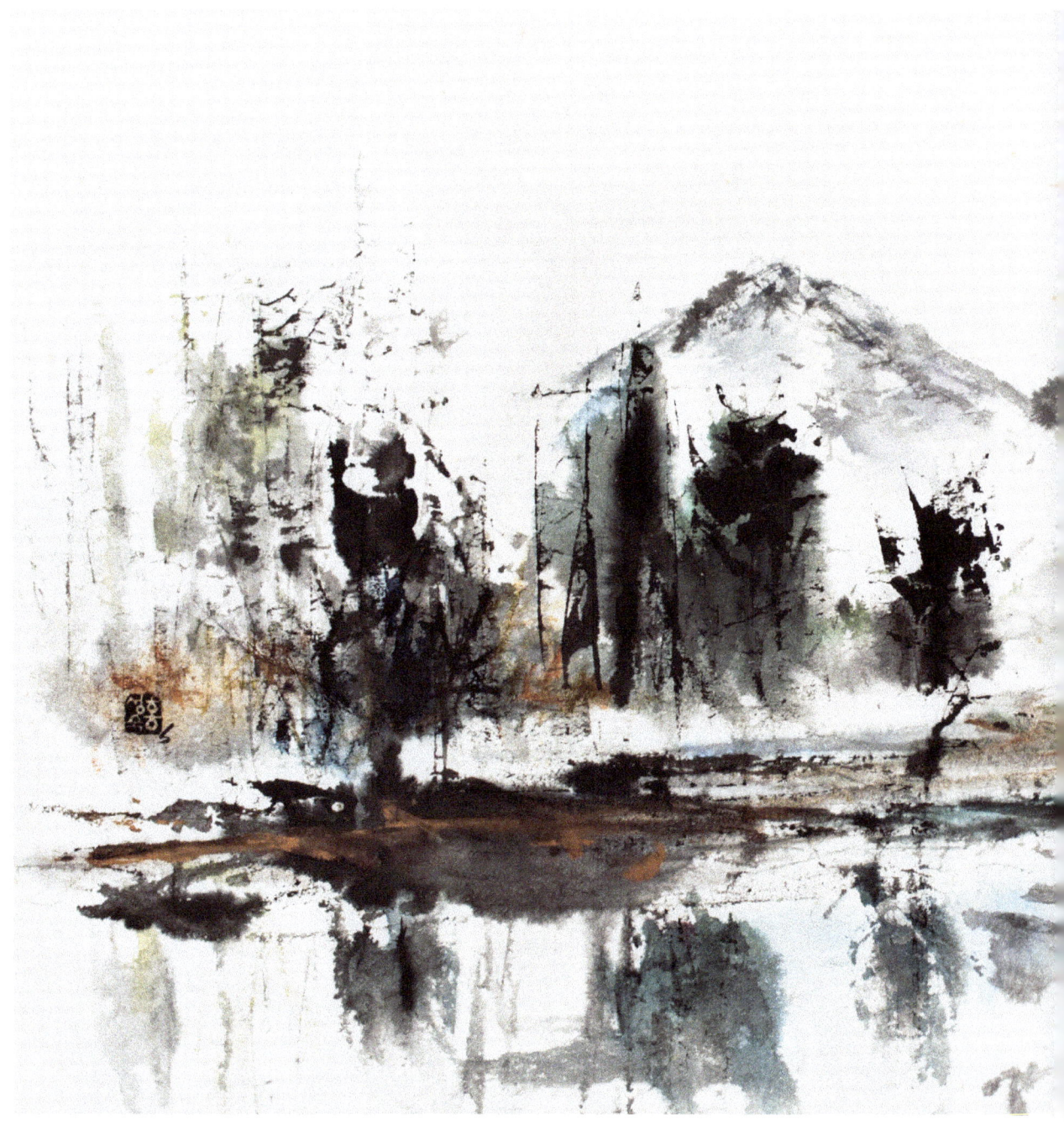

THIS ARTWORK WAS CREATED WITHOUT USING A BRUSH. INSTEAD I USED COLOR STICKS AS WELL AS TWIGS. FOR THE MOUNTAINS, I FIRST CRINKLED PARTIAL RICE PAPER AND THEN ADDED COLOR.

COMPOSITION, PERSPECTIVE, AND SPACE

For me, artistic value is something that is universal. We all can appreciate the beauty of a work of art, regardless of where or when it was made. With that said, there are many diverse ways to arrange line, shape, and color on a page, especially within different cultural traditions.

The arrangement of features in traditional water-ink painting has commonalities with Western painting, but there are also stark differences. Chinese landscapes, for instance, are typically far less detailed than Western watercolors or acrylics. The main focus of a water-ink landscape is considered the "host" of the painting, and the supporting elements are considered the "guests." With the sparseness of detail, the relationship between host and guest has to be just right, and the balance of line and space needs to be carefully orchestrated to create movement in painting. Chinese painting is about the depiction of ideas—capturing the spirit of a view. Its composition depends largely on the mood or taste of the artist. In many ways, the approach toward composition and perspective in ink painting leaves more room for interpretation than its Western counterpart. In traditional water-ink painting, the artist often uses a shifting perspective so that the eye travels from one place to another and the viewer feels like a traveler moving through the painting.

HOST AND GUEST

When I decide to paint something that I haven't tried before, I first familiarize myself with the subject in detail: observing, sketching, and photographing the subject from all sides and then studying the photographs. Perhaps I'll also find pictures in magazines or books, and read about the subject. I do this in order to internalize the nature or essence of the subject—essentially to "learn it by heart."

> Each tradition has developed its own resolution and techniques for expressing light and color, and even atmosphere. Where Western artists are acutely conscious of atmospheric light, the season, and weather, the East Asian artist tries to make a general statement of the aspects, but is subtly conscious of the line, the surface balance of the pictorial composition, and the texture of vegetation. The East Asian artist may suppress the color in order to catch nuances of line and tone. He or she rarely attempts to paint the color of anything as ephemeral as sunlight, but will use color as a decorative feature as in painting flowers.
>
> —MARY TREGEAR, FORMER CURATOR OF THE ASHMOLEAN MUSEUM IN OXFORD, ENGLAND

WHEN WORKNG ON SILK,
YOU MAY USE EITHER
DYE OR INK. THE ABOVE
ARTWORK IS DYE ON SILK.

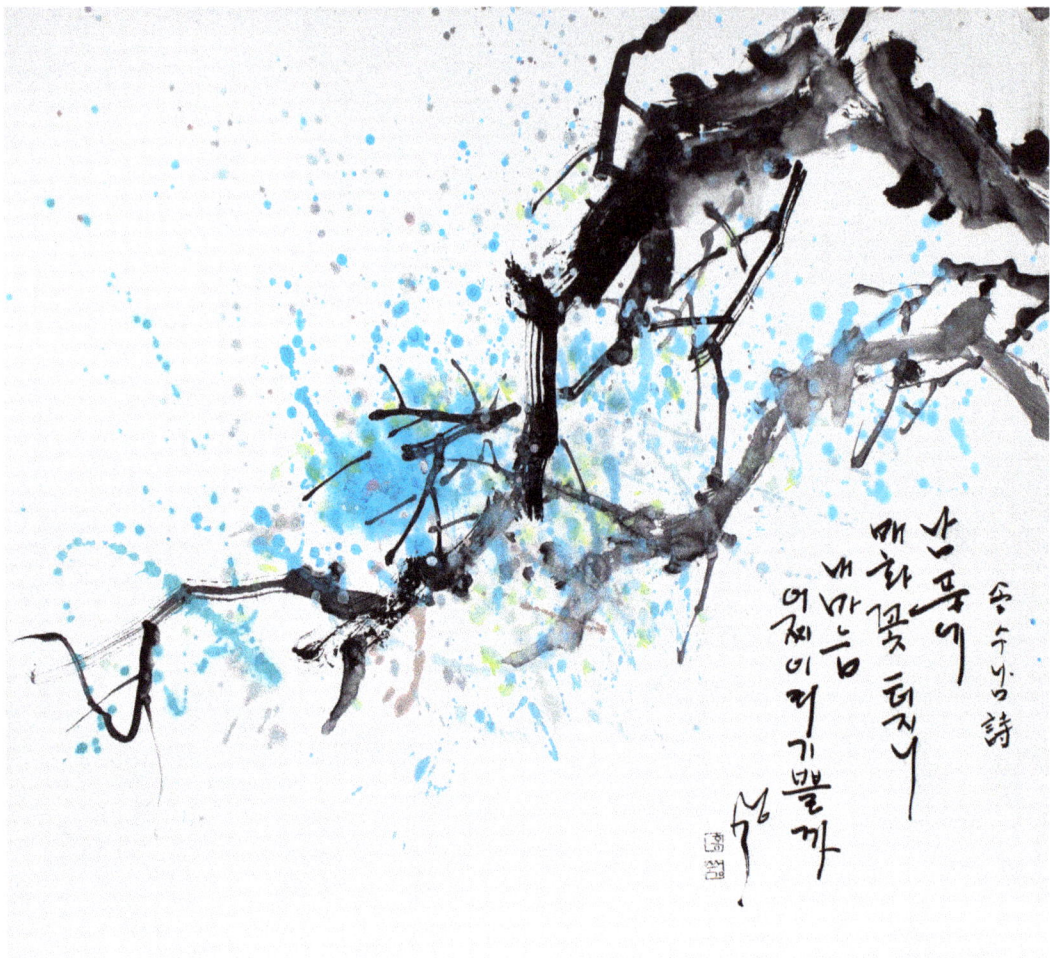

Usually I begin by painting the main focus, the "host," then add the supporting elements—"the guests"—as the picture takes shape. Depending on the situation, I can include one guest or more. Usually I begin with the foreground, then create the middle ground, and finally the background. In many landscape paintings, the elements in the foreground are expressed in a darker tone and more detail. However, in some paintings the middle ground is strongest.

After establishing the perspective, I tweak the composition of the whole, and create a sense of unity by adding different elements and washes.

This painting of a plumburst is a simple example. The thick trunk of the tree serves as the host, while the lighter branch below it is a guest. Among the plum blossoms, the main splash of blue on the center-left is the host, and the surrounding blue splashes are guests. I used Jackson Pollock's splash technique to express the fullness of the blossoms, rather than painting details of the flowers. Although plum blossom is usually depicted in white or red, I used blue to suggest the freshness of the flowers.

To balance the composition, I added lines from a contemporary poem by the Korean painter and writer Song Sunam:

Plum blossoms burst in the south wind
Why do I feel so full of joy?

Traditionally, painting, calligraphy, and poetry are referred to as the "three perfections." Combining writing with painting is an ancient, yet still common, practice in East Asian art. As early as the ninth century, Chinese art historians wrote that "writing and painting have different names but a common body." I felt that this painting would be missing something without the presence of the calligraphy. The inclusion of the poem makes the work complete.

COMPOSITIONAL ELEMENTS

When I compose a painting, I need to think about many contrasting elements—big and small, density and spaciousness, far and near, heavy and light—as well as a variety of angles and views. At the same time, I make sure I have enough contrasting elements in the design, tones, and colors. The most important thing for me to consider is the empty (negative) space distribution. The harmonious distribution of empty spaces within the shapes and lines of a painting create a sense of movement. The breathing spaces between the strokes are crucial. When you observe and emulate the work of many masters, you can naturally acquire a sense of composition over time.

CAPTURING THE ESSENCE

One of my teachers used to tell me that ink painting can be compared to "drinking fresh water." Fresh is best, and in order to retain that in a painting, I rarely retouch my brushwork. However, I frequently do a number of paintings of the same subject before I achieve the one that's "fresh." I often begin by painting in detail, and gradually eliminate detail in later iterations of the painting. I usually like the simplified version best, due to the mystery of the emptiness.

White spaces are opportunities for reflection and response in an ongoing conversation. The more I paint, the more my imagination seems to grow in the empty spaces.

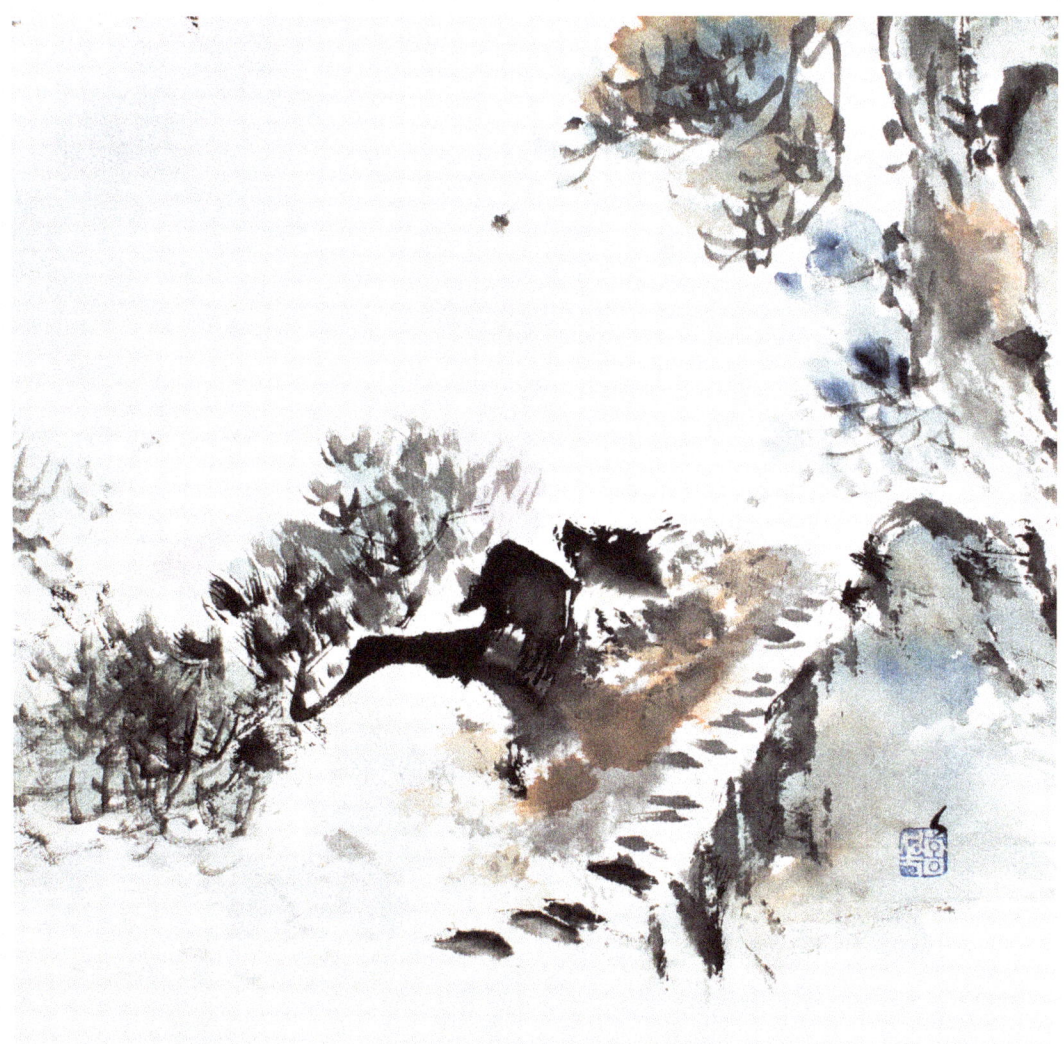

Spring

In early Spring, the world is full of subtle shades of green interspersed with specks of color.

WILLOW TREE

This tree welcomes Spring. Gentle breezes accentuate the slender gracefulness of the branches.

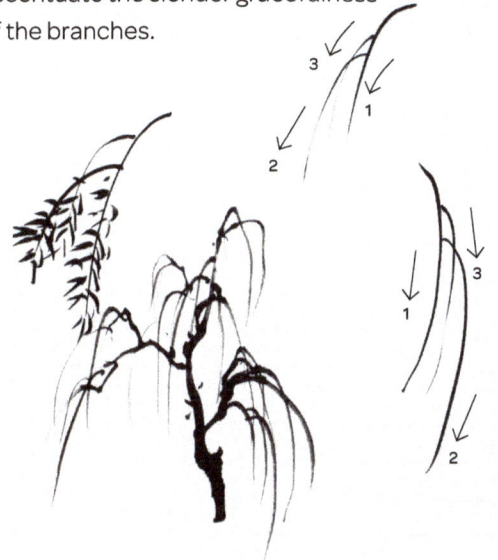

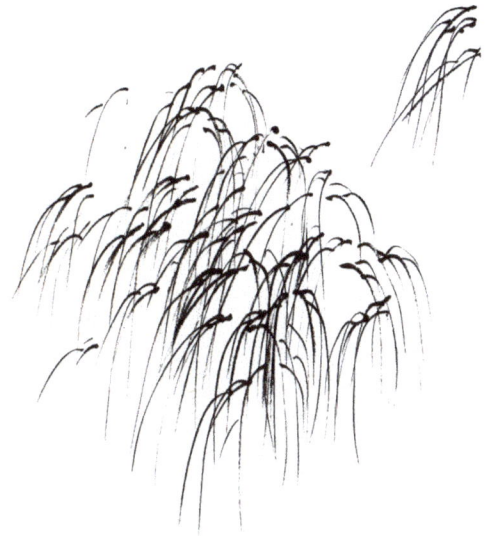

1. Follow the order depicted by lines 1, 2, and 3. Brush strokes need to be gently lifted toward the end of the stroke, like wild orchid strokes.

2. Repeat the lines 1, 2, and 3. The foreground strokes need to be darker and bolder, whereas the background strokes become smaller and muted.

3. I usually paint the willow branches first because I like to establish the three-dimensionality of the tree before adding the trunk. If you paint the trunk first, leave white spaces for the branches and leaves. Paint the branches and leaves with split brush strokes, using a slightly different tone of green.

I added a boat to enrich the landscape and convey a sense of distance. The background is less detailed and somewhat blurry.

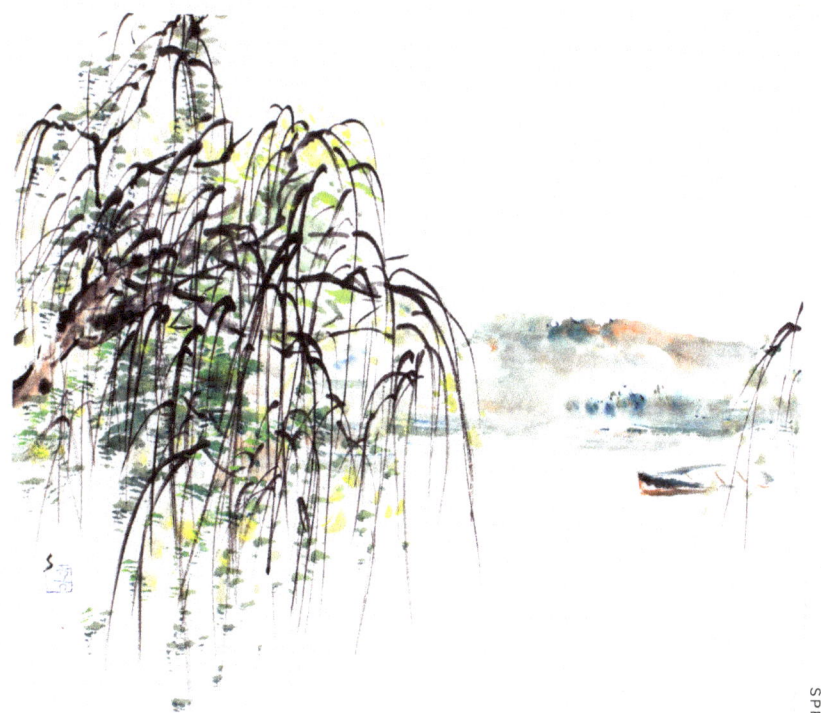

SPRING BRANCHES WITH BIRDS

Forsythia dresses up early for spring. She dazzles us with bright yellow tones that gently turn to green.

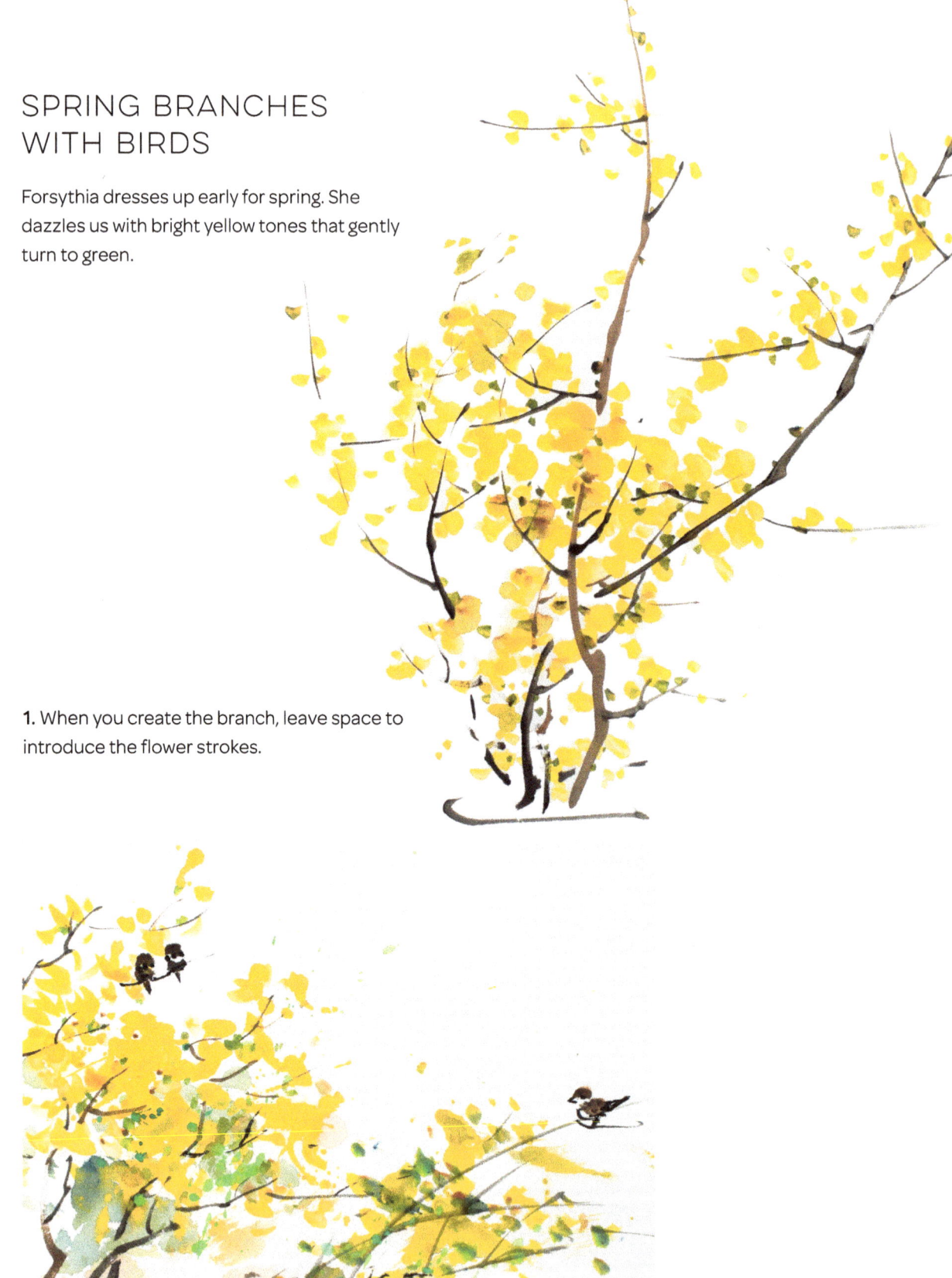

1. When you create the branch, leave space to introduce the flower strokes.

2. I painted the flowers with a splash technique, then added the small sparrows.

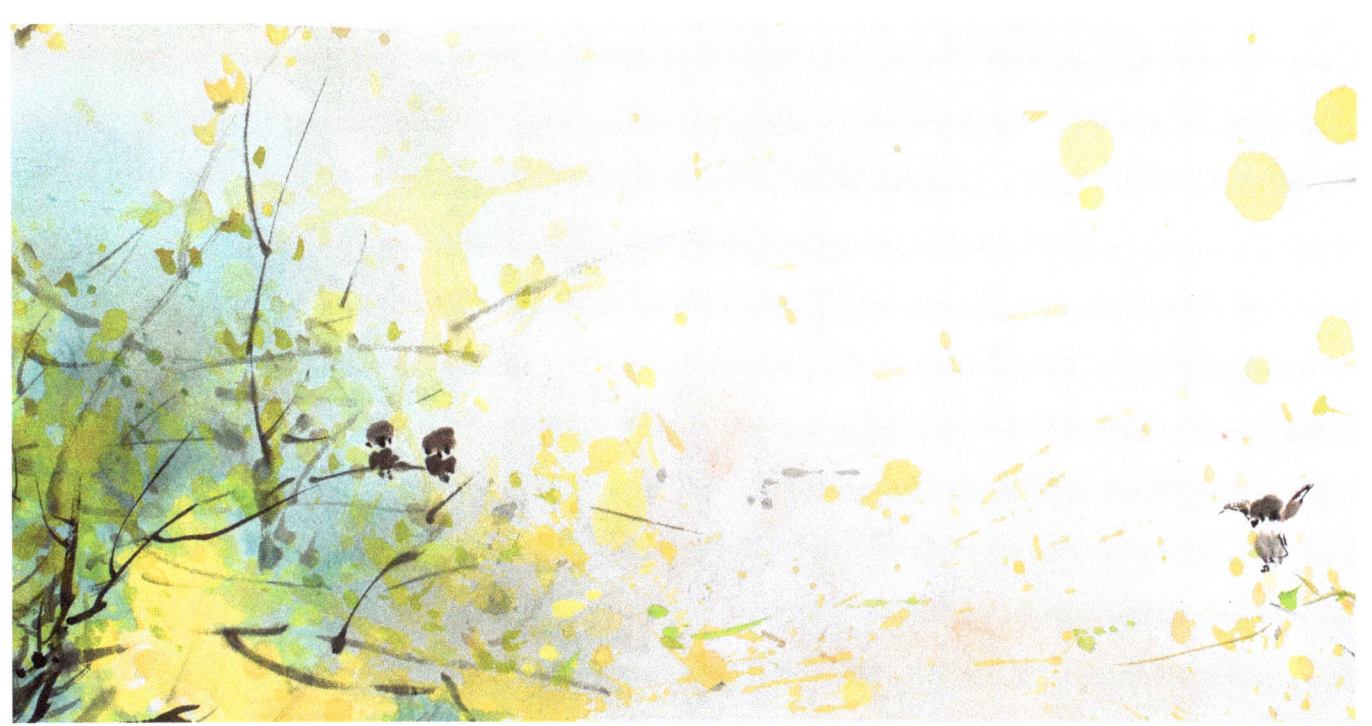

Examples of sparrows with a different kind of tree.

POND WITH DUCKS

I often take long walks along a pond near my home. The many ducks, swans, turtles, and rare birds make it so lively.

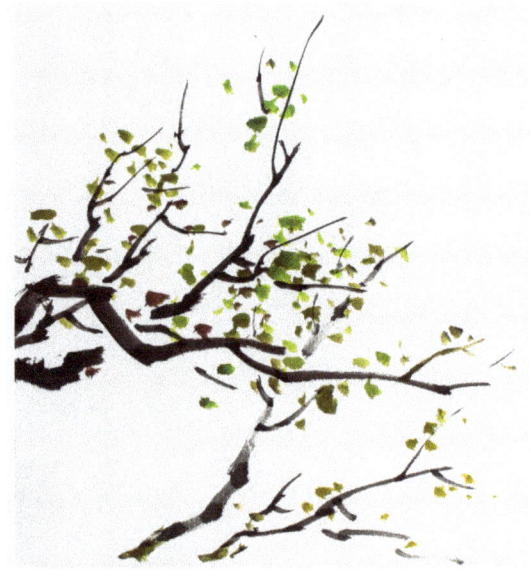

1. I create the branches first, then follow with leaves in many soft shades of green.

2. I add the background foliage, and then the ducks paddling in various position.

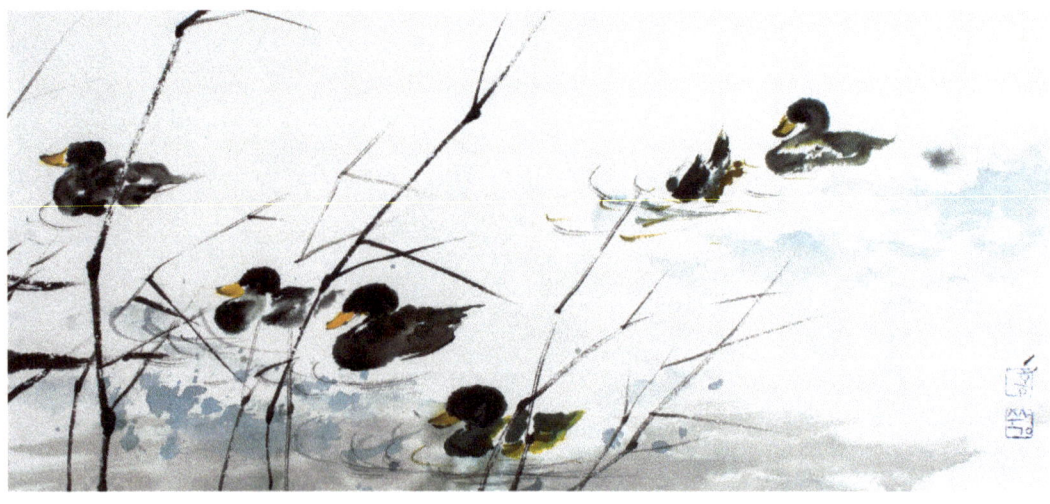

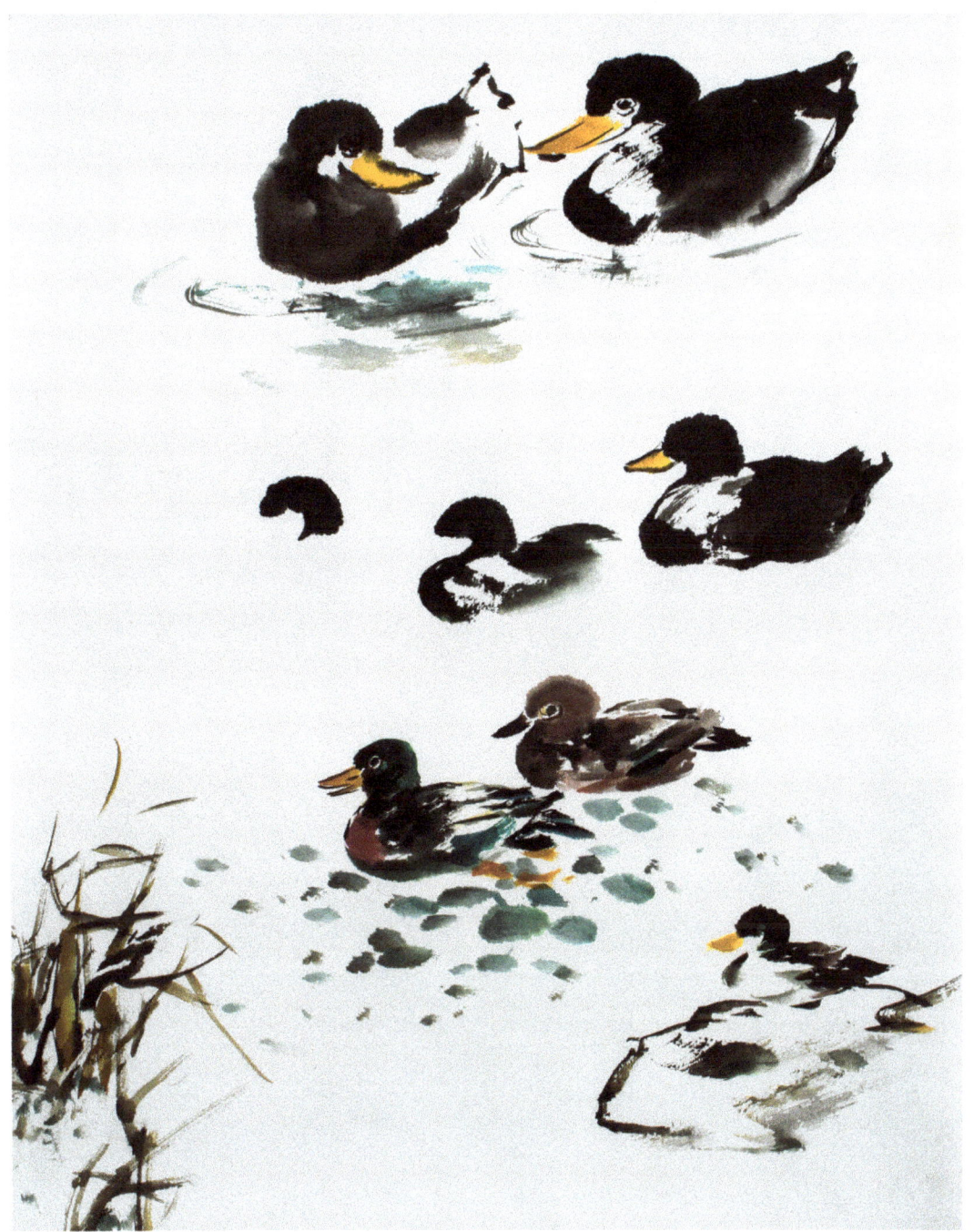

Ducks signal the beginning of spring. Although it is not easy to capture the movement and posture of ducks, it is a joy to observe them swimming. I like to imagine that I could fly like them.

When they swim, a duck's body shape looks like the number two (2). Use a brush to practice writing a number two, fluidly and without breaks. To obtain the right texture, lift the brush a little when you depict body parts.

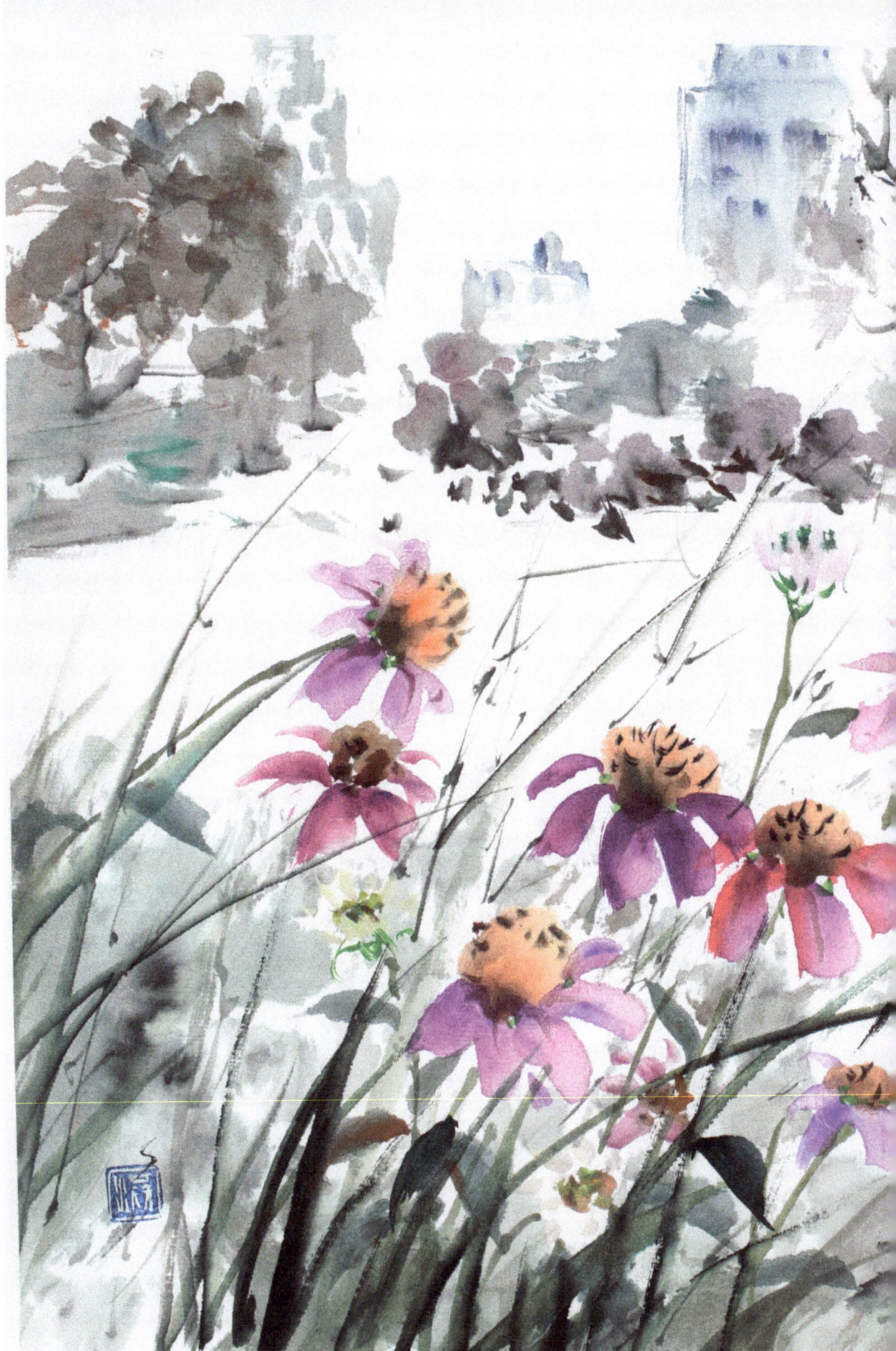

Summer

Although I love all the seasons, I particularly enjoy the Summer when I become immersed in tending my wildflower and vegetable garden, as well as strolling on the beach.

AVALON GARDEN: ECHINACEA AND DRAGONFLIES

The idea for this painting came to me after several visits to a walking trail, where I photographed and sketched a meadow. I also planted several different colors of echinacea in my garden, along with other wildflowers.

1. Paint the center of each flower first, and then the petals. Create a variety of echinacea flowers—mature ones losing their petals, and very young ones, just opening. Paint them from different angles. Add a second variety of a different color wildflower to make the painting more natural and interesting.

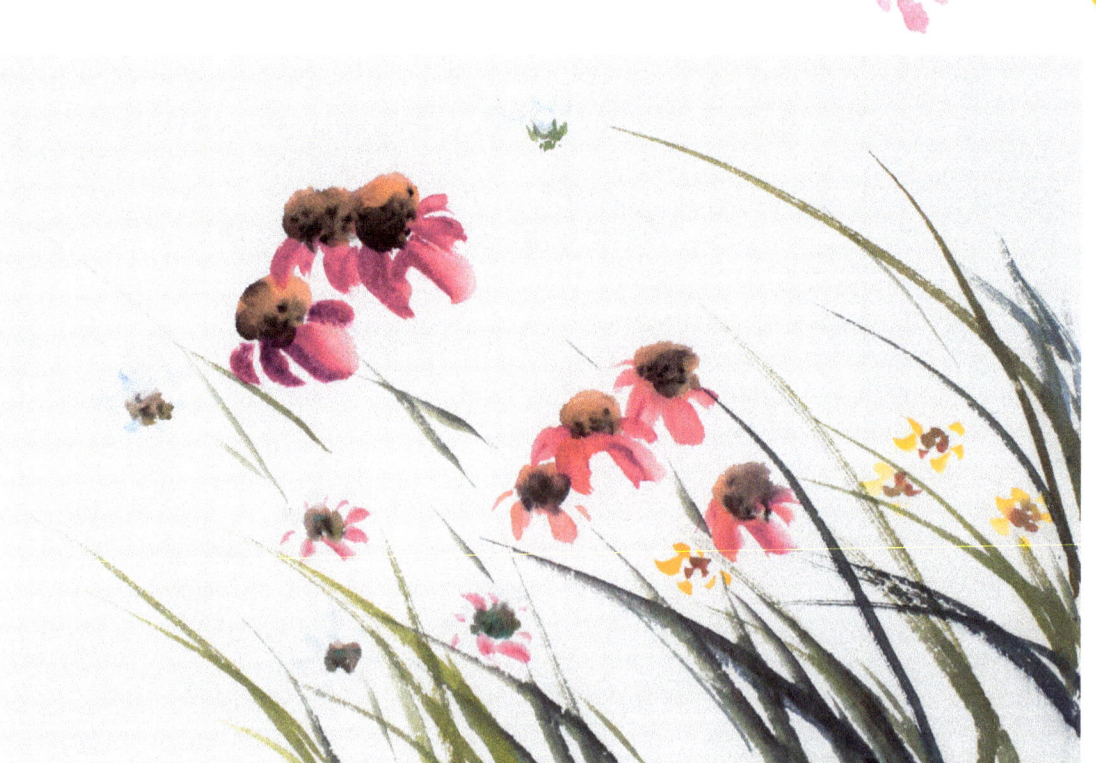

2. Use orchid strokes to paint the grass. Add the stalks of the flowers with vertical strokes, then add the leaves.

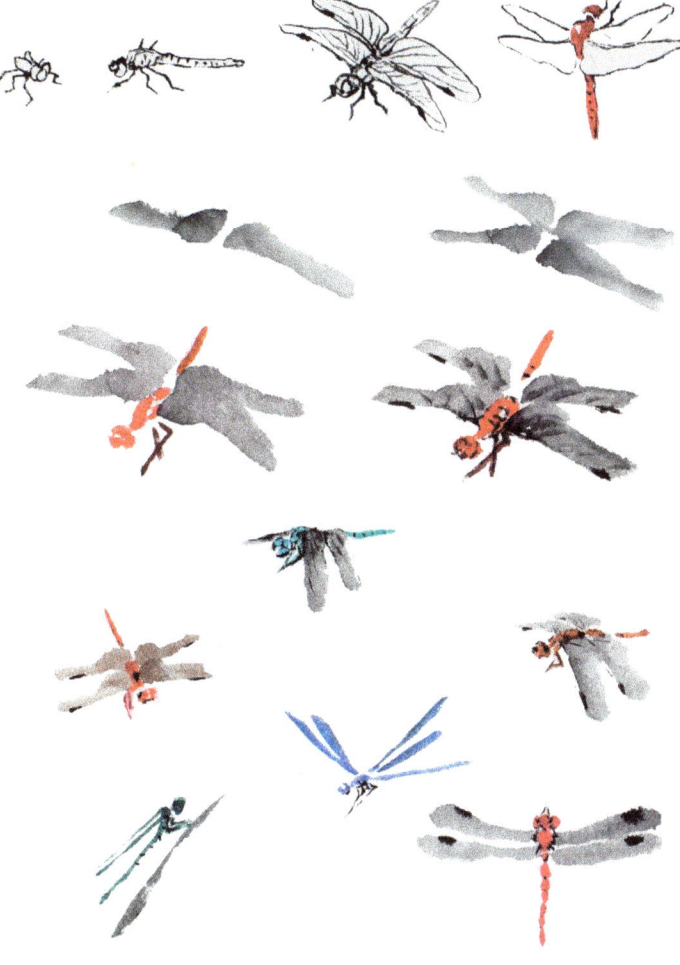

3. Practice painting dragonflies or other insects until the brush strokes feel natural to you.

4. In the middle ground, paint dragonflies at different angles. Start with the wings, then add the body, head, and legs. Add detail accents to the wings while the brush strokes are still a little wet.

 Lastly, create the background. Let it remain barely defined, so that the flowers and the activity of the dragonflies stand out.

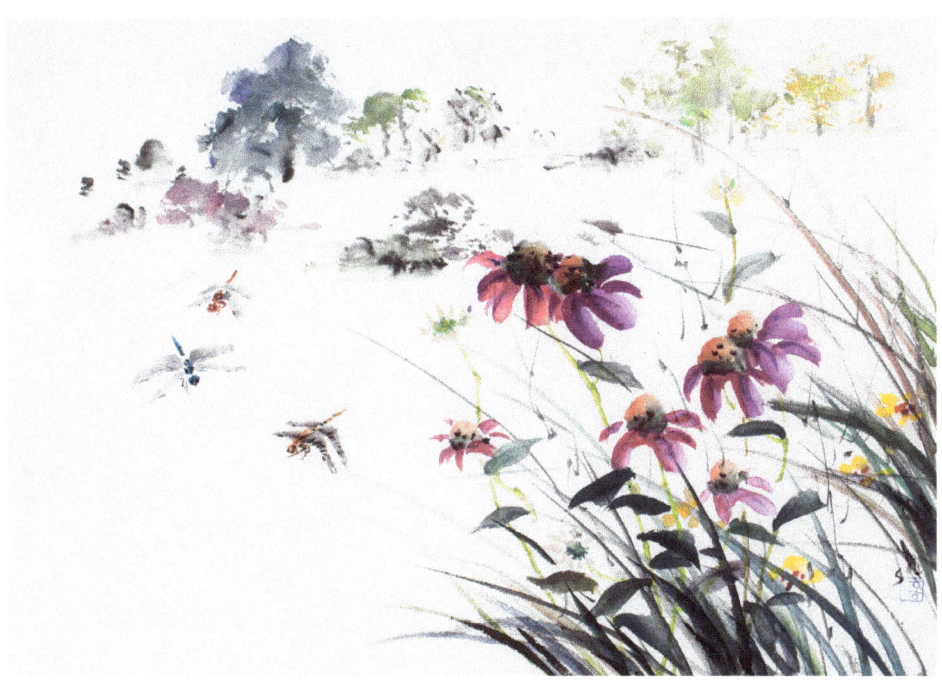

DUNES

The beaches near my home are dotted with sand dunes and the delicate flora that decorate them. Here are several different examples of reeds.

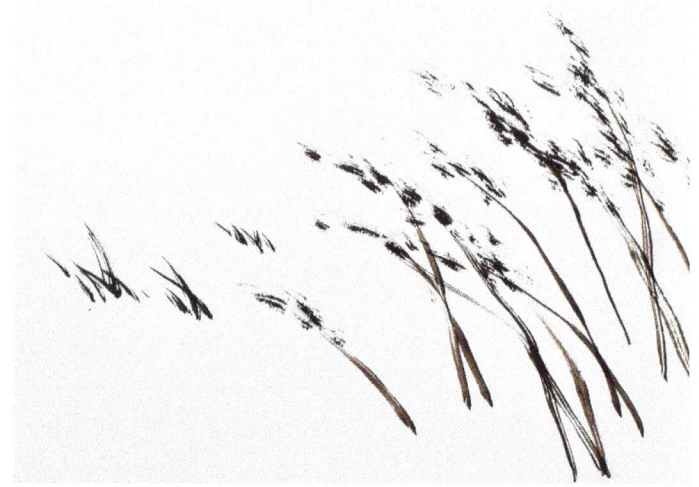

1. I create a pattern of stalks.

2. Convey the texture of blooms by using a split dry brush.

3. Add expression of water and sky by using a hake brush or a large, soft brush.

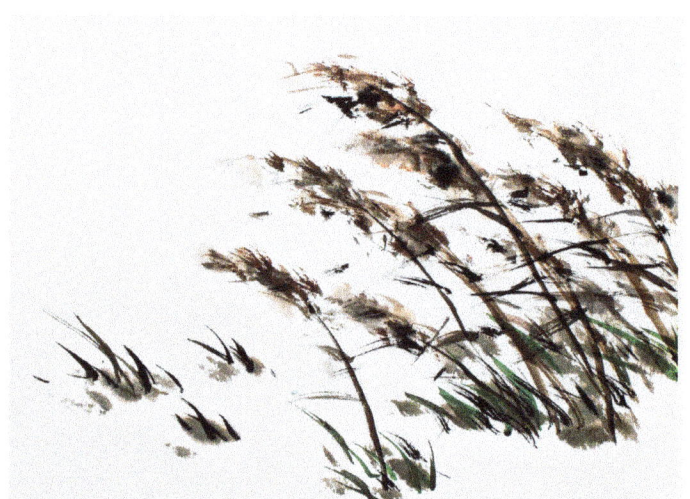

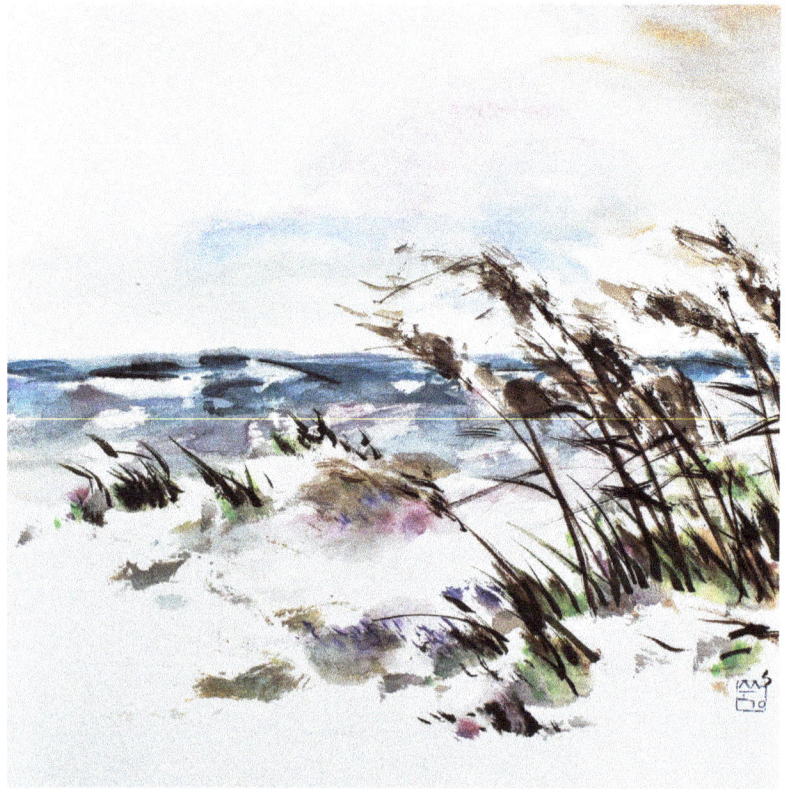

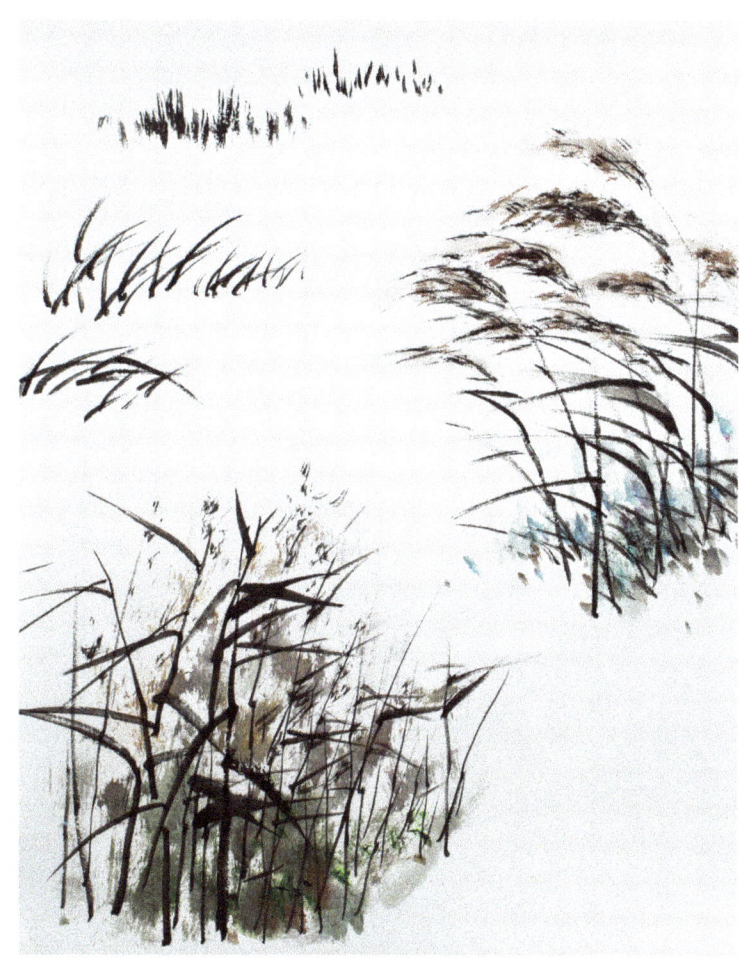

BELOW: ANOTHER DUNE SCENE WITH SUMMER FLOWERS

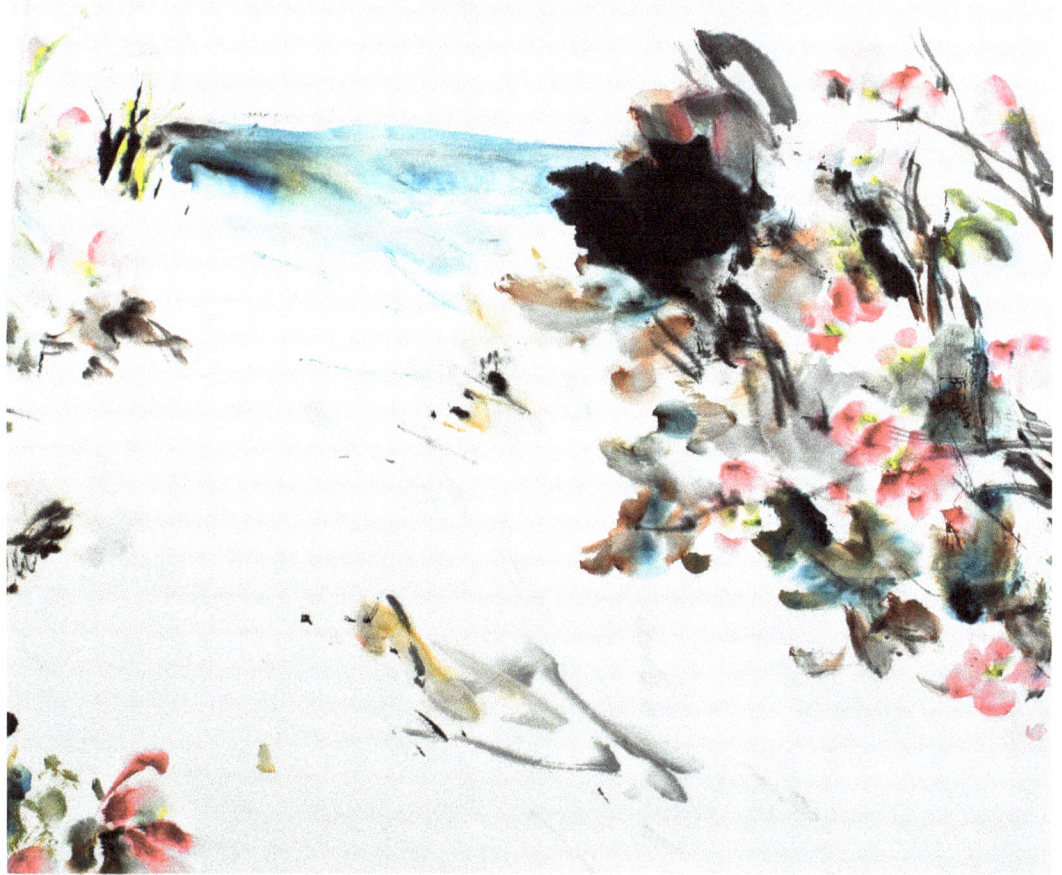

BANANA PALMS

I began sketching this topic when I visited my mother-in-law in the South of France. I love to sit outdoors in cafés and sketch.

1. I used a full side brush to create the leaves. I split the work into two halves to introduce two different ways to capture banana leaves.

On the left, I suggested two lines to express the direction of the leaves. On the right, I created the leaves without any line suggestions.

2. Create a sense of place by adding a boat as well as distant flying birds.

3. Express water, using a wash and the hake brush.

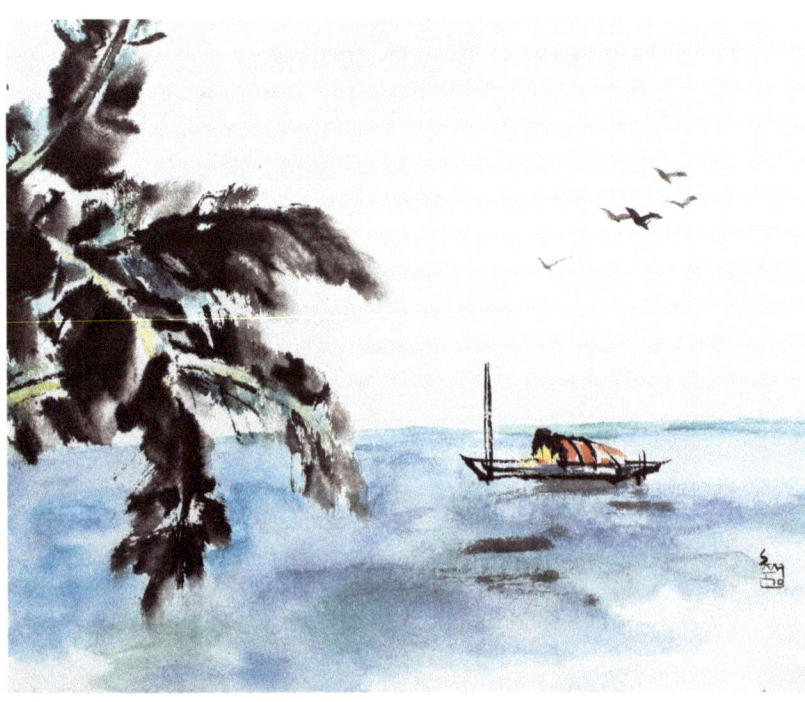

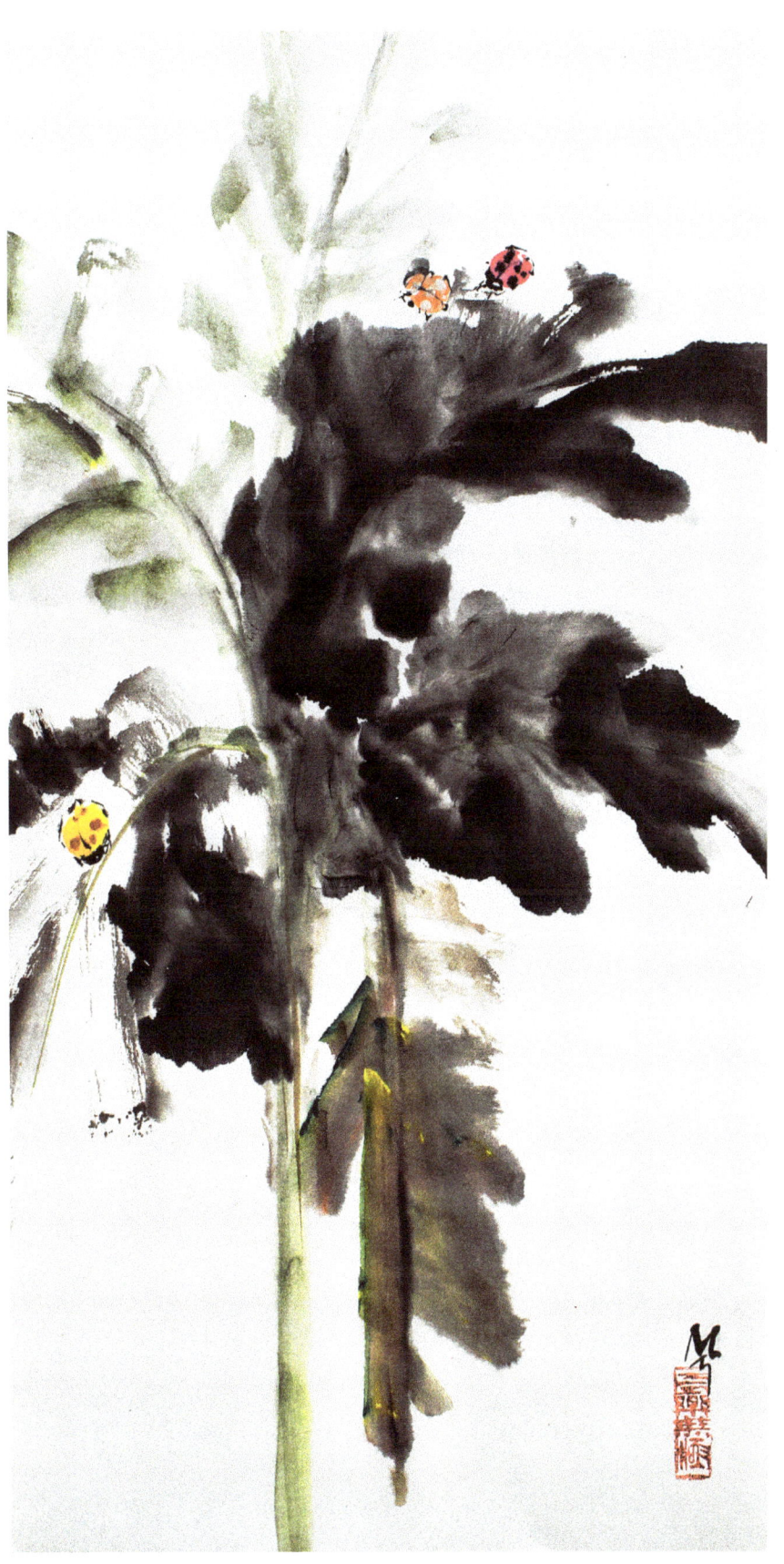

Fall

Traditionally, ink painters use relatively subdued colors, but after I arrived in the United States, I was amazed by the riotous colors of Fall landscapes. I was inspired to absorb them into my work.

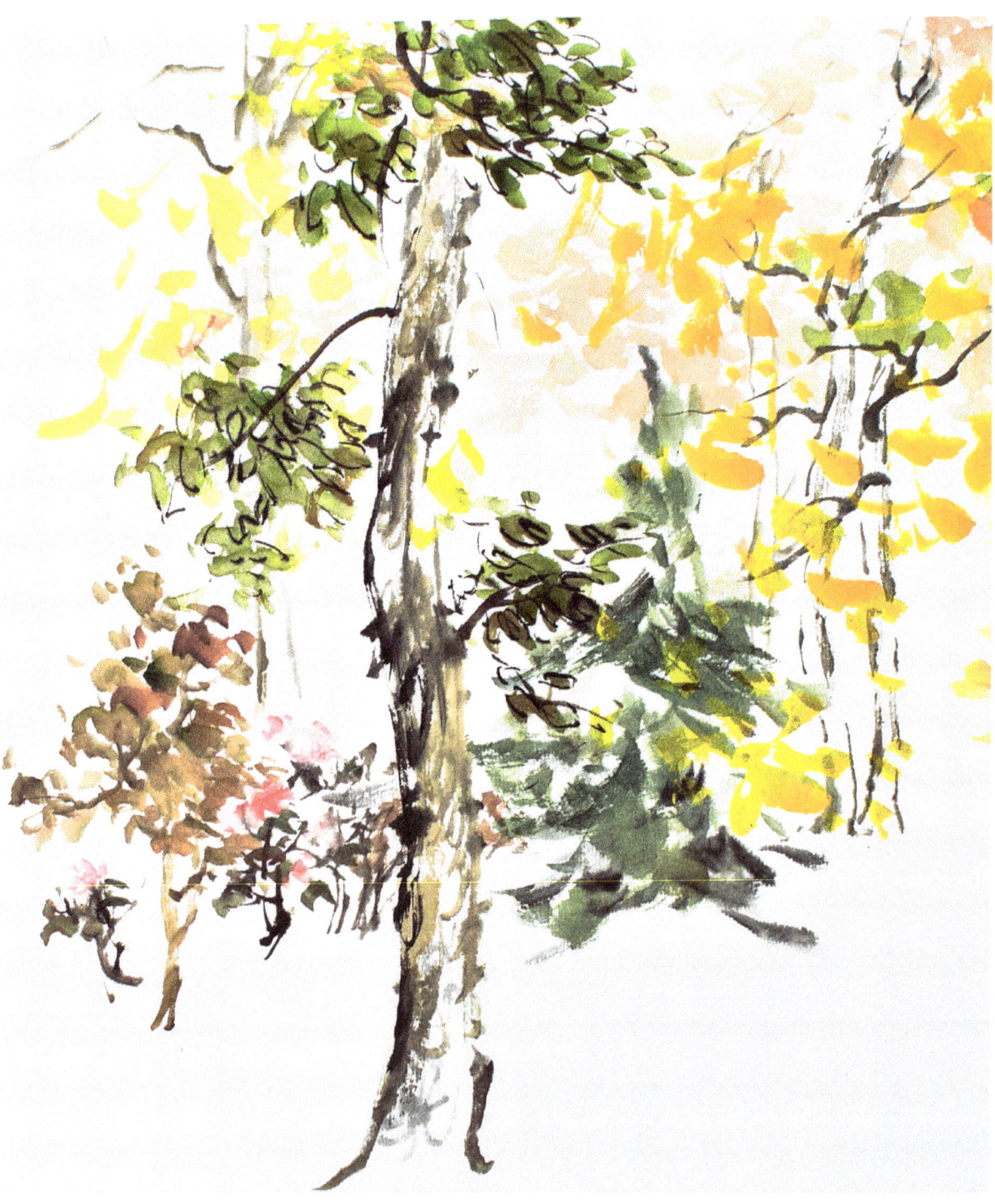

FALL AT THE BEACH

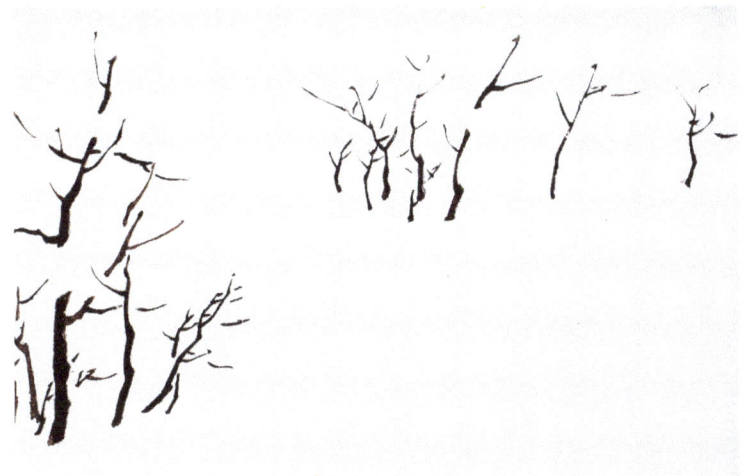

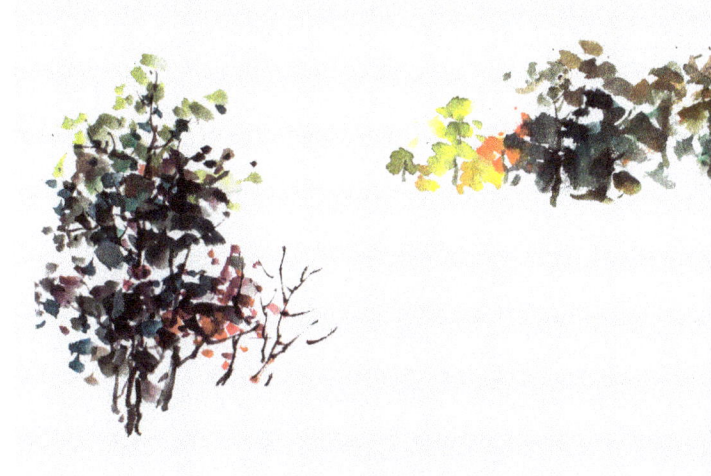

1. I created a group of trees in the foreground and a contrasting group in the background.

2. I added Fall color foliage to the branches.

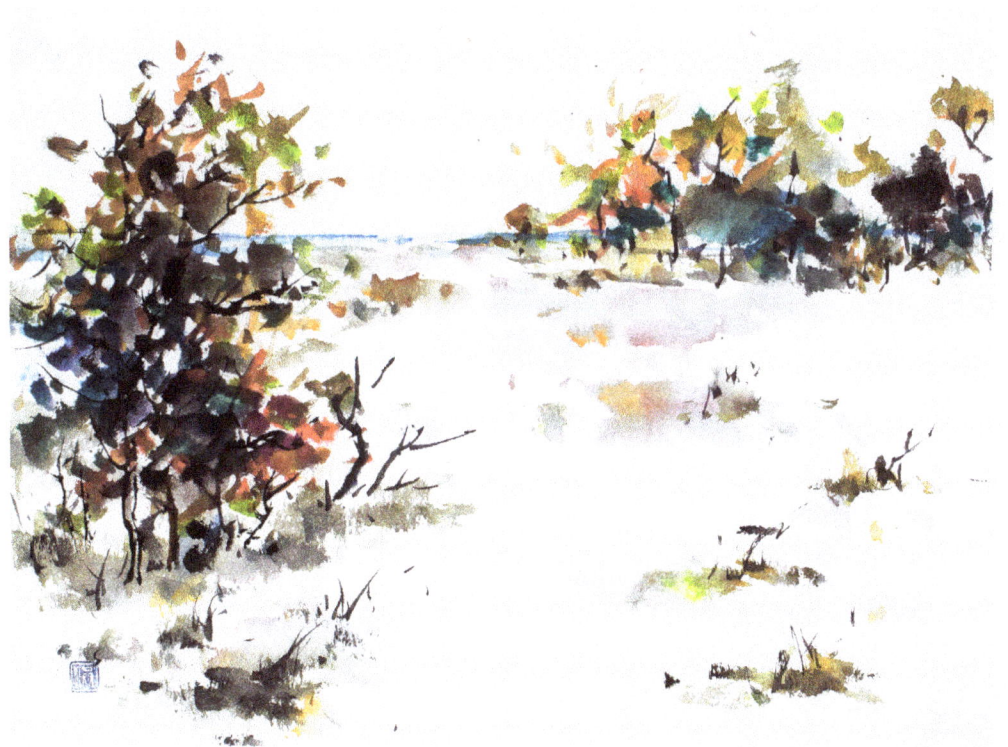

3. I introduced washes to depict the ground under the trees as well as the dunes, and included some clumps of beach grass. Lastly, I created an impression of distance with the use of minimal water washes.

SILVER BIRCH TREE

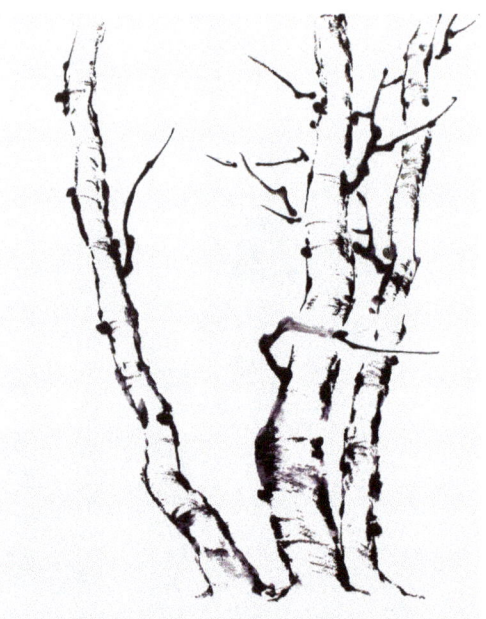

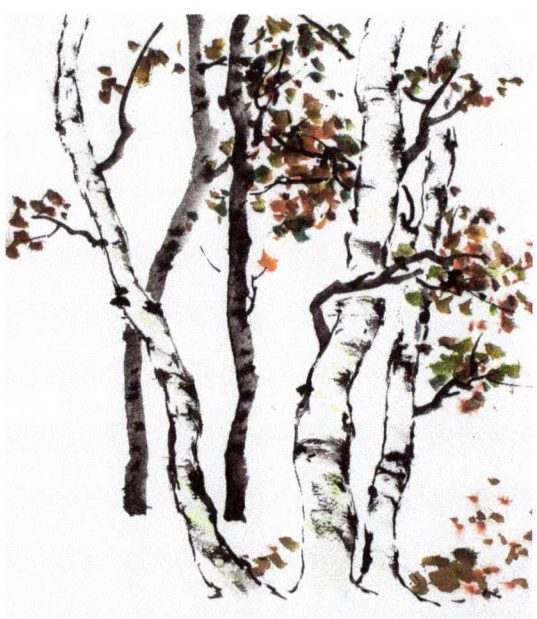

1. I used gentle side-brush movements with a broken texture for the outlines of each tree, leaving spaces on the trunks for the branches in front. Afterward I added branches in back.

2. I added birch trees in the distance with thinner wash strokes, then added texture with darker ink and some Fall foliage.

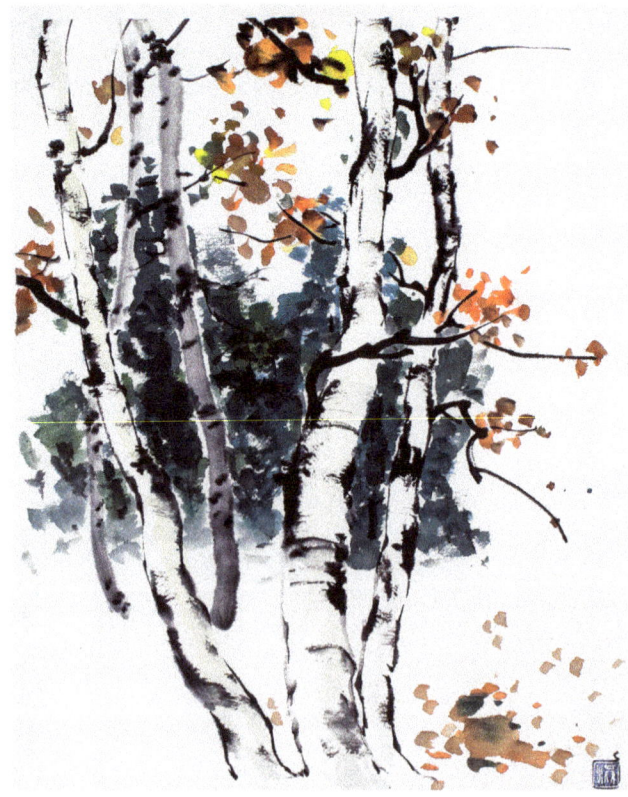

3. Then I added a clump of bushes in the background, which conveyed a sense of perspective.

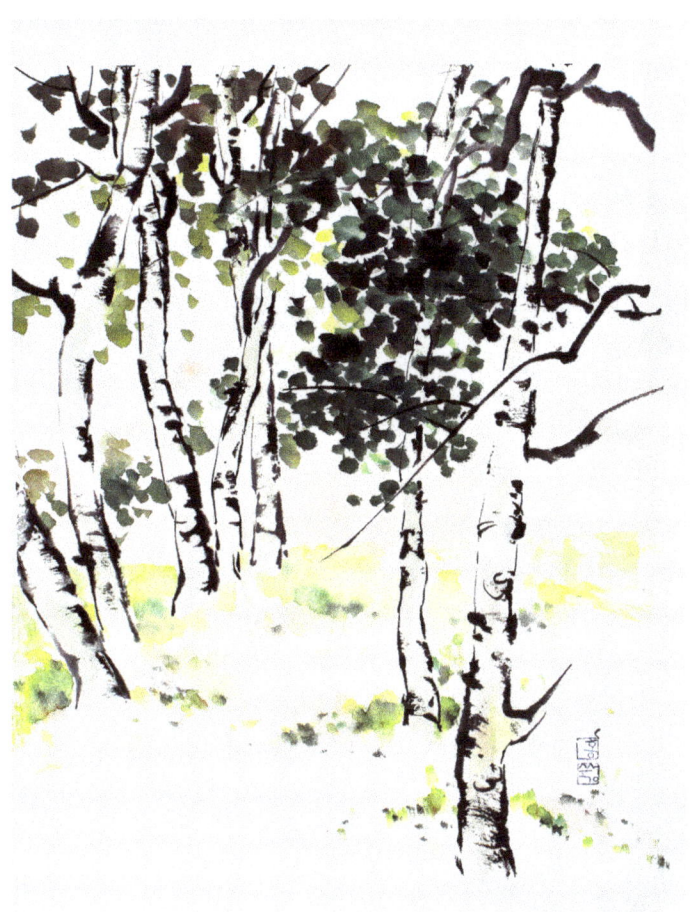

A VARIETY OF SPRING BIRCHES

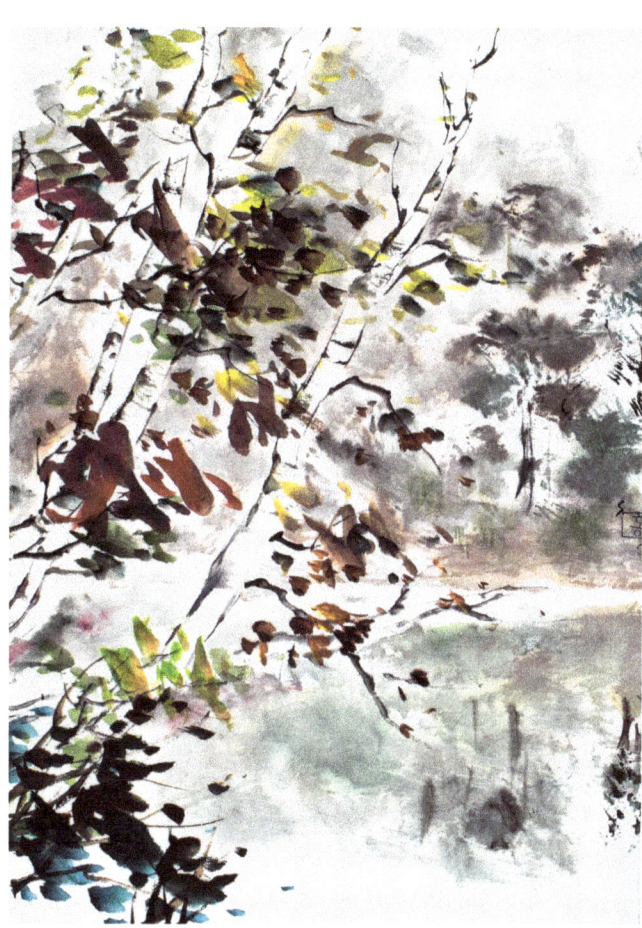

FALL BIRCH TREES SURROUNDING A POND

MAPLE TREE

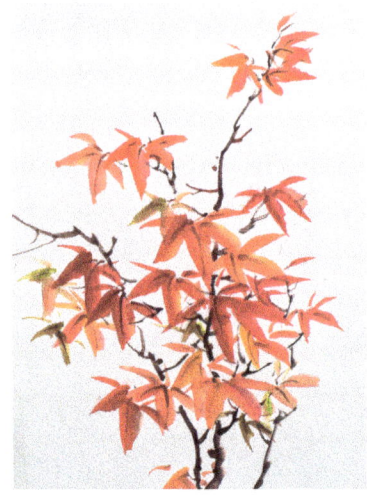
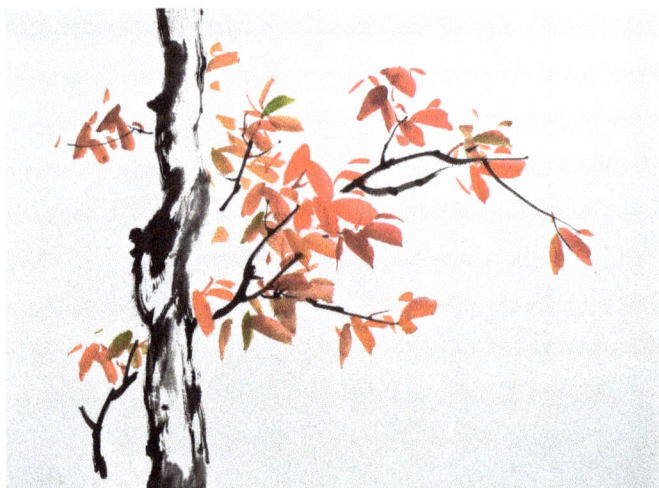

1. Host groupings of leaves are expressed using broader strokes and bolder colors. I usually depict the branches first and allow spaces for the leaves in front. Afterward I added branches in back.

2. I created the large, old trunk first, then added small branches behind the trunk, followed by some leaves.

3. Behind the maple branches, I created smaller trunks as well as rocks and ground reeds. I added branches extending from trees outside of the picture.

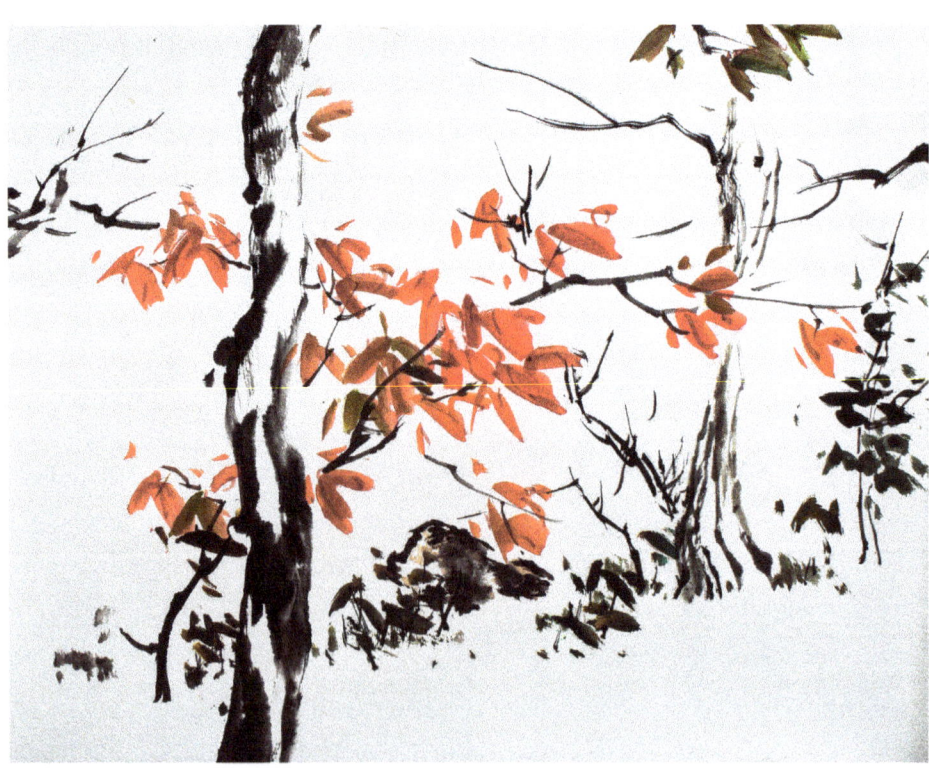

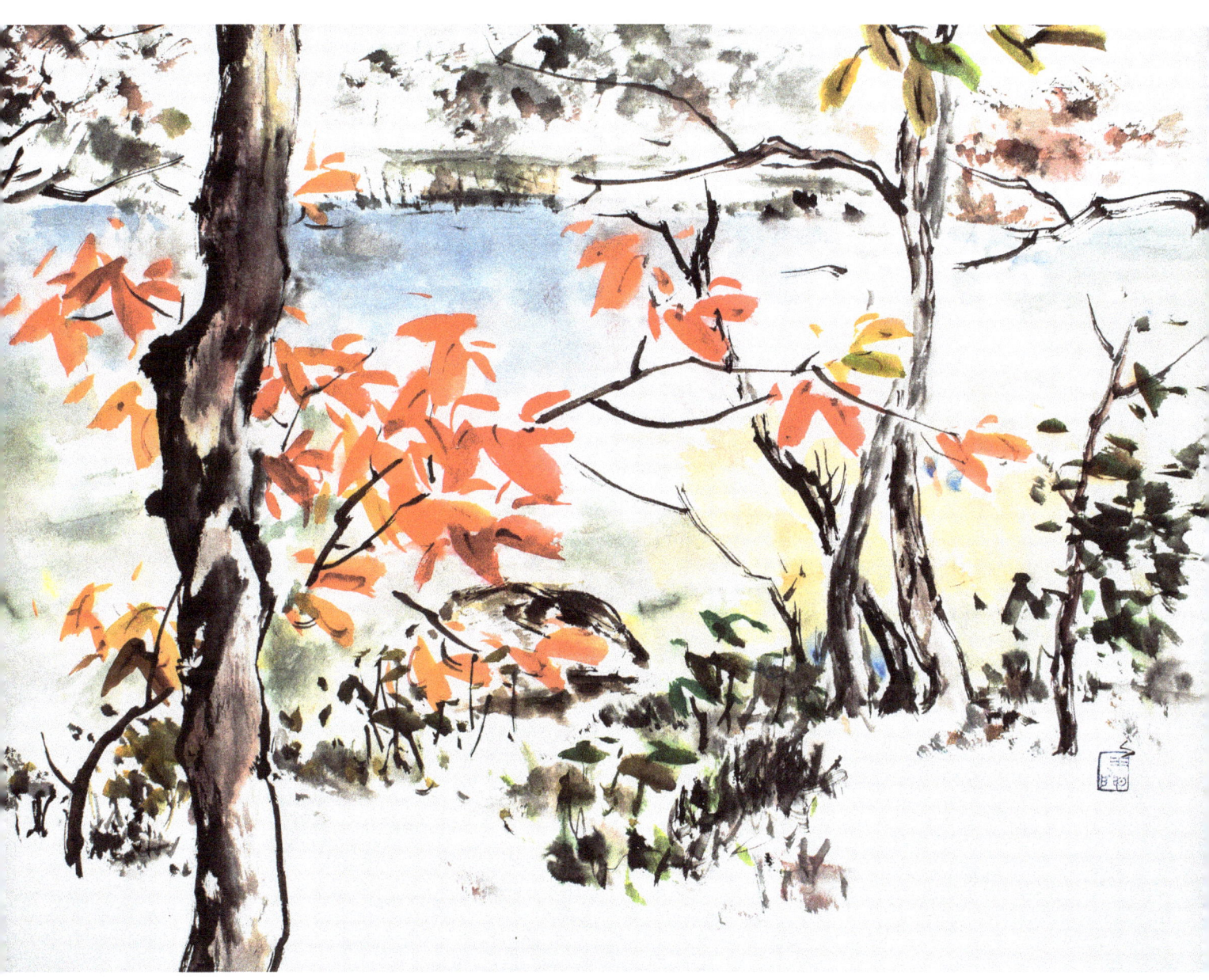

4. I introduced the foliage of distant branches, as well as background scenery with less-detailed strokes. And, finally, I added water washes.

Winter

Winter scenes clear my thoughts and fill me with a sense of peace as the whole world seems to slow down.

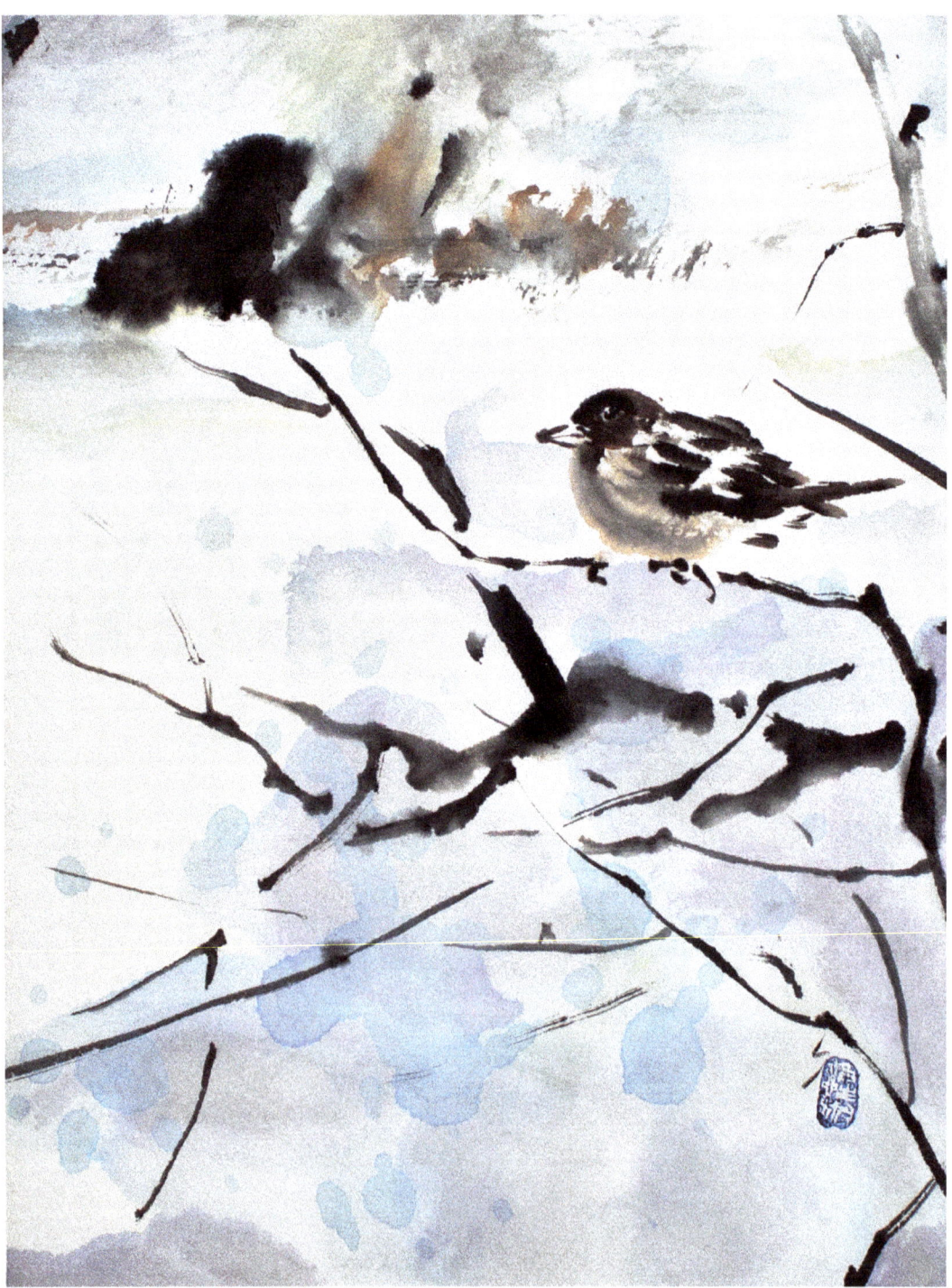

SNOW-COVERED PINE NEEDLES

1. To convey an impression of snow, I created a gap between the branch and the pine needles. Blank spaces are effective in creating the idea of snow.

2. I depicted partially hidden rocks in the foreground. In the background, I created two groups of trees far enough away to convey a sense of snowy expanse.

3. To emphasize the whiteness of the snow, I added blue washes, then splashed white gouache over the blue.

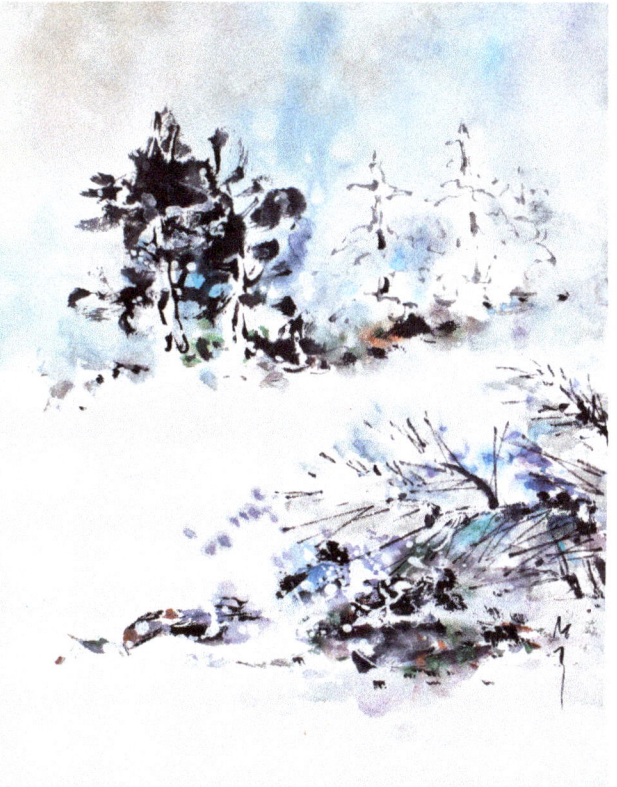

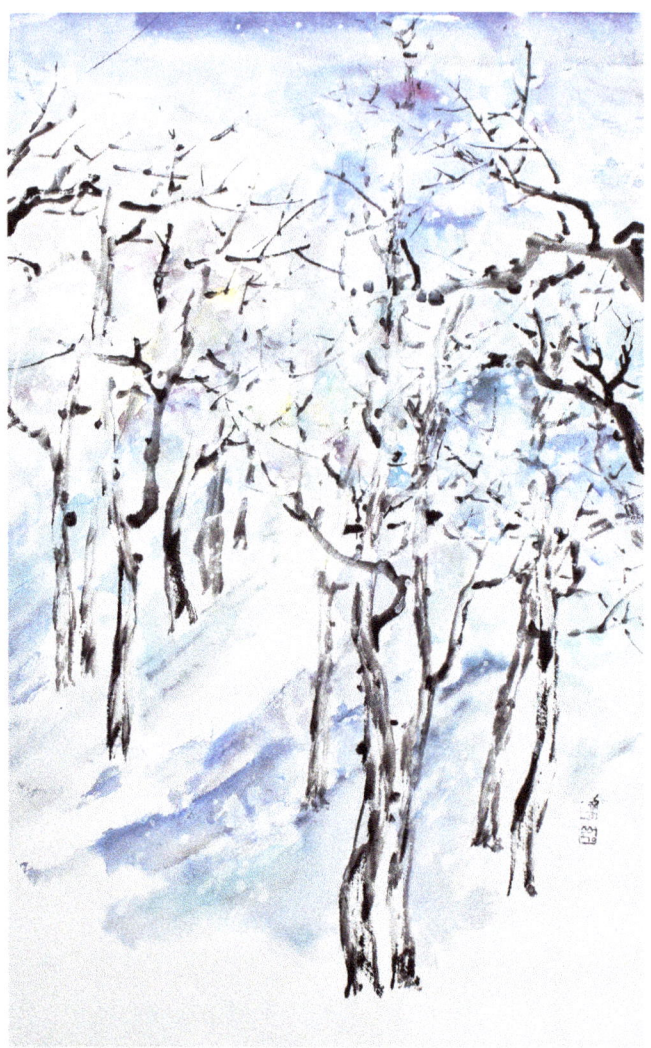

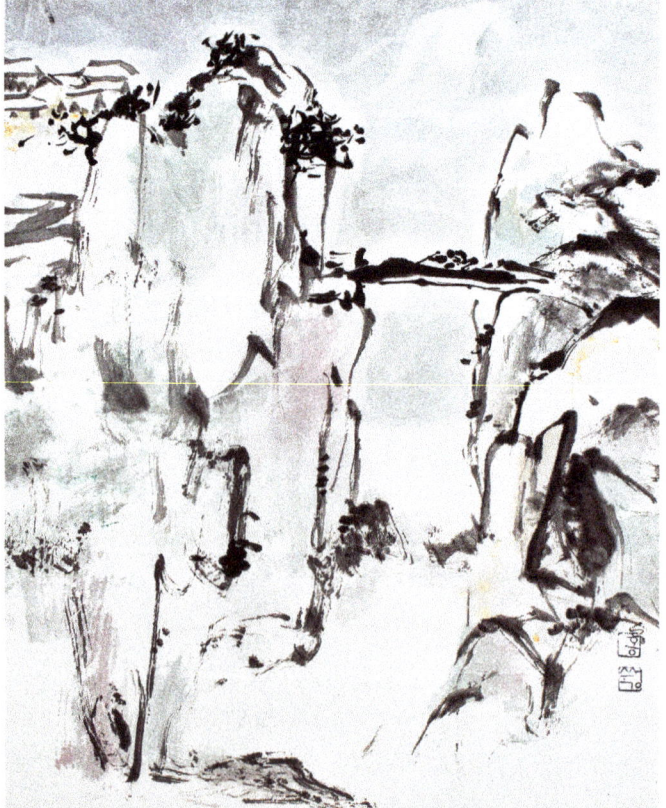

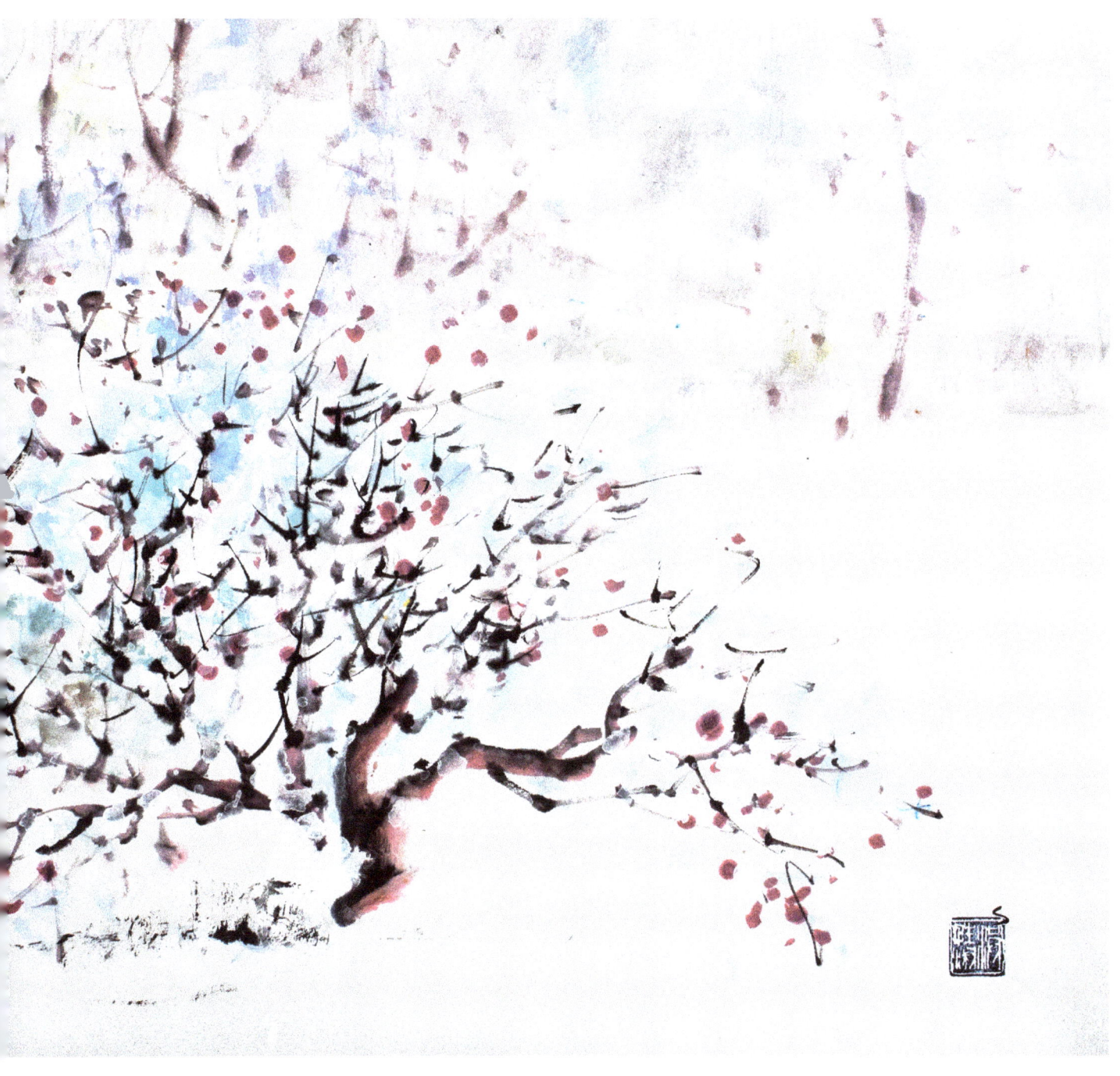

OPPOSITE ABOVE: SNOW IN THE FOREST
OPPOSITE BELOW: SNOW IN THE MOUNTAINS
ABOVE: WINTRY PARK

CENTRAL PARK

When I am in New York City, I often visit Central Park, which is like an oasis for me. I love the natural, lush landscape juxtaposed against the backdrop of skyscrapers and brick!

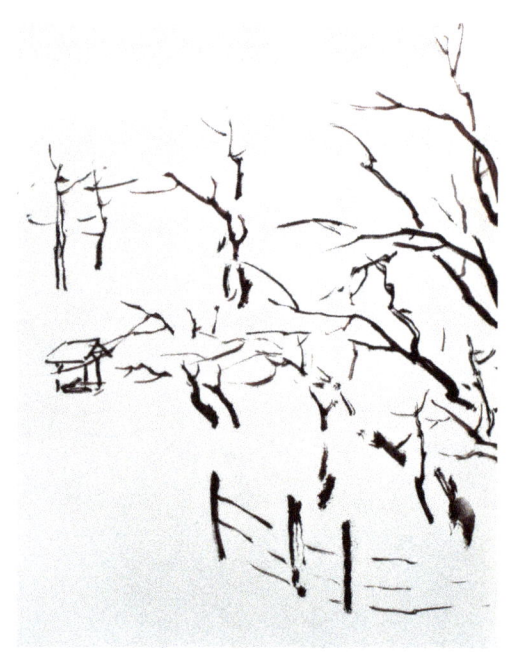

1. I began by creating the basic structure of trees, from the foreground to the background. Then I added the fence.

2. I painted the buildings, followed by a tiny pedestrian wearing a red coat. Then, using faded bluish washes, I depicted the winter sky.

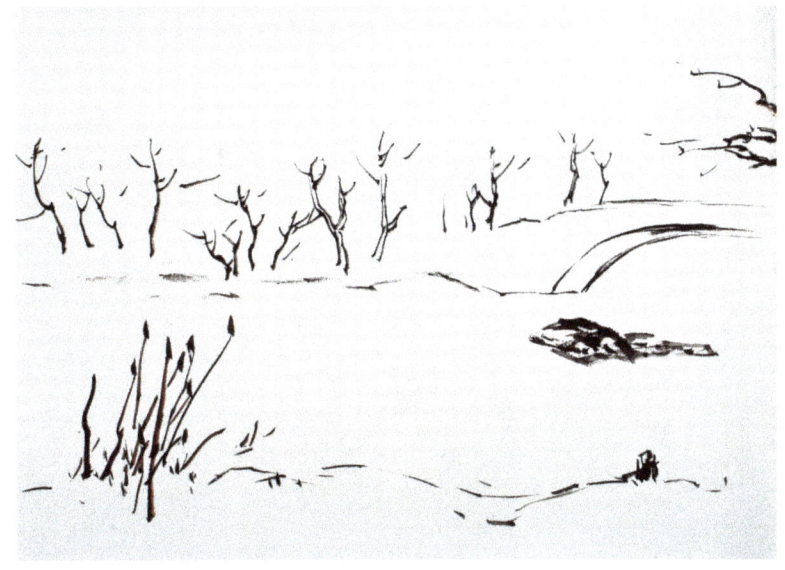

1. I created the basic tree structures from foreground to background, followed by a bridge.

2. I added buildings behind the trees, then filled in wintry foliage. The sky and pond completed the work, along with some washes in the foreground to portray a snowy effect.

MORE PARK AND CITY VIEWS

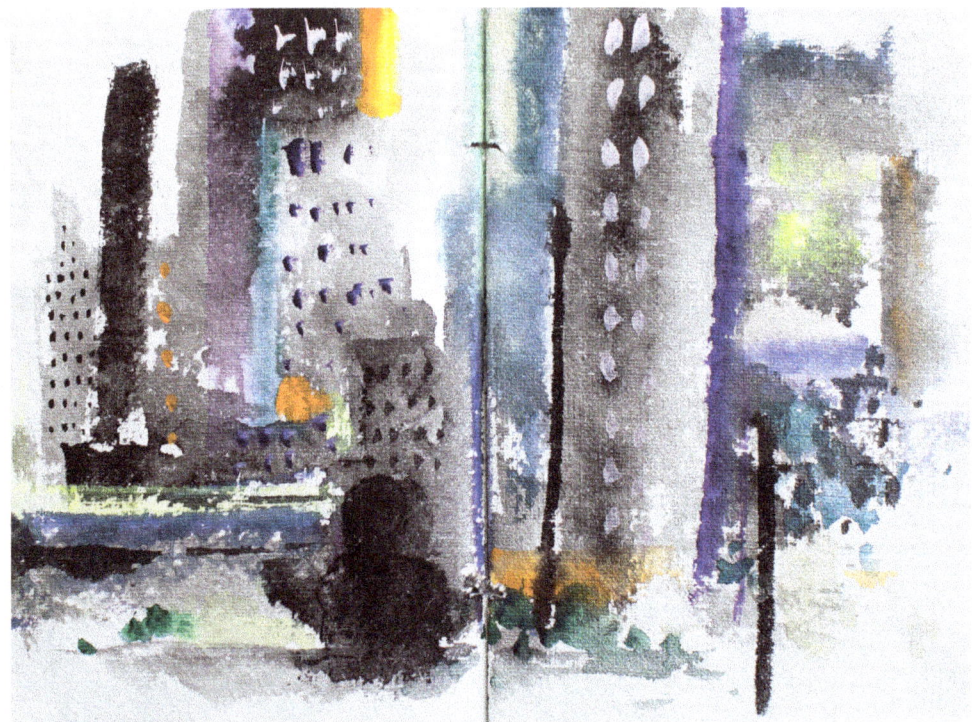

SKYSCRAPER SKETCH

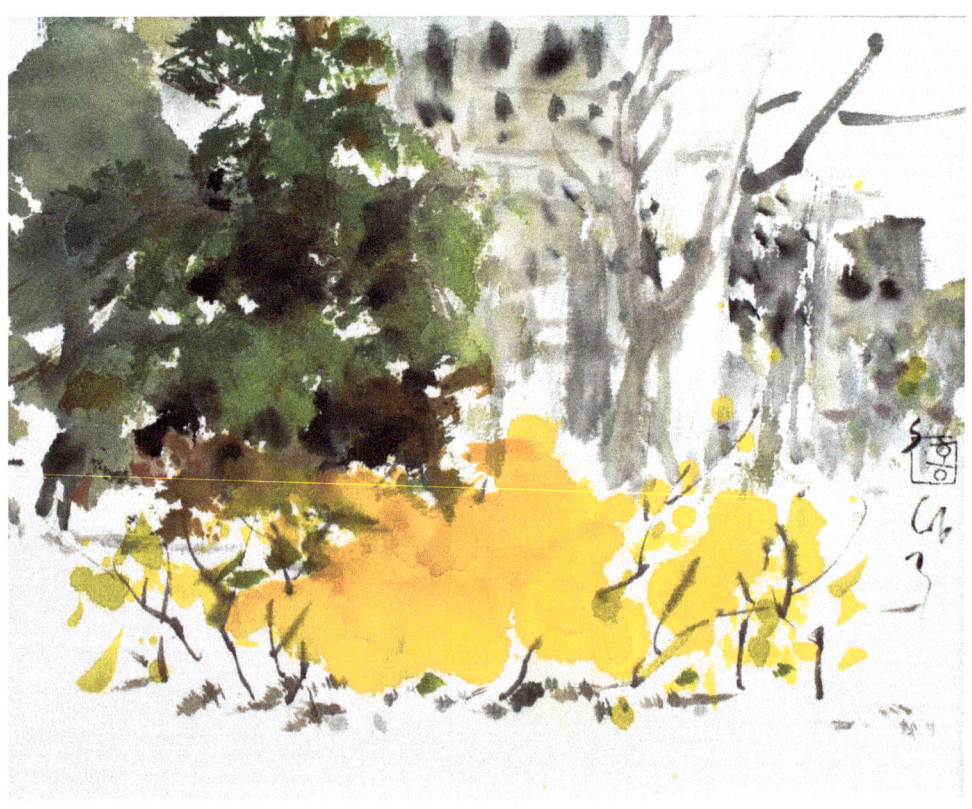

SPRING IN THE PARK

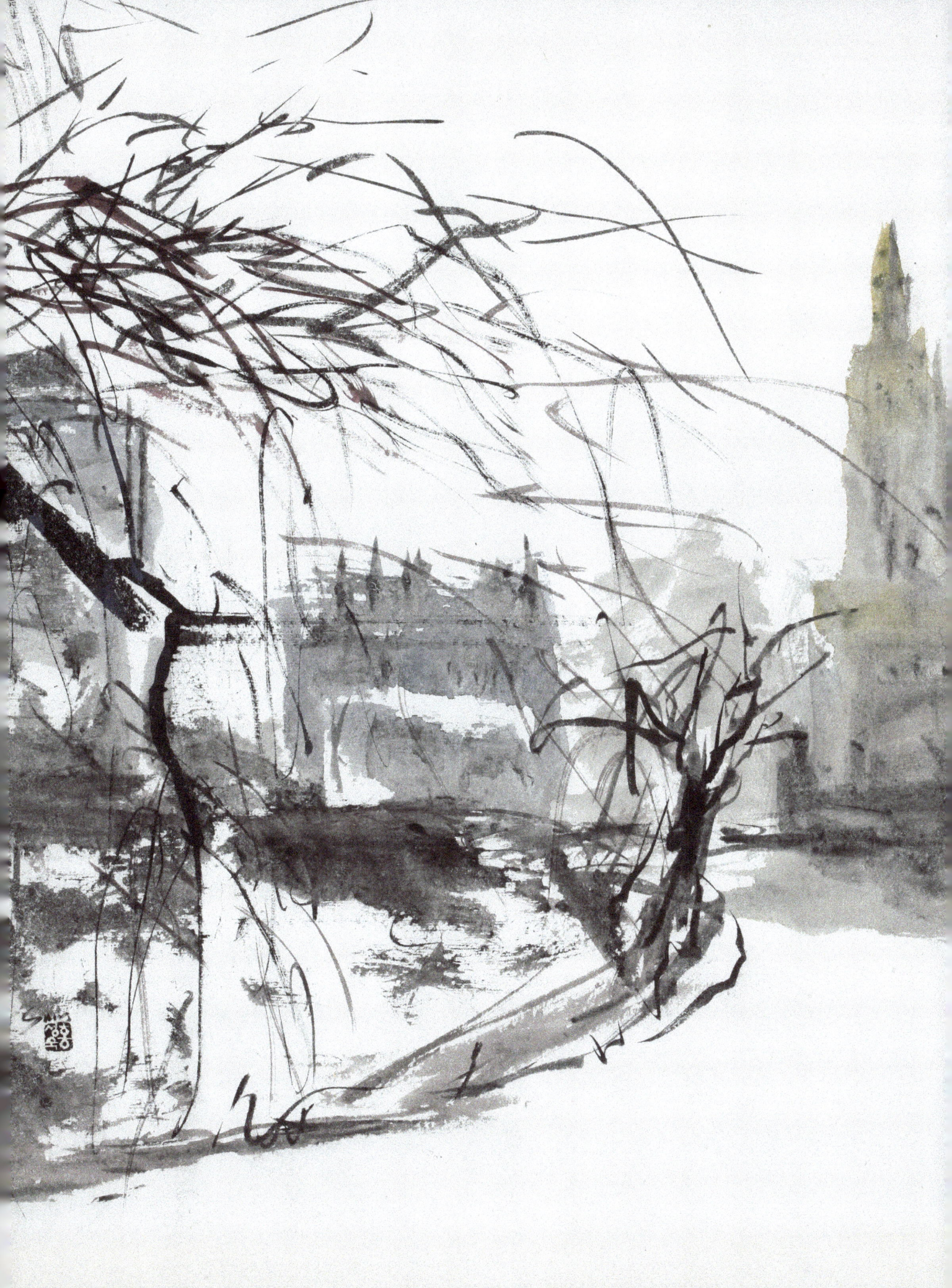

MISTY, WINDY, STORMY DAY

These three conditions create endless opportunities to explore a variety of special brushwork techniques, which stimulate the imagination.

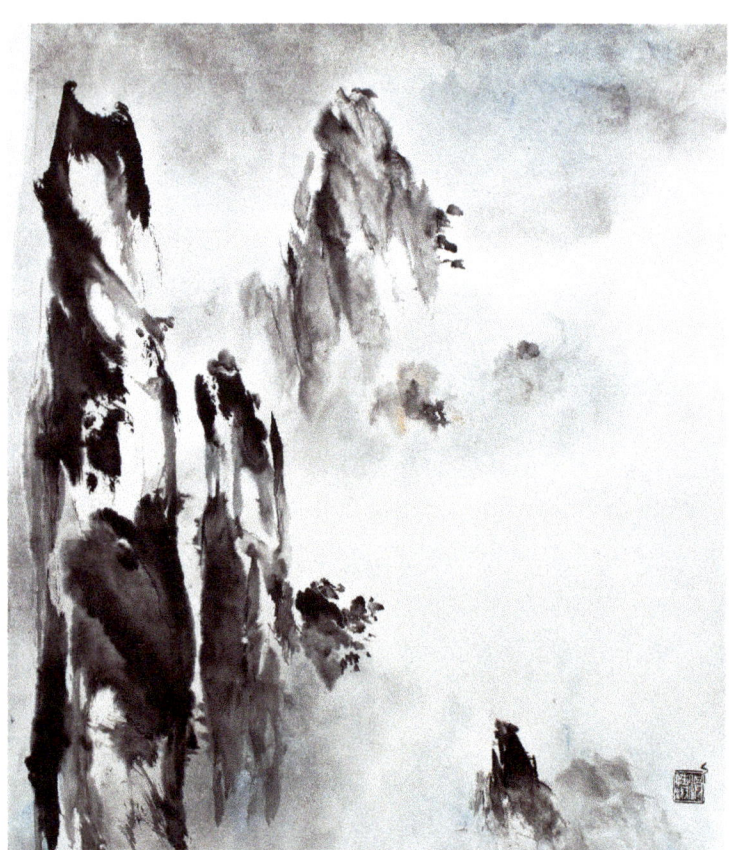

RIGHT: MISTY DAY IN THE MOUNTAINS: SEMI-SIZED PAPER IS A GOOD CHOICE FOR CONVEYING MISTY CONDITIONS BECAUSE WASHES PAINTED ON IT CREATE SMOOTH TRANSITIONS.

BELOW: STORMY DAY ON THE WATER USING RELATIVELY RAPID STROKES.

OPPOSITE: WINDY DAY ON A LAKE. I CREATED THE LEAF STROKES USING RAPID MOVEMENTS.

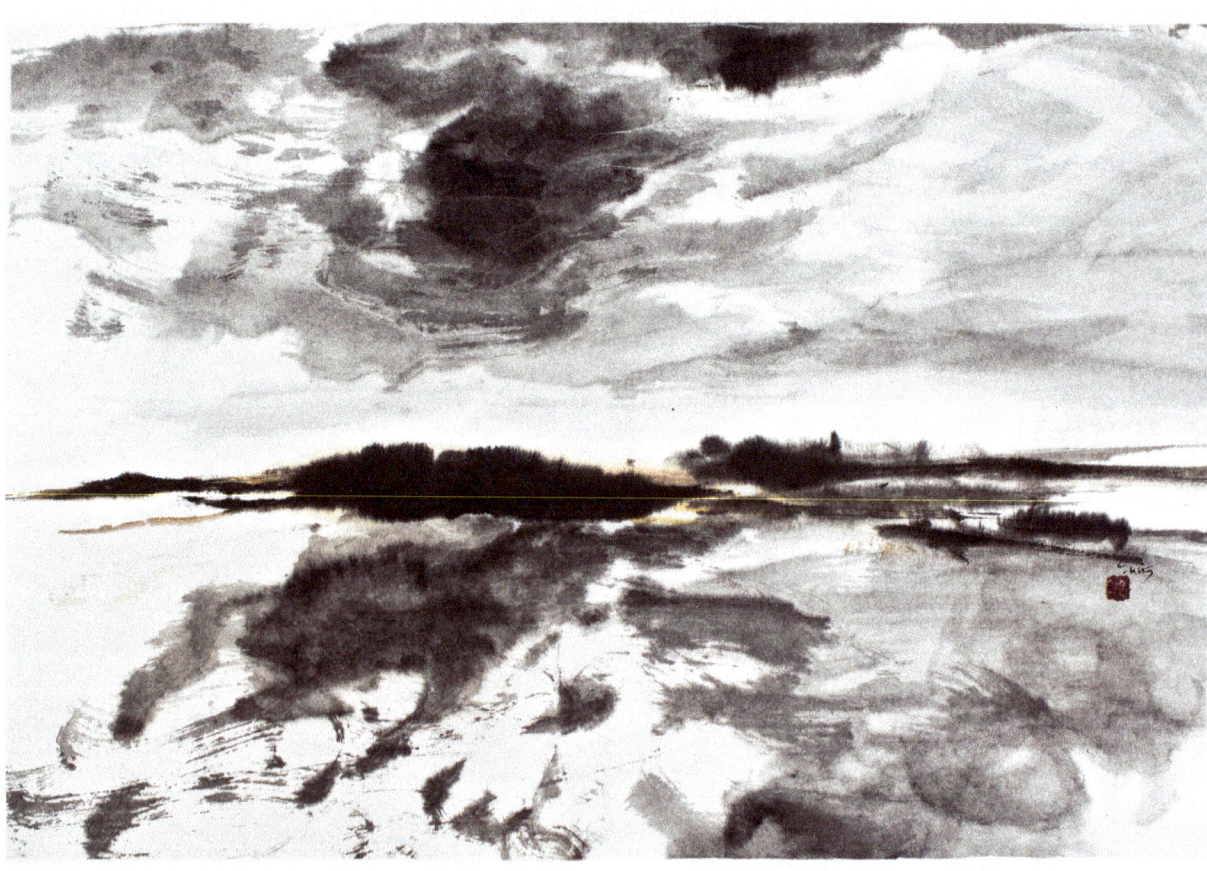

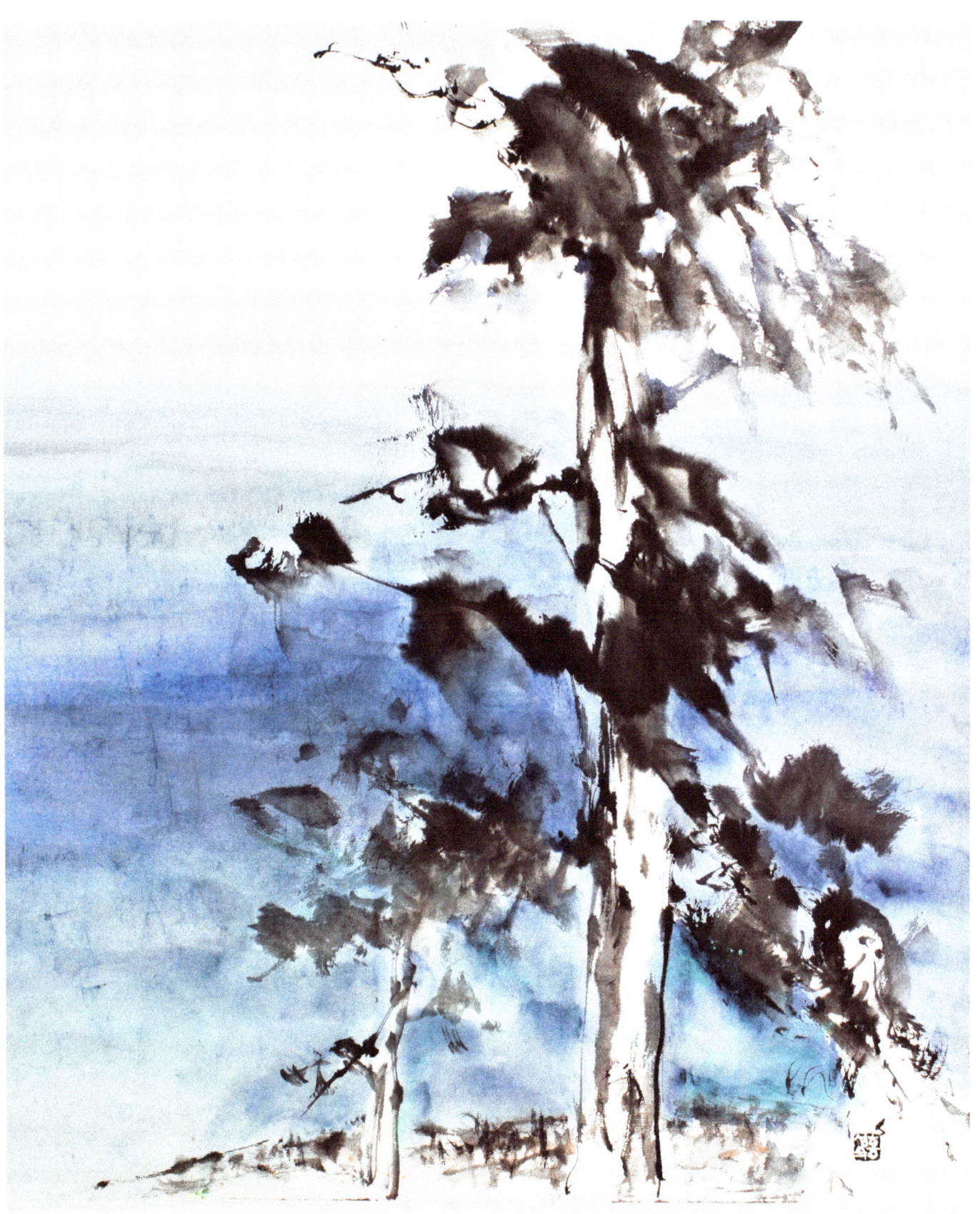

Painting Music

I've spent a lot of time depicting music through painting over the years. Initially, when I tried it, it was only experimentation for myself. Then, in 2005, at the invitation of the chamber group Ardesco, I participated in a multimedia performance, entitled *Brush Voice*. While I painted on a lighted glass table, a photographer took photos of my brush strokes, which were then edited on a computer by a graphic designer. For the actual performance, my work was projected onto a large screen while Ardesco played music entitled, "Emergence, Abundance, and Purification." I wasn't sure what to expect but I loved it—and I recognized that my *qi* had traveled to a new medium and a new experience with me.

After that, I had the courage to do a couple of live performances with a jazz musician. What would have been terrifying for me before was now exhilarating, and I began to understand that when I have my brush in my hand, I am a dancer and a musician too.

As I pointed out at the start of this book, my journey with my brush parallels my journey from Korea to the West, from following the forms of traditional painting to discovering my own style, one that combines Eastern and Western sensibilities.

The Ardesco event was the point of departure for yet another journey—this one toward pure abstraction. And it *is* a journey; it doesn't happen all at once. The act of transforming the abstract language of music into a visible medium is full of challenges, because it involves more than just the transmission of a momentary impression. Music has its own *qi*, and that is what you want to capture.

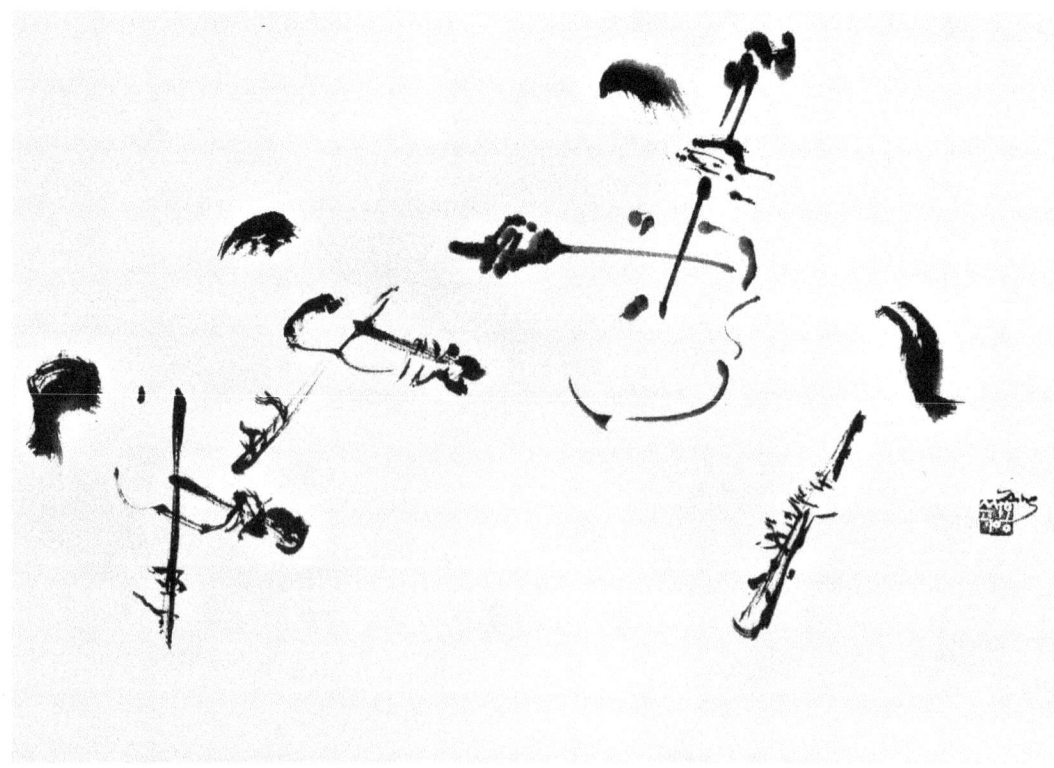

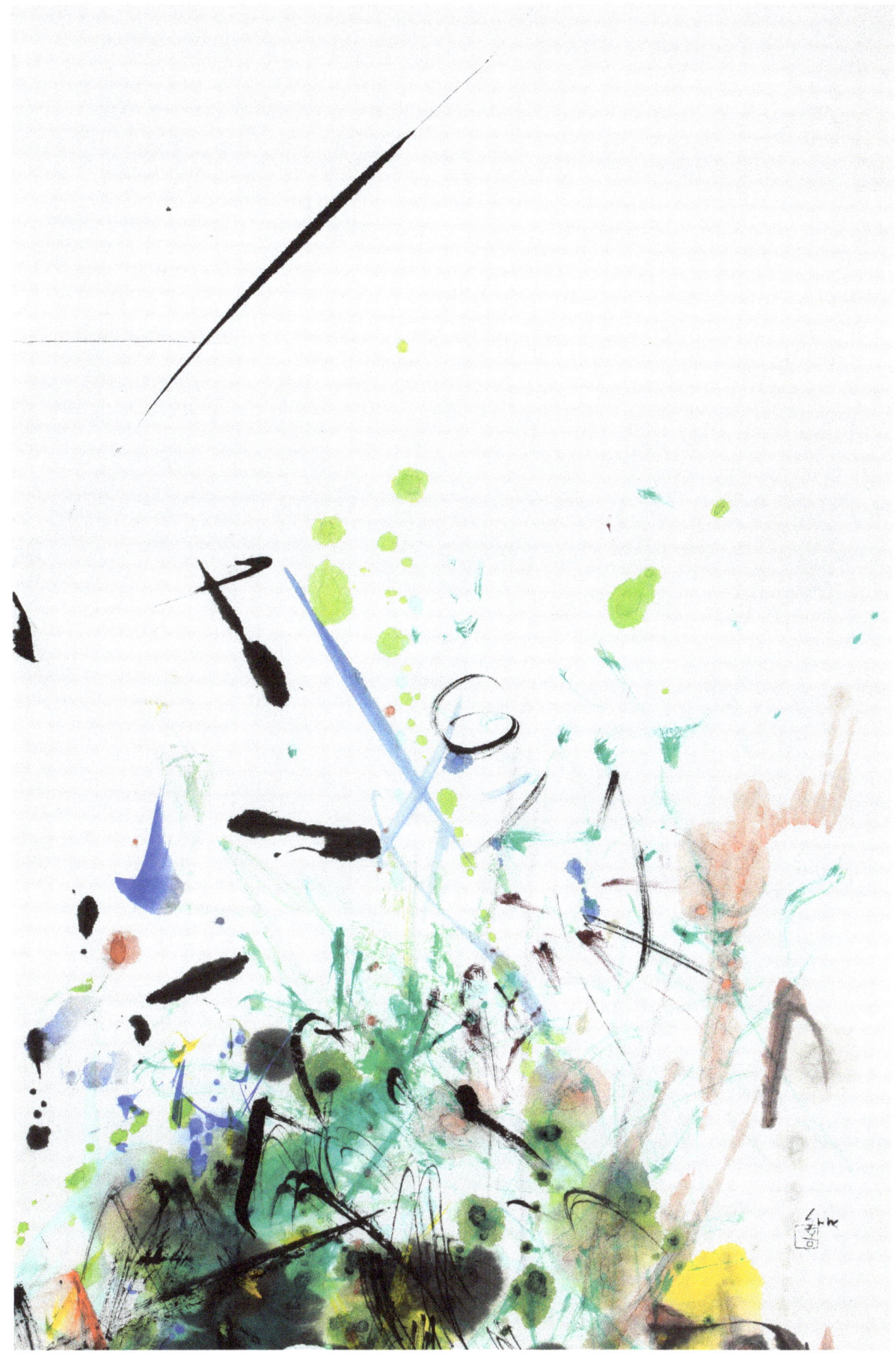

I stand when I paint so that my body moves with the brush, so that the brush stroke doesn't begin with my brush but travels there from my mind through my arm and fingers to the tip of the brush. I'm even more aware of the brush stroke being an extension of the feeling and movement in the body when I paint to music. They are inseparable.

The translation of music into images is not limited to the creation of lines. Splashes, blobs, and gentle washes accompany these lines to enhance the techniques of abstract expression. Along with lines, broad strokes and a wide array of colors are used to capture the emotive and elusive nature of music.

I think that the brushes used by East Asian artists are some of the most effective tools to bridge the worlds of music and art. Like silk thread, the different kinds of animal hair used in these brushes are able to reflect the subtle emotional fluctuations of music through their malleability.

In the same way that instrumental melodies convey worlds of experience that transcend the physical senses, the East Asian brush excels at stimulating visual imagination. If the musical content is rich and complex, I use a more colorful palette; if the music is meditative, I tend to use black ink. Each work is, in part, a response to the aesthetic inspiration of the moment, rather than adhering to a set of rules.

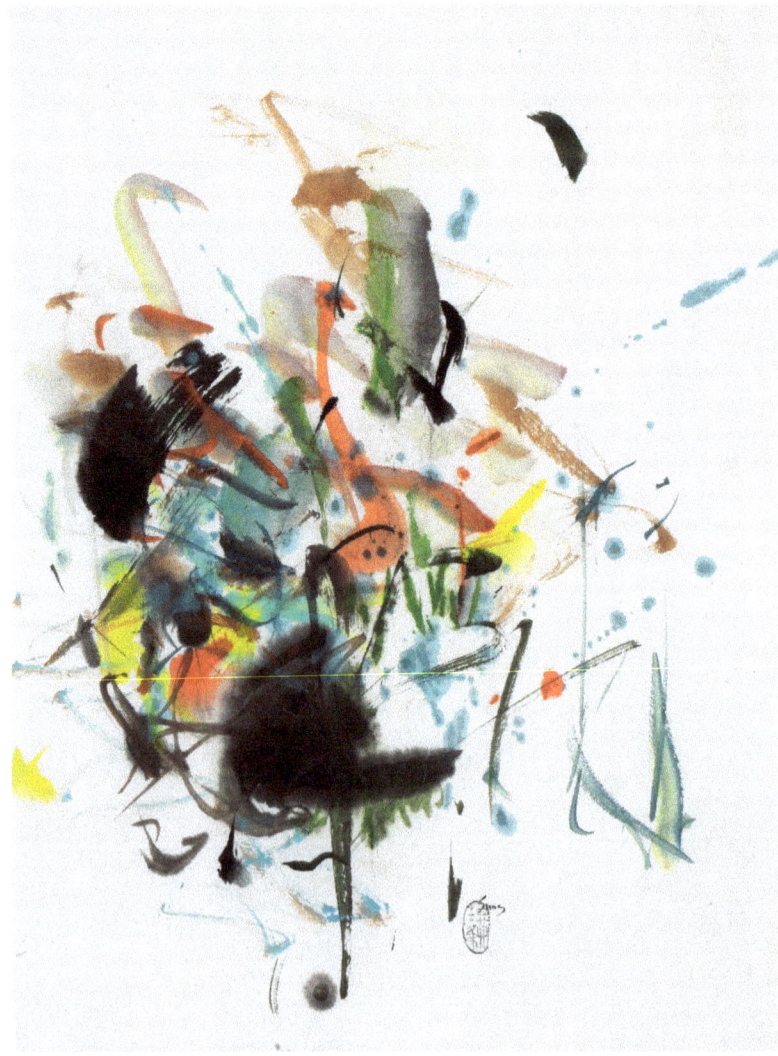

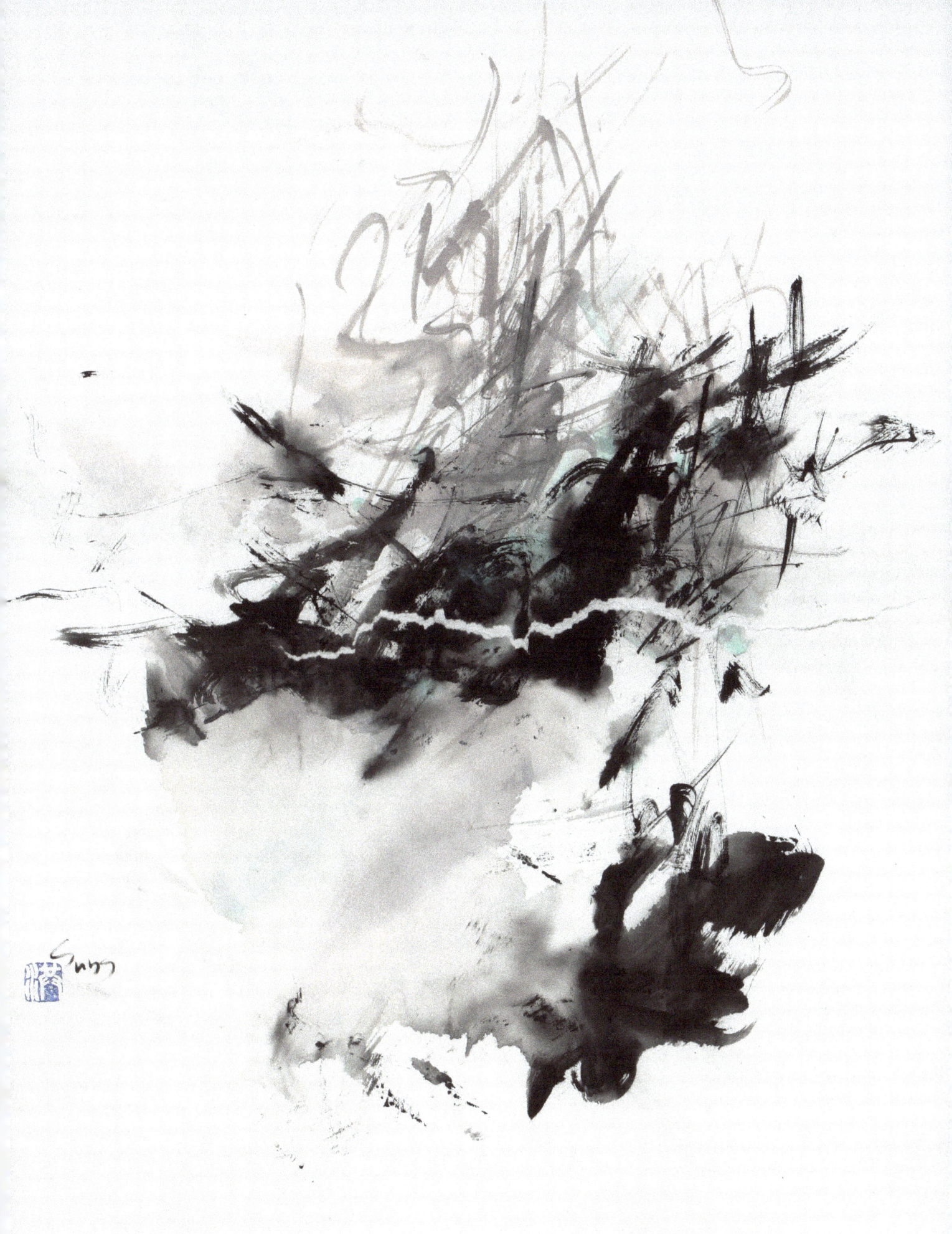

I discovered that my intuitive responses to different kinds of music create the possibility of endless harmony and rhythm. I use the strokes of my brush to dance, and make soundless music. At the end of the day, I've never felt so free as I do when I paint music.

I hope that one day you too may be tempted to try this. Even for a beginner it can be an excellent way to experiment with a brush, developing a feel for creating different kinds of strokes without having to worry about the pictorial results.

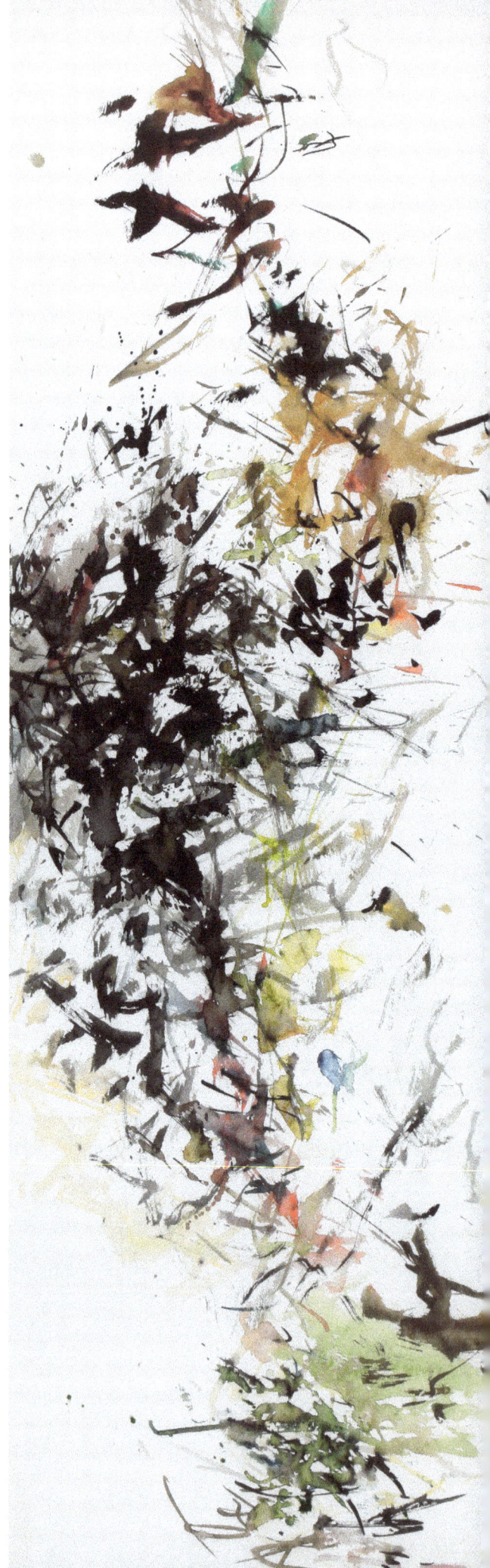

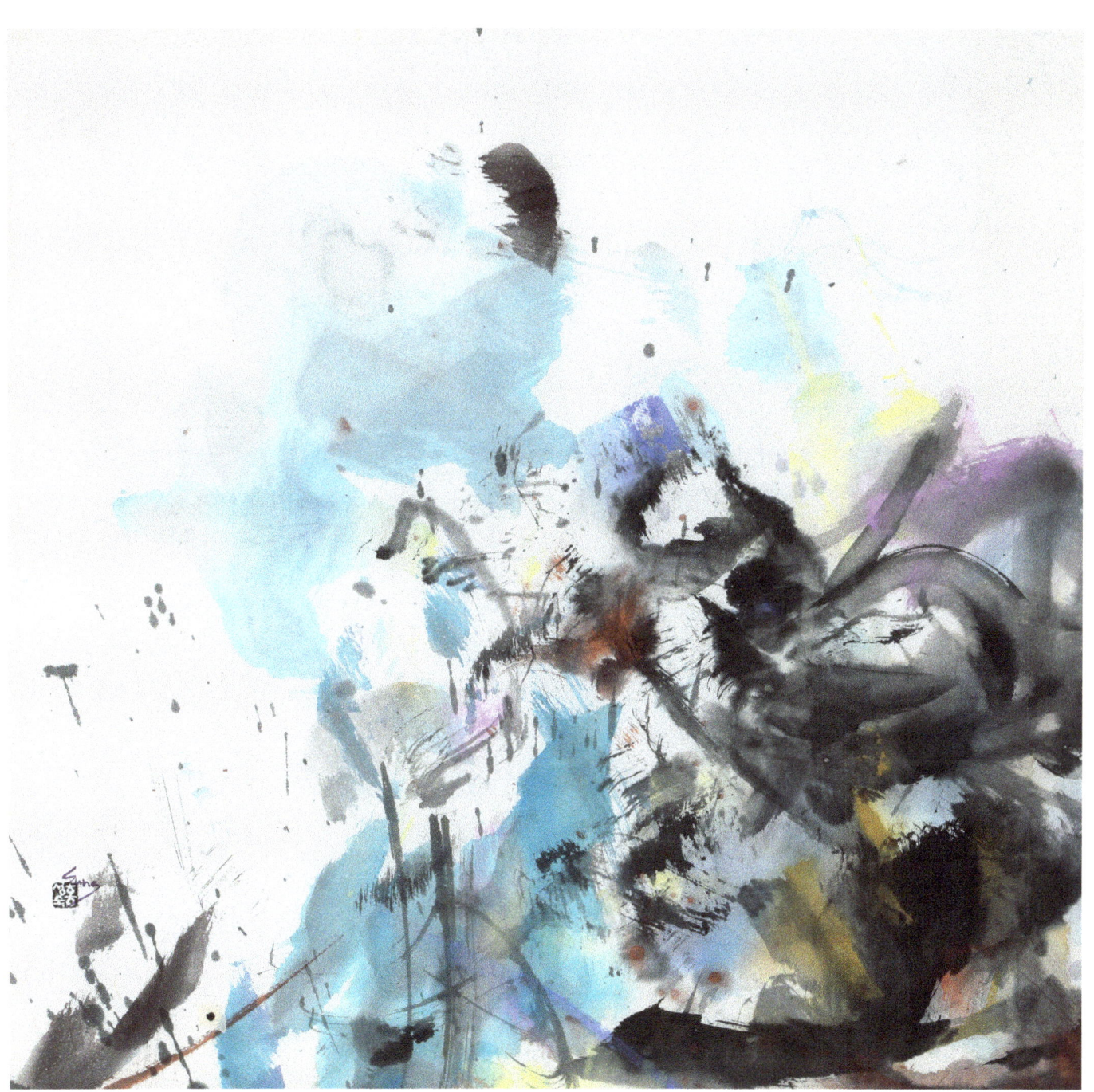

Mounting Paper

Special paper for mounting paintings is available where Asian art supplies are sold. You can also use double *shuen*, or semi-sized paper for mounting. The best papers have a fiber content that allow them to be strong, yet flexible. They're heavier than the paper you used for painting. Allow for a 1.5-inch (3.8 cm) margin all the way around when cutting the mounting paper for a specific artwork.

FOR THE PASTE

I prefer—and I teach my students to mount artwork with—powdered mounting paste, which is available where you buy your other supplies. Some people prefer to use pre-mixed wallpaper paste. Whichever type of paste you use, be sure that it will dry transparently.

Note: The directions here are for mixing and using powdered mounting paste.

TOOLS AND MATERIALS

- bowl
- measuring cup
- water
- measuring spoon
- powdered mounting paste
- spoon or wooden spatula for mixing
- archival spray fixative
- smooth waterproof work surface
- water spritzer
- wide, soft-bristle brush for applying the paste
- mounting paper
- scissors
- stiff-bristled brush to smooth the mounting paper after pasting
- wooden board large enough to hold the mounted painting for drying
- paper towel
- needle to remove lint and dust from the moist artwork
- kitchen knife to remove completed artwork from the mounting board

PROCEDURE

1. Make the paste by pouring 1 cup (237 ml) of water into a bowl. Sprinkle a teaspoon (5 ml) of powdered mounting paste over the water, and stir continuously for 1 or 2 minutes, until the mixture is gelatinous. Take care that it is not too thick, or it may cause the painting to tear during the process. You can add a little more water at any time. The glue will last a couple of days if you cover it, and you can add more water if necessary. Let the mixture rest until it thickens (about 10 minutes). The consistency of the paste should allow it to drip gently.

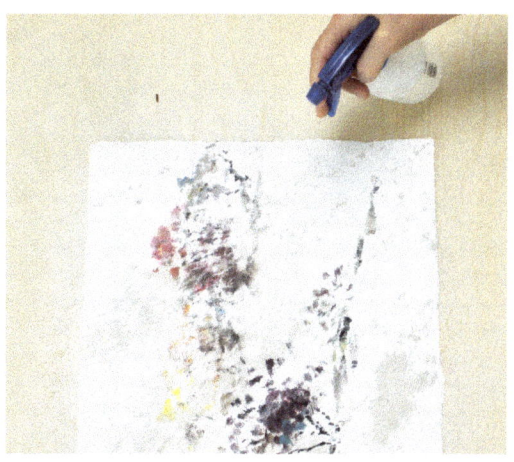

3. Prepare the painting. Certain colors (usually the deeper ones) will bleed. To prevent smearing, spray the painting with archival fixative and allow it to dry before mounting it. Make certain your work area is clean and dry. Place the painting facedown on the work surface. Lightly spritz the back of the painting with water to moisten and flatten it.

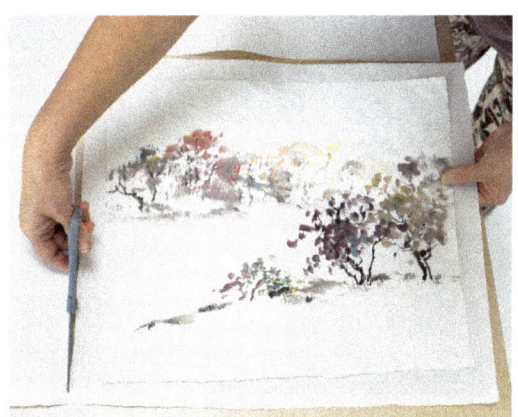

2. Cut the mounting paper. The paper should be cut to the dimensions of the painting, with an additional minimum of a 1.5-inch (3.8 cm) border all around. Also cut a 2 x 6-inch (5 x 15 cm) paper tab. This will help you remove the dried painting from the mounting board.

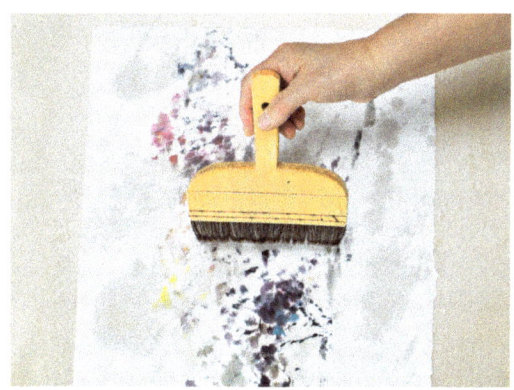

4. Brush on paste. Dip a wide, soft-bristle brush into the paste. Remove any excess. Begin applying the paste to the back of the painting, working from the center outward in every direction; alternate your brush strokes in opposite directions. For example, if you stroke from the center to the upper right corner, the following stroke should be from the center to the lower left corner. Repeat this, gradually adding more glue until the paper becomes somewhat translucent and smooth. Using a needle, remove any brush bristles attached to the paper.

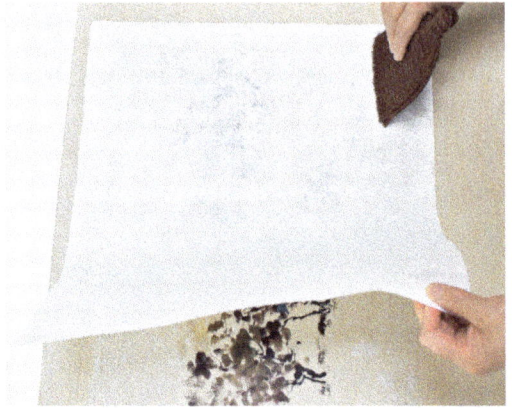

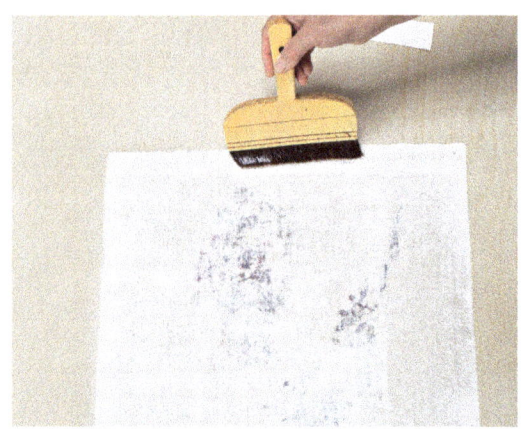

6. Prepare the margins. When the backing is smooth, brush paste onto the outer edges of the mounting paper's margins.

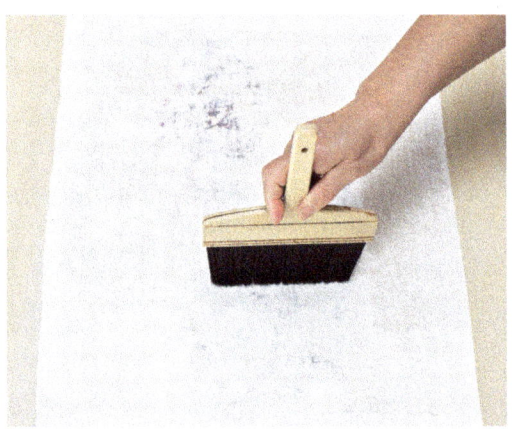

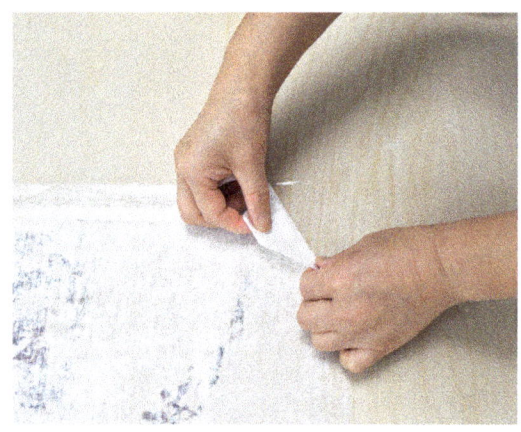

5. Attach the mounting paper. Identify the roughest side of the mounting paper. Center and lay the paper, rough-side down, on the paste-covered back of the painting, allowing for the borders all around, then press down with your hands from the center toward the edges. Using a dry, stiff-bristled brush, gently brush the mounting paper into place, moving from each side inward. Continue brushing to adhere the two sheets of paper tightly and consistently. If small air pockets or wrinkles form, gently tap them with the end of the bristles to remove the bubbles or use the tips of your fingers. Continue this process until the mounting paper attaches smoothly to the painting. Be careful not to scrape away fibers from the back of the mounting paper.

7. Lift the painting. While the paper is still moist, gently pull the mounting paper and painting from the working surface. Before lifting it more than a few inches, make sure the painting has not separated from the backing.

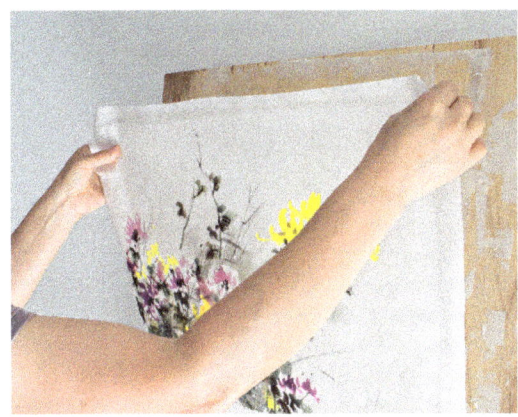

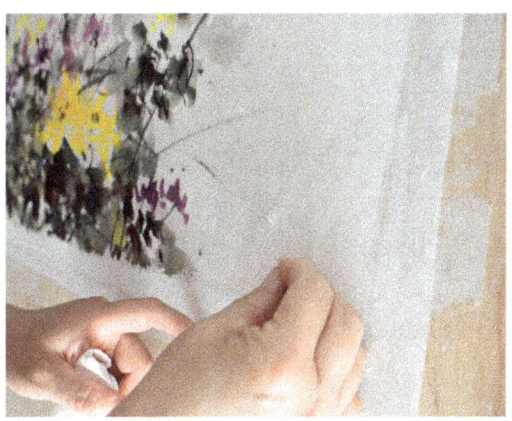

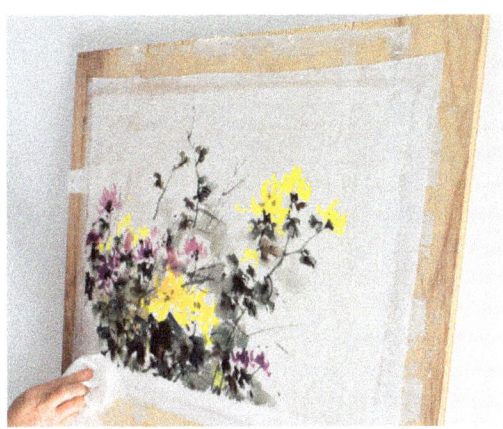

9. Remove dust and lint. While the painting is still wet, gently remove small hairs and particles that are attached or embedded in the paper with the point of a needle. Smooth the cleaned areas with your fingers. Allow the painting to dry for 24 hours or more.

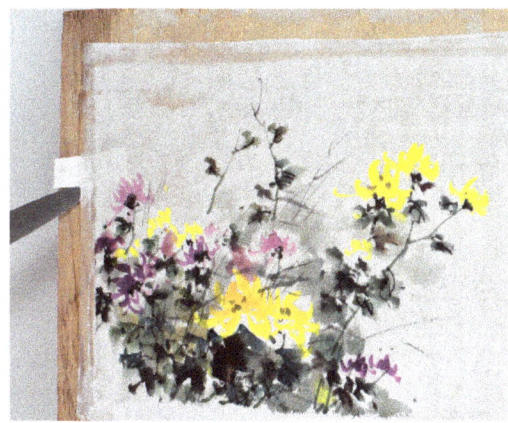

8. Dry the painting. Place the mounted painting on the upright drying board, image-side up. At the top edge, carefully insert the mounting tab between the paper and the board so that half of the tab sticks out beyond the edge of the paper. Gently and firmly smooth down the edges with a paper towel, from left to right or vice versa, without touching the painting. Make certain there are no unglued areas along the edges. If the edges are not glued, the painting will warp.

10. Remove the painting from the board. When the painting is completely dry, insert a knife behind the tab with the sharp edge of the blade facing outward. Make sure that the blade lies as flat as possible against the board, and slide it gently to separate the top edge of the paper from the board. Hold the top corners of the mounted artwork. Lift slowly from the top down, gently pulling the remainder of the painting from the board. Trim the margins with scissors, leaving a ½-inch (1.3 cm) border.

Note: For my own paintings, I repeat this process, gluing a second backing to the first to provide enough strength for framing.

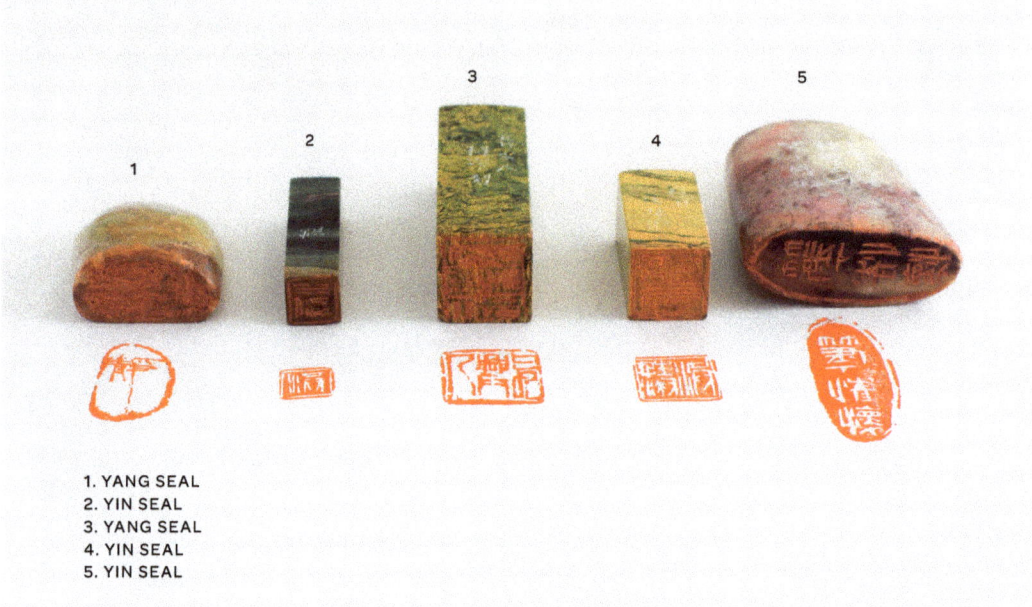

1. YANG SEAL
2. YIN SEAL
3. YANG SEAL
4. YIN SEAL
5. YIN SEAL

T-SQUARE

THE SPIRIT OF THE BRUSH

NAME AND MOOD SEALS

The use of seals is traditional to ink painting and adds something special to a finished work, not only in how it looks, but also in the information that it conveys. I have about twenty-five of them in different sizes, shapes, and designs, including name seals and mood seals.

The way you use your seals will depend on the painting, who it is for, and where you intend to show it. For instance, sometimes in signing a painting I use only a single seal with my name. For other paintings, I use two name seals placed next to each other, one with my actual name, and one with my *gō*, or art name, Ahwon, which means "elegant garden." Art names are traditionally given to students by masters as a symbol of long affiliation with their lineage.

Mood seals, which are used by themselves or in tandem with a name seal, offer phrases that have a personal meaning for the artist. For example, my seals include "stillness," "the spirit of the brush," "humanity and love," "citizen of Changhung," and "half-day leisure."

You can purchase seals, precarved with a mood or phrase, where Chinese painting supplies are sold. To have a seal custom-carved with your name, a special pen name, or phrase, you will need the design and carving services of a seal engraver. You can find seal engravers online. Alternatively, if your nearest city has a Chinatown, you may find a seal engraver there or through a museum that specializes in East Asian painting.

There are two styles of seal-carving: positive (yang) and negative (yin). The script of yin style seals is "empty." In other words, the seals are carved so that the empty spaces represent script. The script of yang seals is "full," formed by the stone, with the space around the script empty. Sometimes I use both styles within a single seal. Square shapes are commonly used, but I prefer irregular shapes. I use both Korean and Chinese script, and in the West I also use my English signature next to the seals.

I was taught that seals should be used like a spice in food—beautiful, but not calling too much attention to itself. I choose the seal I want to use according to the subject matter and the size of the painting. The placement of the seal is very important, because it becomes part of the composition. It should not disturb the flow of the painting, but should sit in a subtle place to complement the painting. An artist's aesthetic sense is judged on the relationship between the seal and the image.

To find the right spot for a seal, print it on a small piece of paper, cut it out, and then move it around on your painting, trying it in different locations. If you are making a series of paintings, print as many seals as needed, lay out the paintings, and place the temporary seals in position. Adjust the seals until you find a balanced and interesting placement.

To print the seals, you will need seal paste, which can be purchased where you buy your other ink painting supplies. Red seal paste is used traditionally, but I often prefer other colors such as blue, brown, and green, since red can sometimes stand out too much. Using a T-square will ensure that you stamp the seal at the correct angle. This is done after a painting is mounted and dried, to avoid possible seal paste smears.

Gallery

Here is a gallery of my landscape views in all seasons, on all my travels, near and far.

ABOVE: LANDSCAPE
OPPOSITE ABOVE: GRAND CANYON
OPPOSITE BELOW: PINE BRANCH WITH THE MOON

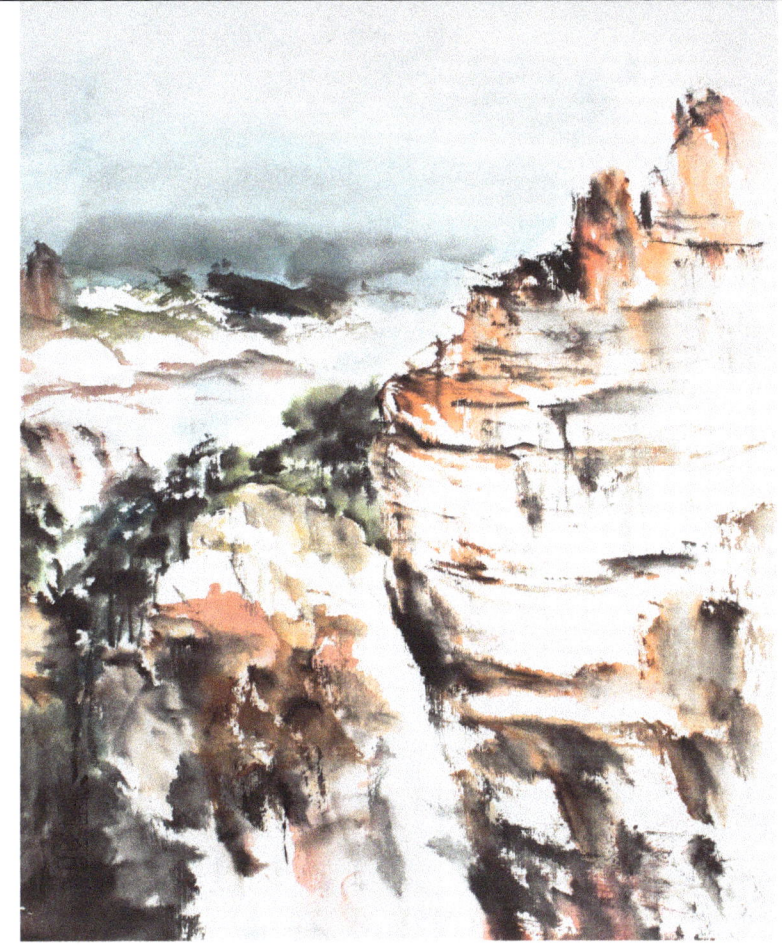
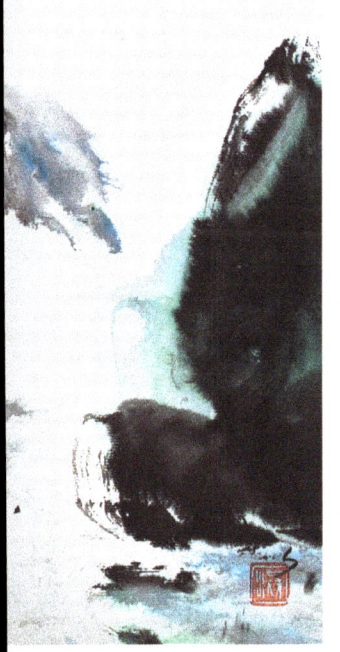
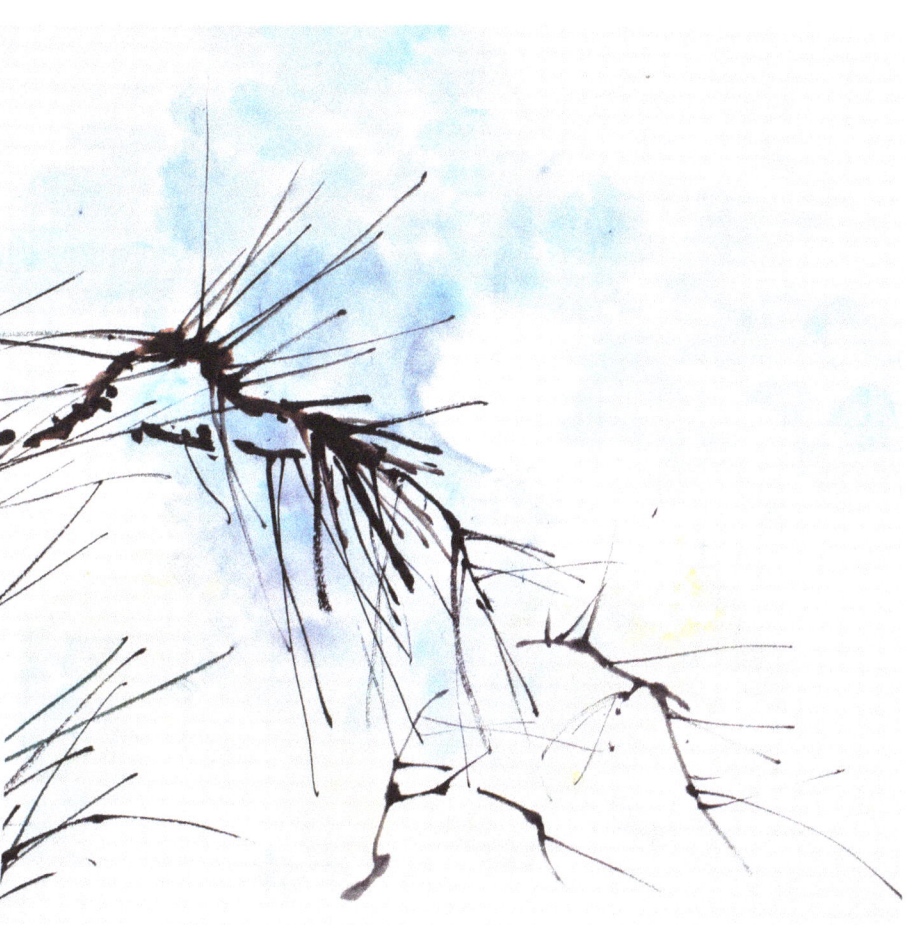

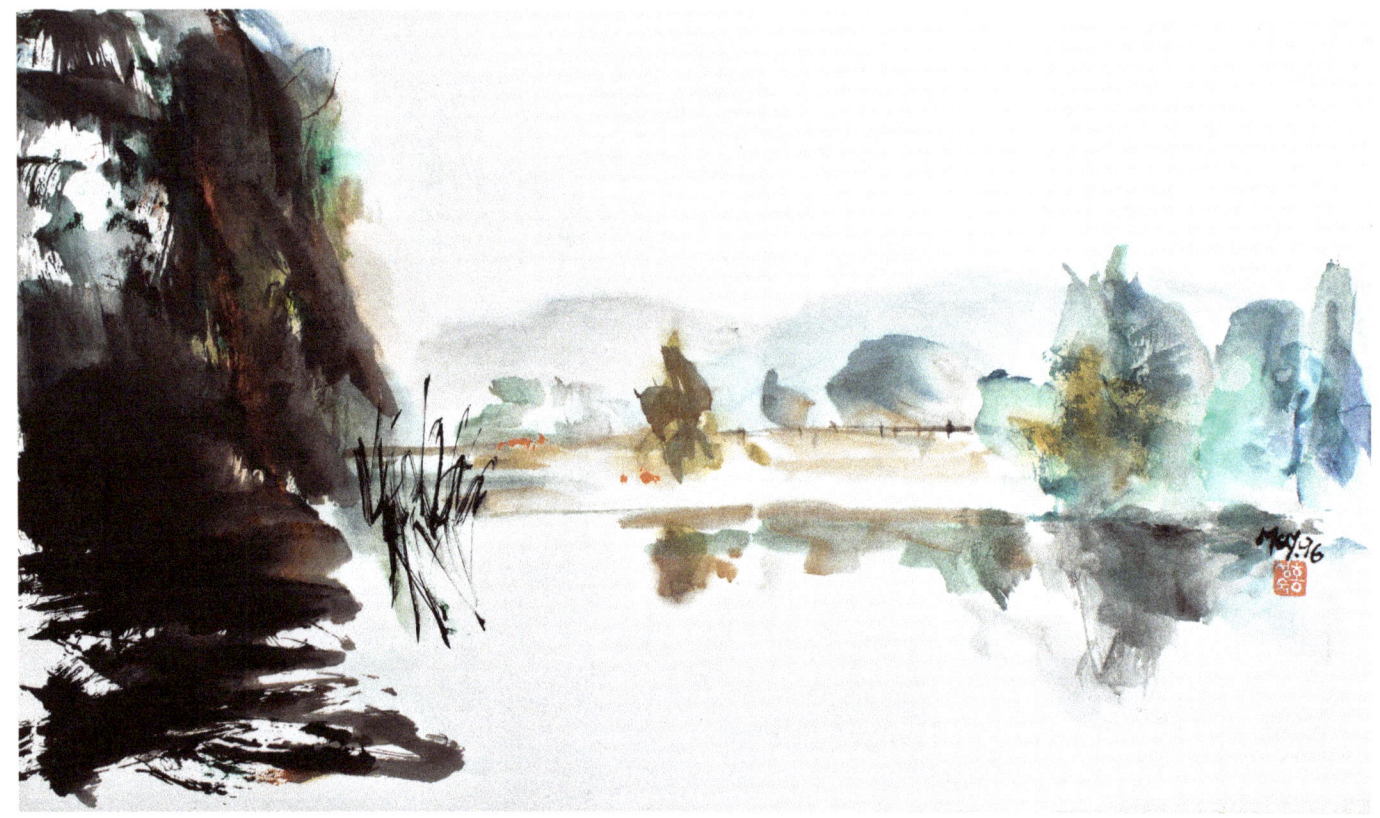

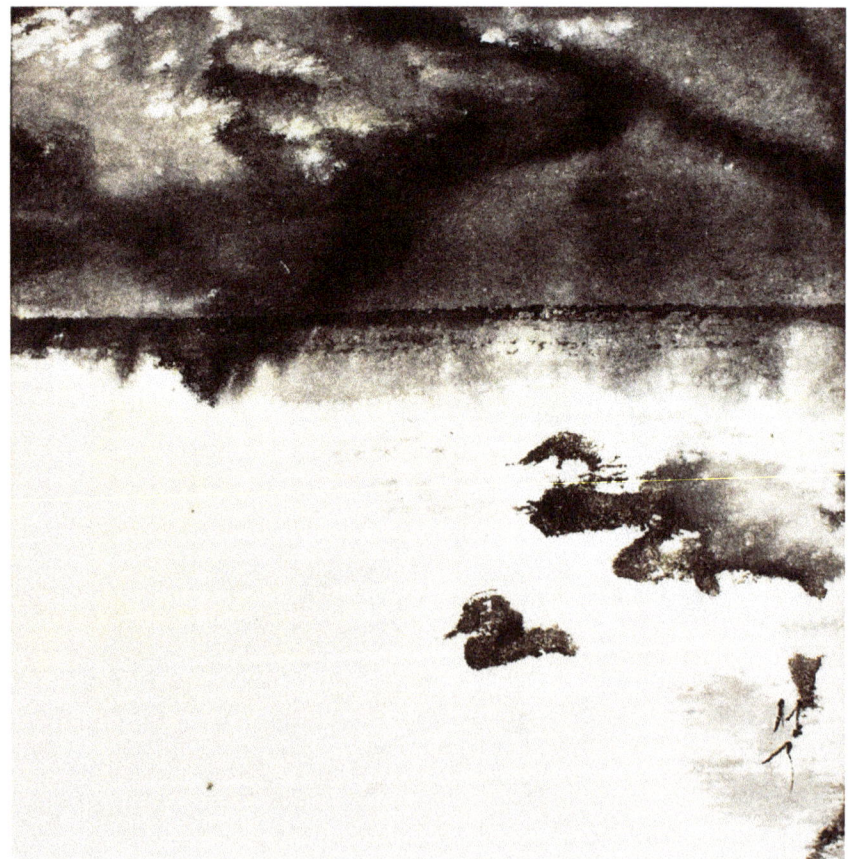

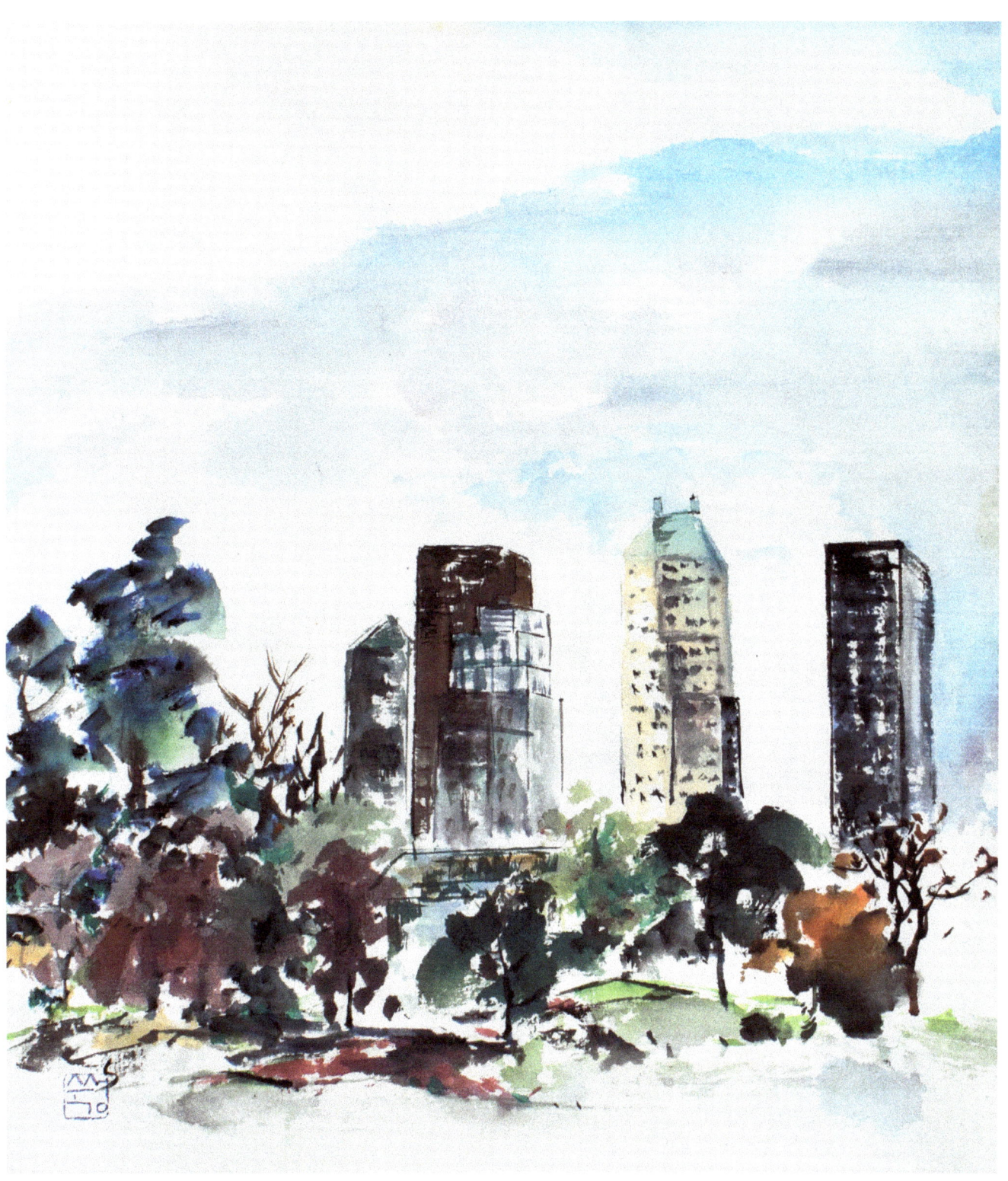

OPPOSITE ABOVE: MID SUMMER
OPPOSITE BELOW: A GLIMPSE OF THE POND
ABOVE: DEEP SUMMER IN THE PARK

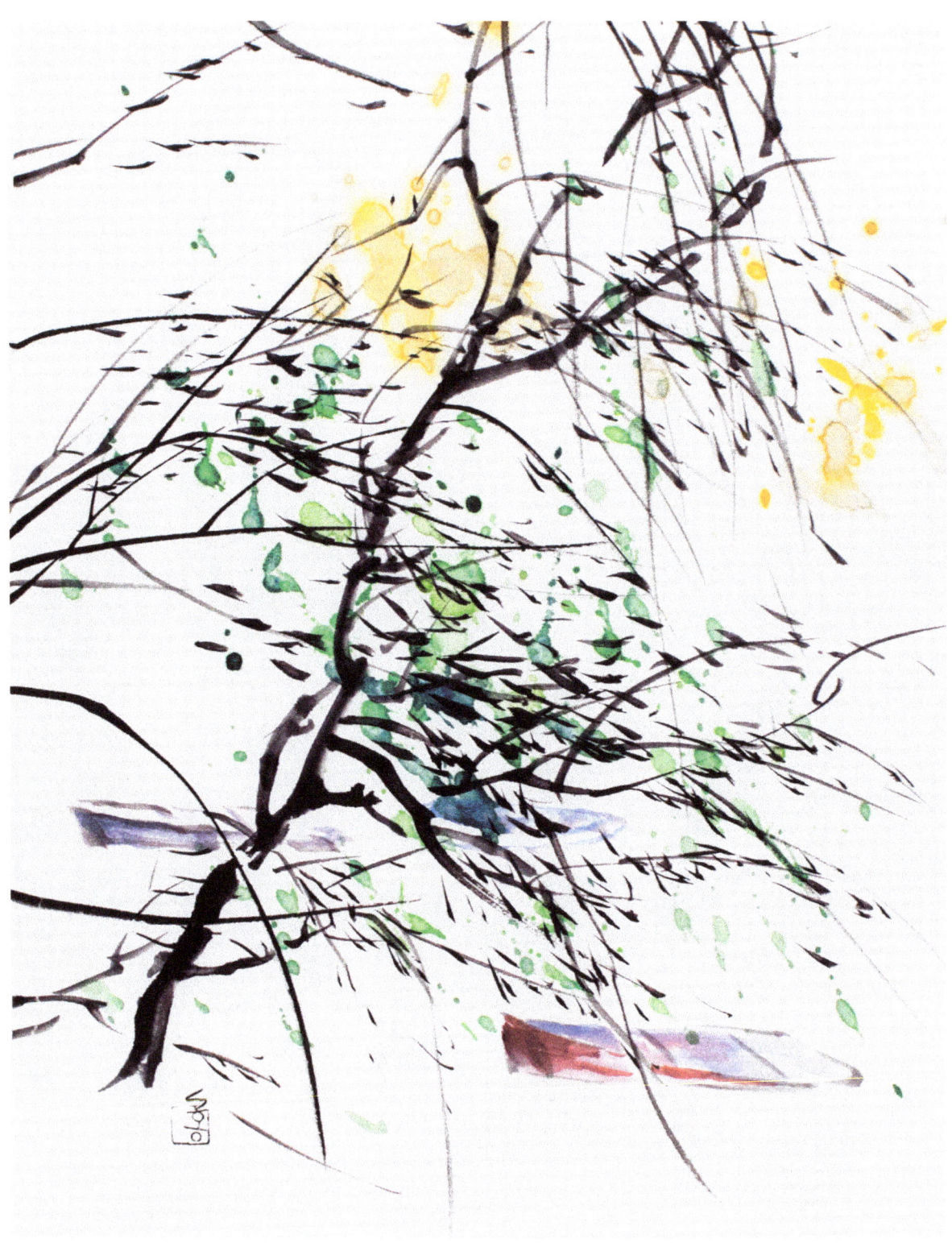

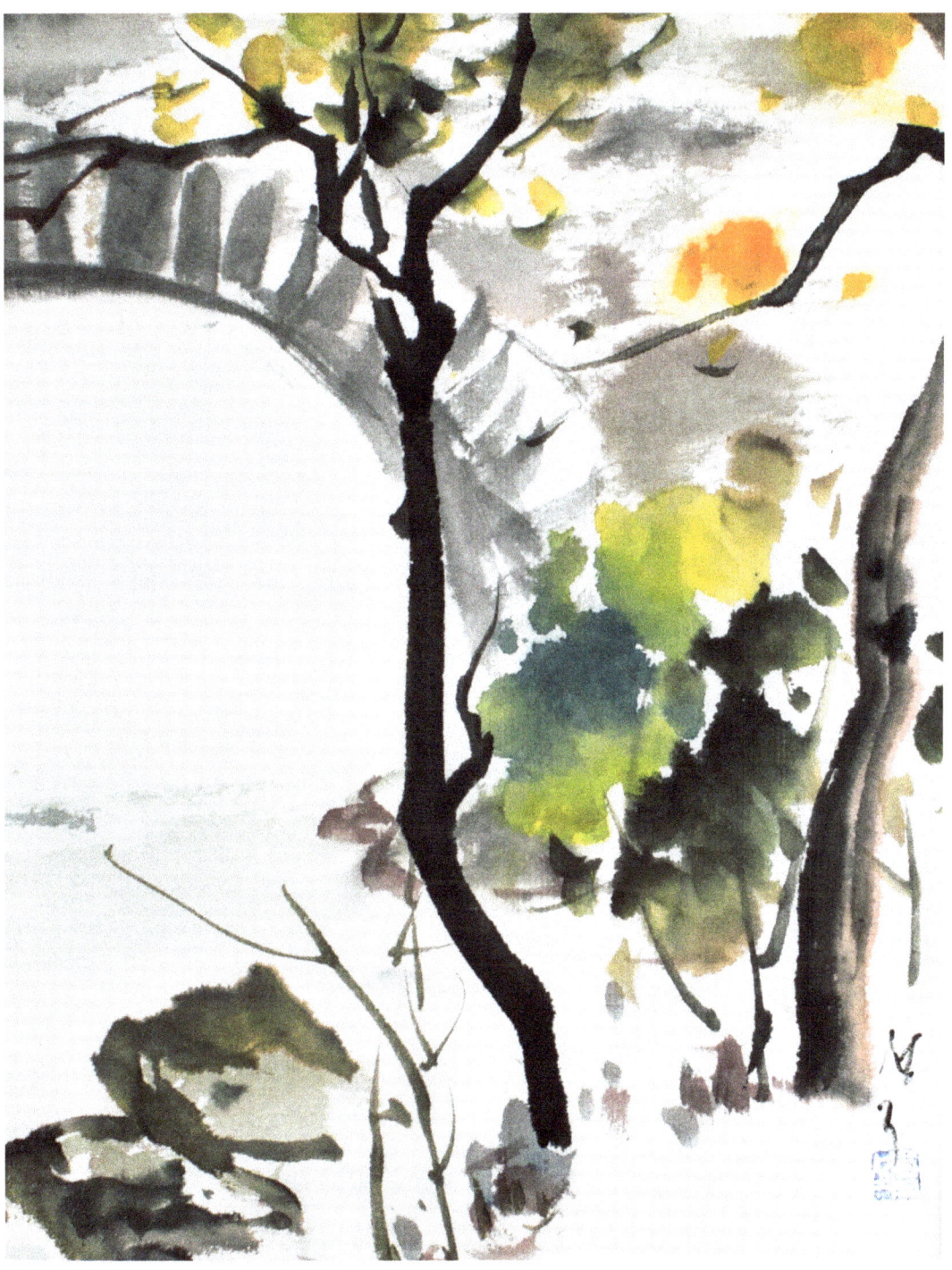

OPPOSITE: SPRING IN THE PARK
ABOVE: FALL IN THE PARK

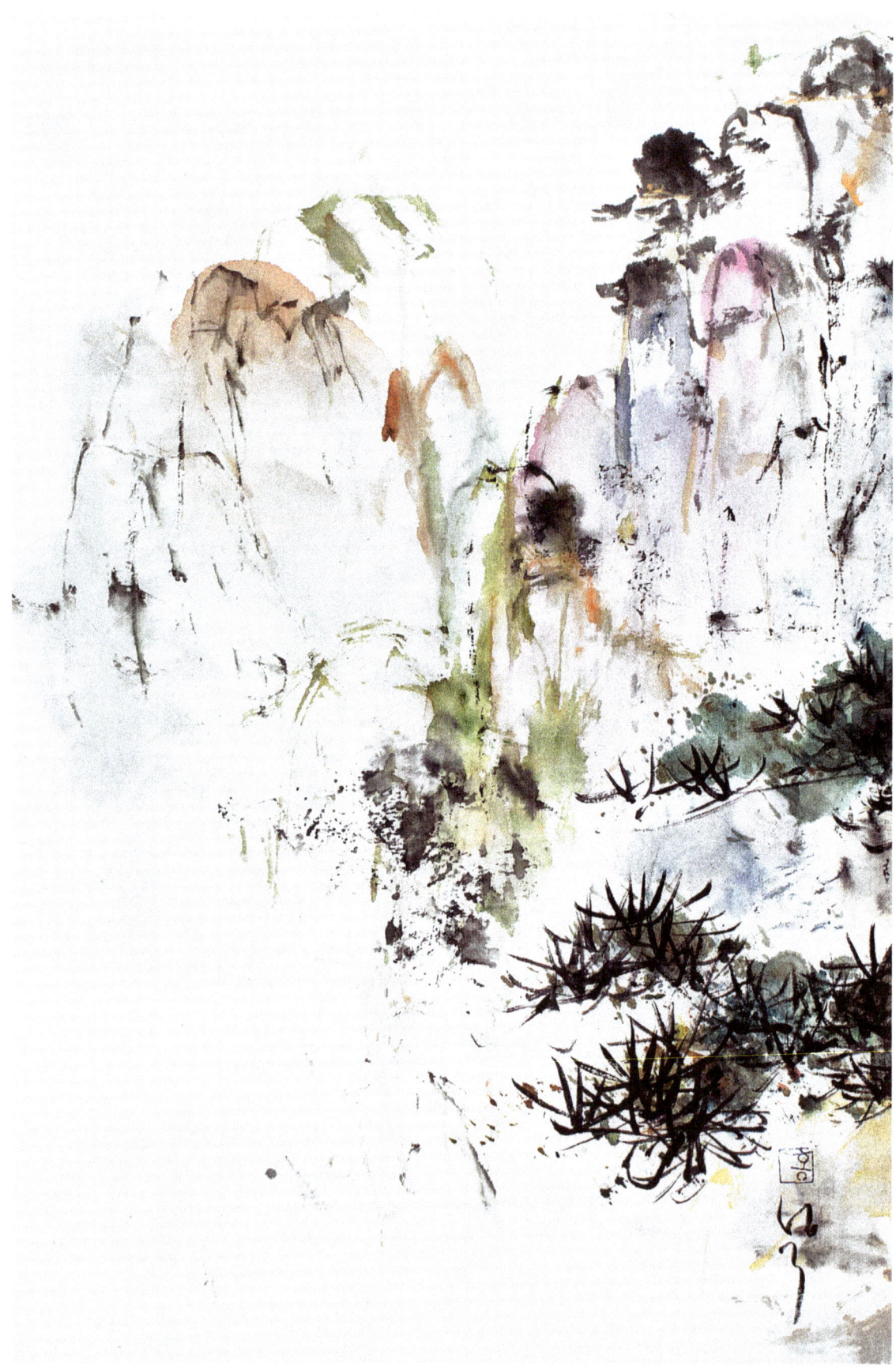

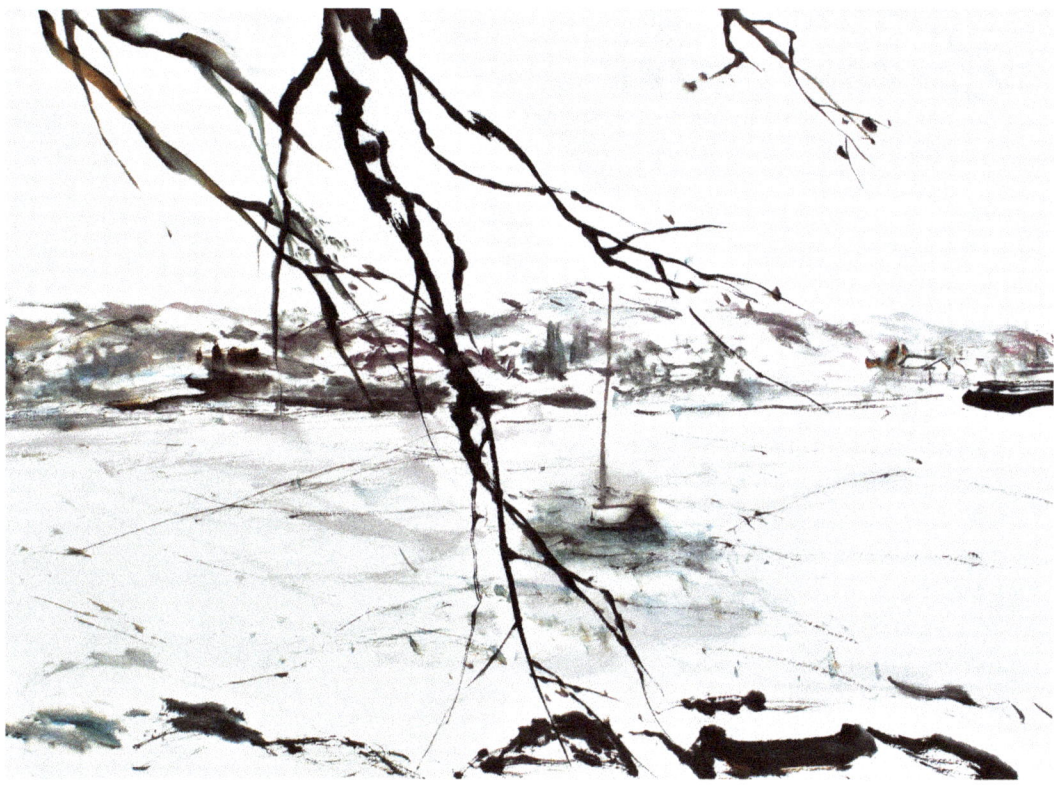

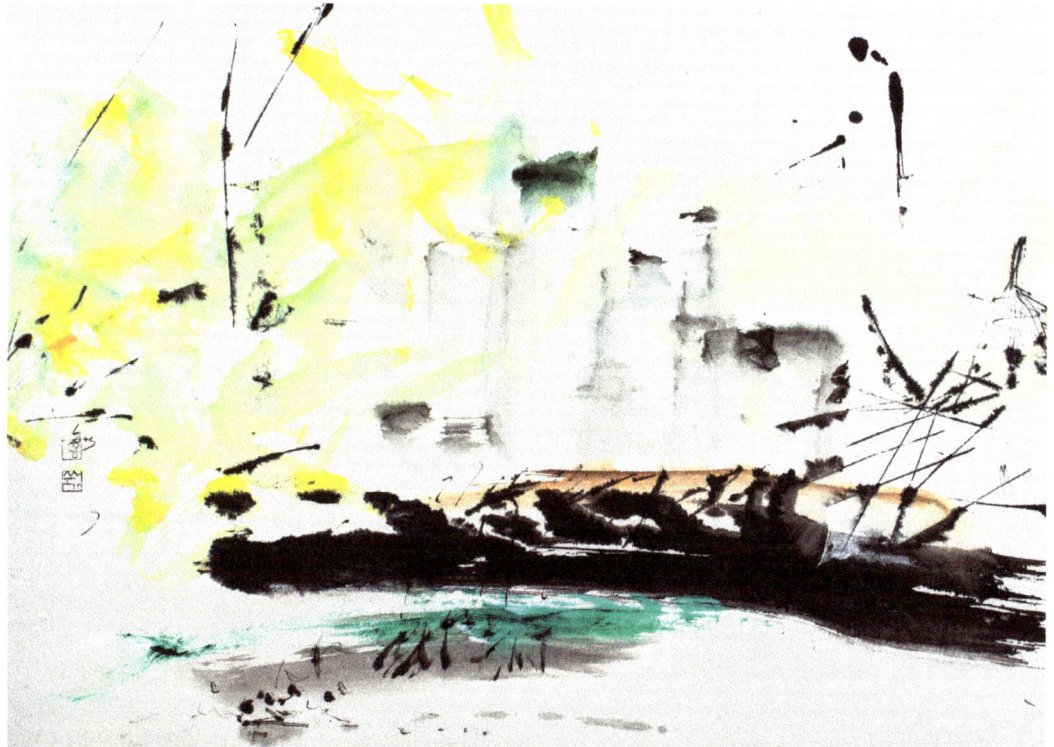

OPPOSITE: YELLOW MOUNTAIN
ABOVE: WINTER BREEZE
BELOW: A GLIMPSE OF THE CITY

Conclusion

I love screen books—Asian-style books with accordion-fold pages—because I can turn them into a pictorial travel diary, whether it's capturing a walk near my home or a journey to another part of the world.

Whereas a single sheet of paper or silk typically forms the base for most East Asian painting and calligraphy, there is also a long history of artists choosing instead to work on portable substrates: albums, hand scrolls, hanging scrolls, and screens that can be tucked away when not in use. Artists and poets have always carried screen books with them for their diaries on the road.

I had the idea of painting in a screen book during my second semester at Goddard when I visited China to sketch on location with my students. There we were, confronting landscapes that have inspired painters for thousands of years. The scenery I knew from poring over master paintings in books suddenly came alive to me: the famous Huangshan, or Yellow Mountain, the Lipu Mountains of Guilin, and Yulong, the Jade Dragon Snowy Mountain, of Yunnan. The spirit and vastness of the mountains and all that they have inspired was truly humbling.

But the journey wasn't just in traveling all that distance and standing in landscapes that are so hugely important in Asian art and literature—it was also in discovering how far I had come in my own art. I was trained in the traditional methods, and here I was standing where masters had stood, but I didn't feel I had to paint as they did. Whereas most Chinese artists depict Huangshan in a vertical monumental style, I opened my screen book, and showed it spreading from one page to the next in a horizontal panoramic style.

The journey reminded me of an old saying that, in order to improve one's work, one should read a thousand books and travel a thousand miles. After my return home, when I looked at the Chinese masters' works, as well as contemporary paintings, depicting the places we had traveled to, I realized that I understood them differently now. The mountains felt so real that they touched my own soul.

Since then I always take one or more screen books to record my personal journey each time I travel. Here are some of my journey albums.

This book began with the journey that I have traveled with my brush. I am still traveling with it here. I hope it will inspire you to record your own journey. There are endless inner worlds to discover in ink painting. Each of us will find our own path, or Dao, to where the brush will take us.

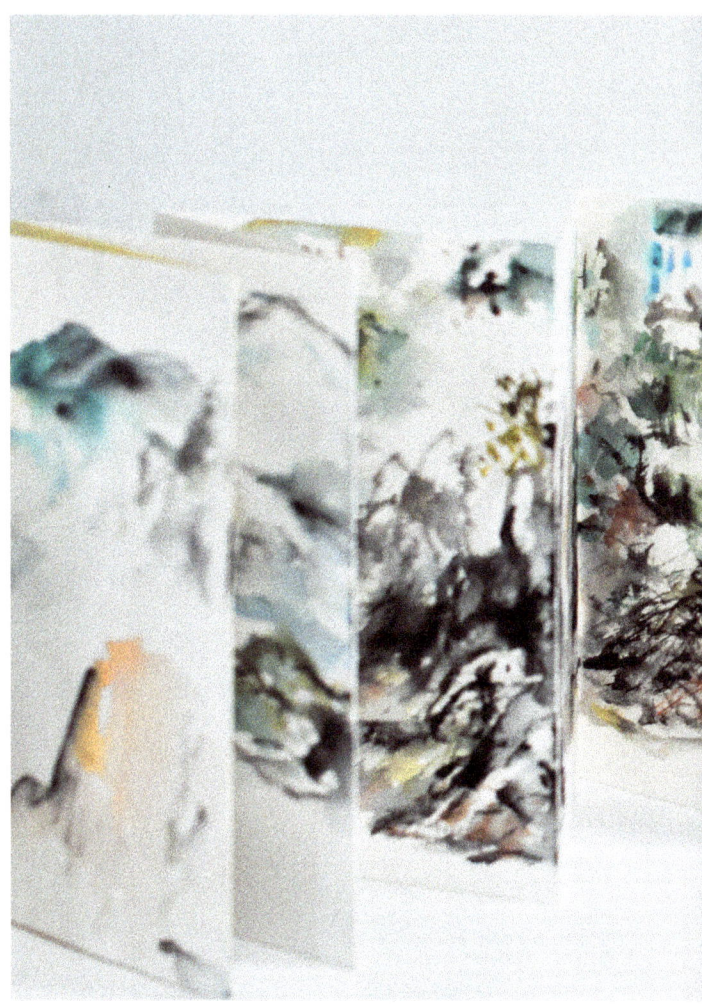

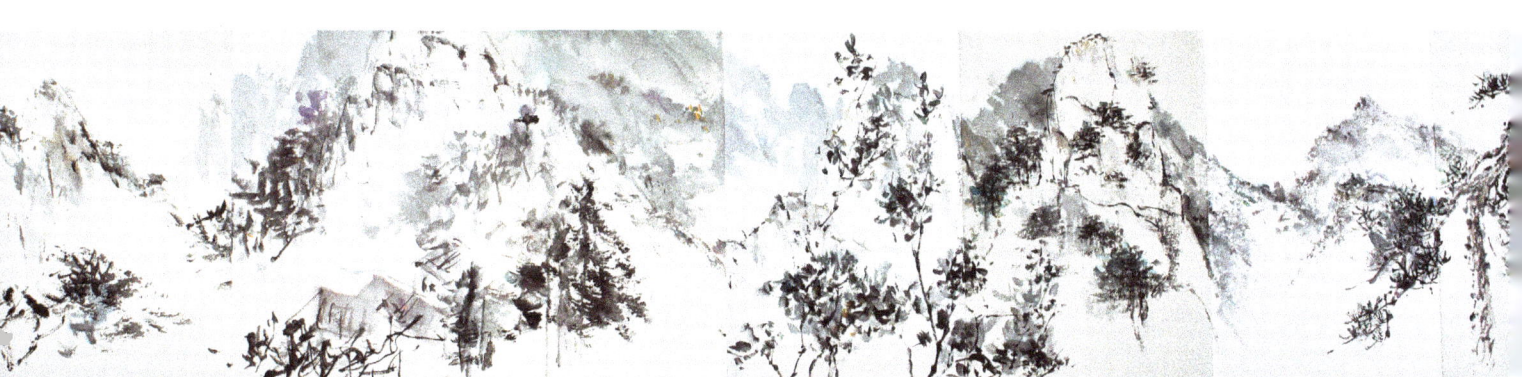

ABOVE: CINQUE TERRE (FIVE VILLAGES) IN ITALY
BELOW: JOURNEY TO HUANGSHAN

Resources

Paper, brushes, paints (Marie's from Shanghai), tubes of watercolor, ink, and instruction books can be purchased online or in the Chinatowns of many U.S. cities. Here are a few of my favorites.

Oriental Culture Enterprises
13-17 Elizabeth Street, 2nd floor
New York, NY 10013
212-226-8461
www.oceweb.com
ocebooks@yahoo.com

Awesome Art Supply
14815 210th Ave NE
Woodinville, WA 98077
425-497-9915
info@AwesomeArtSupply.com
www.awesomeartsupply.com/sumisupplies

Blue Heron Arts
19386 Waterfall Way
Rowland Heights, CA 91748
1-866-534-7116 or 909-594-9257
henryxli@roadrunner.com
www.blueheronarts.com

Oriental Art Supply
21522 Surveyor Circle
Huntington Beach, CA 92646
714-969-4470 or 1-800-969-4471
info@orientalartsupply.com
www.orientalartsupply.com

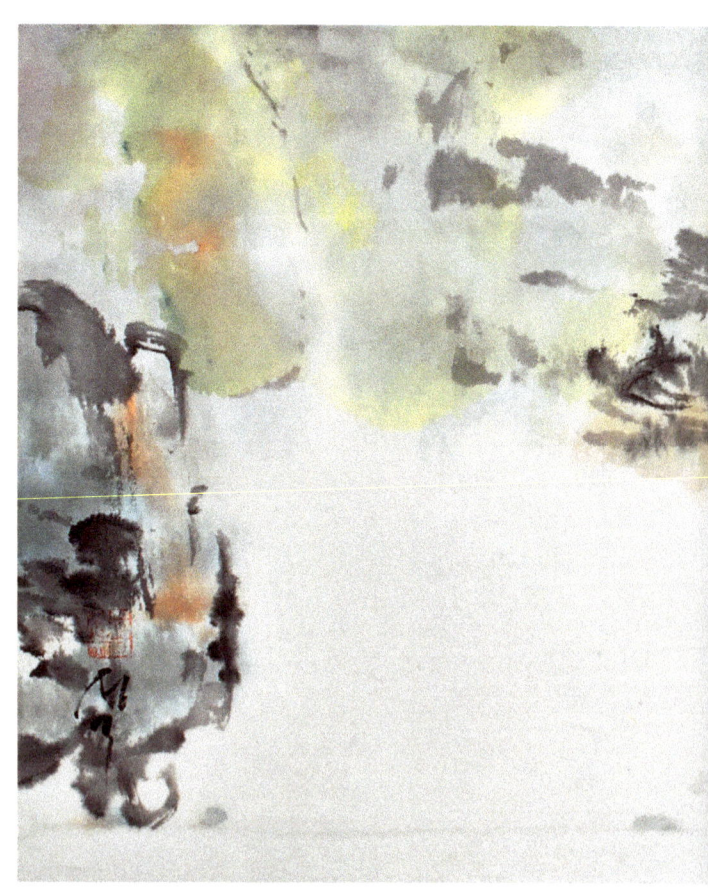

Acknowledgments

I dedicate this book to all of the students in my classes and workshops who inspired new lines of creativity with their questions. My life has been enriched over the years through sharing with them my passion for East Asian art and our life experiences.
In particular, I would like to thank my long-time student, Toinette Lippe, who helped me face the challenges I encountered in writing this book—particularly in regard to describing brush painting techniques.

I would also like to thank my husband, Mark Setton, with whom I have had many discussions about East Asian philosophy over the years. These conversations have helped me articulate my own art practice and the philosophy behind it.

Last, and definitely not least, I thank my editor, Judith Cressy, who conceived this project and had confidence in me as she guided me at every step in telling my brush painting journey.

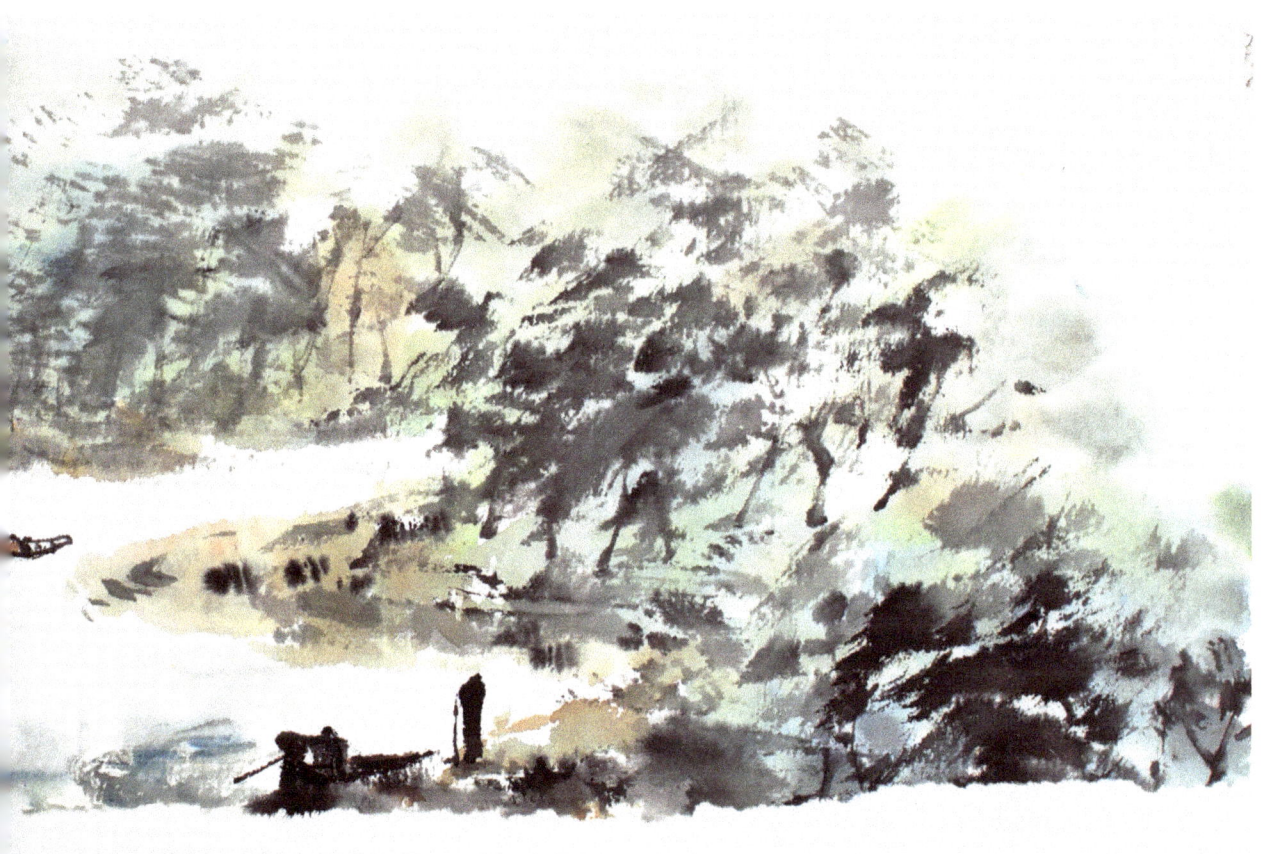

About the Author

SUNGSOOK HONG SETTON is a Korean-American artist and calligrapher. Besides her training in brush painting and calligraphy under Chinese and Korean masters, she has also studied Western art in Germany, the United Kingdom, and the United States, obtaining her BA in studio art at Stony Brook University and MFA in interdisciplinary art at Goddard College.

Setton's work has been widely exhibited in Canada, the United Kingdom, China, Korea, and the United States. She has received two dozen awards for her work, including Best of Show at the National Juried Exhibition by the Sumi-e Society of America. She serves on the faculty of Westchester Community College, the China Institute, and the Art League of Long Island.

Index

A
Ardesco, 102

B
Bada Shanren (Zhu Da), 10
Bamboo brush stroke, 29, 32, 36–39
Banana palms, painting, 84–85
Beaches, painting, 82–83, 87
Bristles (brush), 16
Brush strokes
 bamboo, 29, 32, 36–39
 center, 26–27
 chrysanthemum, 32, 46–51
 dancing, 31
 flying white, 30
 hake, 31
 orchid flower, 29, 32, 33–35
 plum, 32, 40–45
 reverse, 27
 side, 28
 split, 30
Brush Voice (multimedia performance), 102
Brushes
 about, 16–17
 becoming one with, 9–10, 15
 holding, 21–22
 loading, 22–23
 maintaining, 17
 parts of, 16, 17
 preparing new, 17
 sizes, 16–17

C
Center brush stroke, 26–27
Central Park (New York City), painting, 96–99
Chang, 9
Chrysanthemum brush stroke, 32, 46–51
Composition, 68, 70–71

D
Dancing brush stroke, 31
Detail, amount of, 71
Dong Qi Chang, 52
Dots, painting, 27
Dragonflies, painting, 80–81
Dunes, painting, 82–83

E
Echinacea flowers, painting, 80–81

F
Fall at beach, painting, 87
Flying white brush stroke, 30
Foliage, painting, 55–58
Forsythia in spring, painting, 74–75
Four Noble Plants, 16, 32, 36
Four Treasures, 16

H
Hair of brushes, 16
Hake brush stroke, 31
History, 9, 10
Host and guest concepts, 68

I
Ink
 flow, 15
 grinding, 18
 sticks and stones, 18
 tones, 24

L
Landscape painting
 foliage, 55–58
 schools, 52
 tree branches and trunks, 53–55
 trees in distance, 59
 water and waterfalls, 64–67
Landscape painting, rocks and mountains, 60–63
Lines, painting, 26–27

M
Maple tree in fall, painting, 90–91
Materials. *See* Tools and materials
Mood seals, 112–113
Mounting
 procedure, 109–111
 tools and materials for, 108
Music, painting, 102–107
The Mustard Seed Garden Manual, 15

N
Name seals, 112–113
Nature
 capturing spirit of, 12, 14
 cultivating as philosophical principle, 15

O
Orchid flower brush stroke, 29, 32, 33–35

P
Paint, 20
Paper, 19, 108
Perspective, 68, 70
Plum brush stroke, 32, 40–45
Pond with ducks, painting, 76–77

Q
Qi
 kinds of, 12
 in nature, 12, 14

R
Raw (rice) paper, 19
Reverse brush stroke, 27
Rocks and mountains, painting, 60–63

S
Schools of landscape painting, 52
Screen books, 122
Seals, 112–113
Shafts (brush), 16
Side brush stroke, 28
Silver birch tree, painting, 88–89
Sized paper, 19
Snow-covered pine needles, painting, 93
Snow scenes, painting, 93–97
Split brush stroke, 30
Stormy weather, painting, 100–101

T
Table set up, 20
Tools and materials
 accessories, 19
 brushes, 9–10, 15, 16–17, 21–23
 ink, 15, 18, 24
 paint, 20
 paper, 19
Tree branches and trunks, painting, 53–55
Trees, painting
 branches and trunks, 53–55
 in distance, 59
 maple in fall, 90–91
 silver birch, 88–89
 willow, 73
Trees in distance, painting, 59
Tregear, Mary, 68

W
Water and waterfalls, painting, 64–67
Watercolors, 20
Willow trees, painting, 73
Wol-jeon (Woo-sung Chang), 10

www.ingramcontent.com/pod-product-compliance
Lightning Source LLC
Chambersburg PA
CBHW041924180526
45172CB00014B/1374